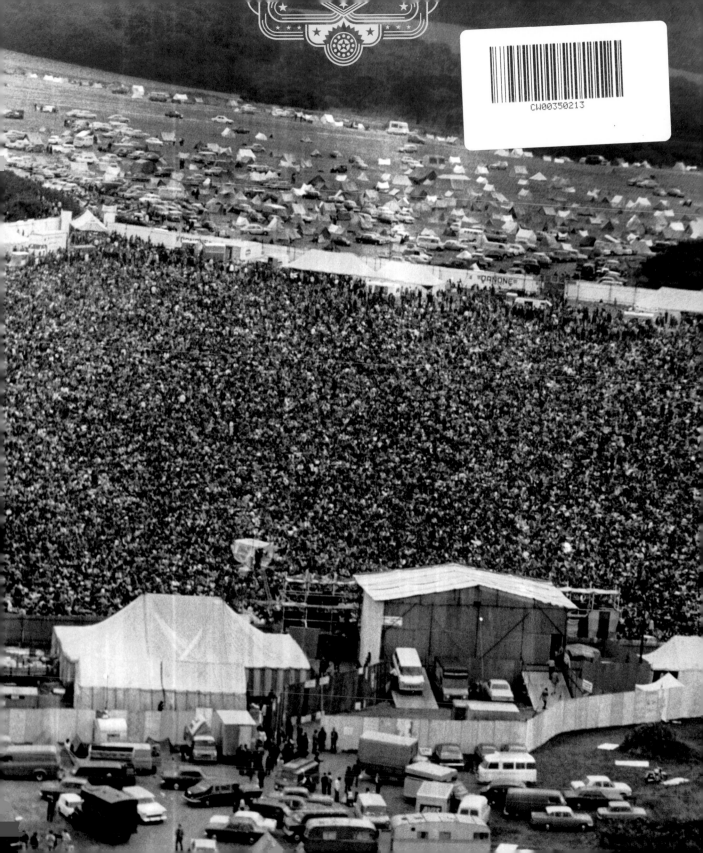

Acknowledgements

This book has been an honour and a pleasure to write. It would not have got off the ground without the drive, support, help and friendship of Peter Harrigan, head of PR at those legendary Isle of Wight festivals and now head of Medina Publishing. The germ for this book grew out of our meeting at the All Wight Now 2018 celebration on the Island to mark the 50th anniversary of the 1968 Isle of Wight Festival. How better to mark the golden anniversary of the 1969 event than to re-examine those events and to give voice to the people who made it happen; played their parts on stage and flocked to Woodside Bay to bear witness to what was, at the time, Britain's biggest rock festival?

I thank Ray Foulk, co-promoter of the iconic first three Island festivals, for his support, friendship and constructive eye for detail. He laid down a superb source in his own acclaimed volumes on those festivals, *Stealing Dylan From Woodstock* and *The Last Great Event*. My book does not claim to have the forensic qualities of those accounts and I heartily recommend them for further reading. Thanks too, to Ray's daughter Caroline for her suggestions and encouragement.

Sherif Dhaimish at Medina Publishing has worked wonders in directing design and production of the book. I also give special thanks to all those who gave up their time, gave up their old photographs and racked the recesses of their brains for their memories. To share those personal accounts of what was a magical time on the Isle of Wight was truly fun... and a privilege.

Bill Bradshaw, Freshwater, Isle of Wight, May 2019

Bill Bradshaw is an award-winning Fleet Street journalist, editor and broadcaster. Before a stellar career in sports journalism, he was a music columnist and interviewed a host of stars from David Essex and Marc Bolan to Sonja Kristina and Cliff Richard.

His first acquaintance with the Isle of Wight came in 1966 at the age of 10 when his parents took him for a holiday and his father Leslie rediscovered the couple who provided his billet prior to his action as a Royal Marine Commando in the 1942 Dieppe raid. He returned after more three decades in Fleet Street as features editor of the *Isle of Wight County Press*. He is married to Jill and has two children, Kit and Holly.

Contents

Foreword: Julie Felix

The Second Isle of Wight Festival of Music, 31 August 1969... and I was there. It was Sunday and I had been asked to perform on the same bill, on the same day, as Bob Dylan. There were people as far as the eye could see, it was surreal to just look out and not be able to see where the crowd ended.

After I had finished my set, I went backstage on to the grass. I was on my own and then Dylan came out of his caravan and joined me. He was anxiously waiting to go on and was waiting for The Band to finish their set. We sat on the grass together and talked for a long time.

When the time came for him to go on, Bob ensured I got a spot at the back of the stage. I was right behind him when he played his own set to end that wonderful festival.

So, I got to do one of the festivals of the decade and, 50 years on, I can reveal I had to turn my back on the party of the decade, because after Bob closed the show at Woodside Bay, I was lucky enough to be invited back to his after-show party at Forelands Farm, in Bembridge, where he had been staying. But... and there is a but.

I do remember going into the farmhouse. Somebody had kindly taken me there, a few miles from the site, and escorted me into this gathering of all the beautiful people. The VIP list and Bob's inner circle included John, George and Ringo from The Beatles and many other famous performers and musicians.

As I walked in I saw John and Yoko Lennon and they said 'Hi'. I think they had just arrived back from the festival, too, and for me that was just about it. That was my party – a quick 'Hello', and I had to go. I needed to make a quick exit as I had a tight filming schedule with the *BBC* next day.

I didn't even have time to speak to Dylan again and I think I may have beaten him back to the house. I'm sure Richie Havens was there, bless him – remember his gap-toothed smile? He had told me he was waiting for his third set to grow in!

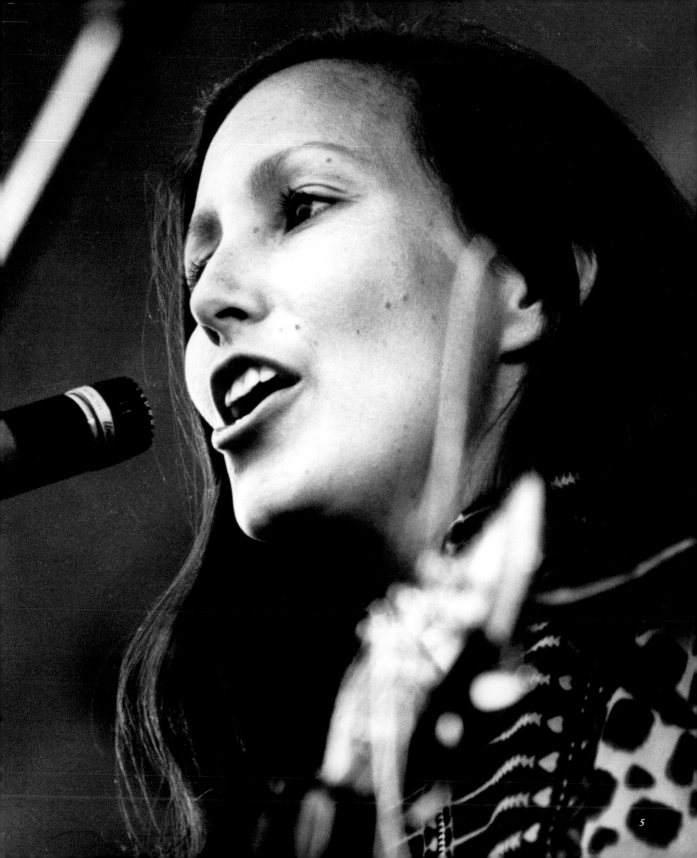

Bob Dylan was born in late May and I was born in early June, which makes us both Geminis. I sometimes think that is part of the reason why I so love his imagery and why I love to sing his songs. Geminis are made up of Castor and Pollux, the twins of Roman mythology, separated by death but desperately trying to reach each other. One is constantly reaching up to the heavens while the other strives to get back to earth.

There is a lot of that sense of longing in Bob Dylan's wonderful songs and I often talk about that to audiences before I sing, for example, 'Mr Tambourine Man'. That is a song of longing and yearning. It's for that reason I was not so keen on The Byrds' more upbeat version.

On that summer Sunday night, fifty years ago, The Band both played their own set and, of course, backed Bob for much of his time on stage. I liked The Band. At first, I admit, I had preferred Dylan's earlier solo performing style but then I got into it, Dylan backed by a great electric band.

I so admire Robbie Robertson, whose mother was a Native American, for the work he did with the Native American Indians in the 1990s and I can relate to that. I have Native American blood on my father's side and I'm pretty sure there is some on my mother's side, too. I feel that. So I loved the music of The Band that night, it was fresh and earthy with a good vibe.

Tom Paxton was great. I've told him, 'Hey, I wish I'd written THAT song, not you.' 'Going to the Zoo' is a song that people associate with me and, of course, the crowd demanded I sing it at the Isle of Wight. It's Tom's song... the royalties would have been nice. I saw him perform recently and he gave me a name-check from the stage – that was good. I wanted to do a show with Tom but, for whatever reason, it has not happened.

Over the 1969 weekend there were some stunning acts, such as The Who and The Moody Blues; Joe Cocker and The Nice; Free and Family; Pentangle and Marsha Hunt. Rock, Psychedelia, Blues and Folk all sharing the same stage.

So what about Isle of Wight 1969 and all those early festivals? Well, they were kind of a mystery to us all. I sang at the Weeley Festival in Essex, for example, a couple of years later and that was a mess. The Isle of Wight in 1969 was beautiful, the aristocracy of festivals.

Sometimes, they can be great and this one, well organised and with Bob Dylan closing it, after years of shunning live performing, was just that.

I did come back to the Island and did the modern festival about ten years ago. It was fine but festivals had changed. It was much more about designer boots and cut-off shorts; there seemed a lot more young business people rather than gypsies, hippies, adventurers and dropouts. In 1969 the performers and the audience were the outsiders, as Leonard Cohen sings in 'The Stranger Song', 'I told you when I came I was a stranger'. That's not the case now. A lot of festival goers now want to be seen there to be part of the in-crowd.

The whole world has changed, too. Today, the global elite is stronger than ever; oil companies continue to destroy the planet but I look for signs of hope. It is great that kids are protesting about climate change; that gay rights are being championed and that finally the injustice of gender inequality is being addressed. I am grateful that I have lived long enough to see the #metoo and #timesup movements take hold. The sooner we bring down the patriarchy, the better. It is time to take the toys away from the boys.

And we should remember that it was not all perfect love and peace back in the day. Free love was a lot better for the guys than it was for a lot of the girls but I still have such a positive view of the Sixties, especially the music of the era. I hear more and more requests for music from that time and while today's music is so slick, technically, where's the story? Where's the road well travelled?

The music of that far-off era, celebrated in these pages, went beyond songs of love and boy-meets-girl. The likes of Bob Dylan, Leonard Cohen and Joni Mitchell went deeper, looking at things in a broader context and into life's journey.

Now, fifty years on from my chat with Bob Dylan backstage at the Isle of Wight, that extraordinary festival is worthy of reflection. As Dylan sang in 'Mr Tambourine Man', 'Yes, to dance beneath the diamond sky, with one hand waving free...' In 2005, I released an album of Dylan songs called *Starry Eyed and Laughing*, the title taken from a line from his song 'Chimes of Freedom'.

Half a century on from Bob Dylan and the 1969 Isle of Wight Festival, I am still following 'Mr Tambourine Man', still listening for the 'Chimes of Freedom'.

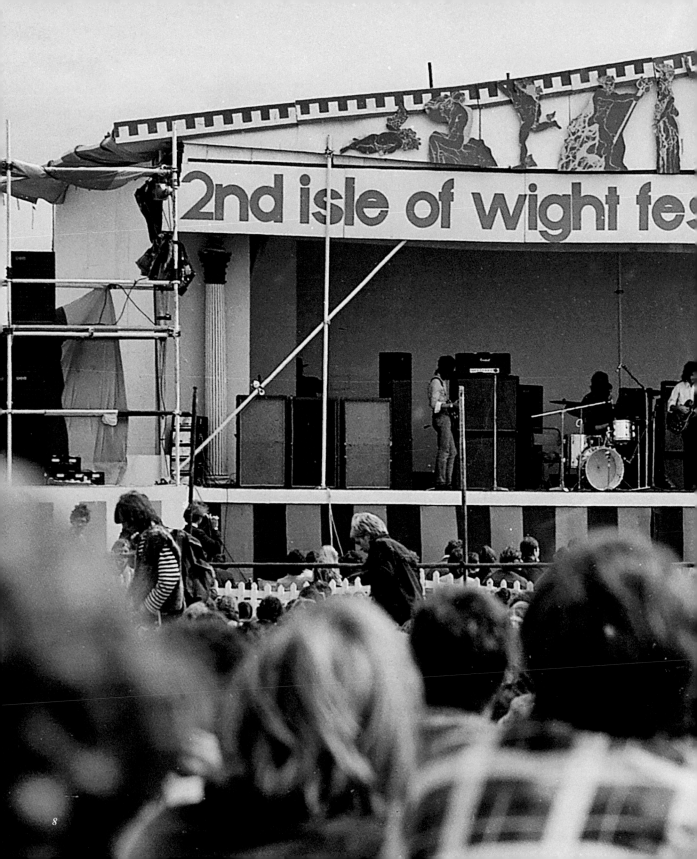

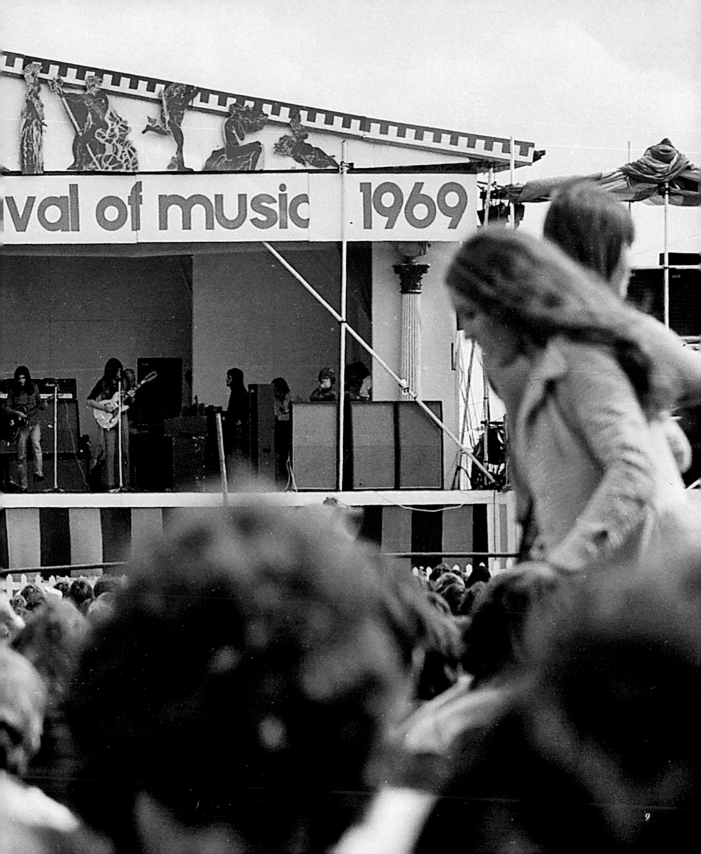

Let's do another one – A BIG ONE – in 1969

It was the last year of the decade, the 1960s were coming to an end. What a decade! There is a decent argument to be made that the world in which we now live was shaped in that narrow window of time. It was the decade Britain finally shrugged off the monochrome hangover of World War Two; a decade of immense social change and of the counter culture; the decade of Vietnam, political assassinations and protest.

And the decade when pop music grew up and morphed into rock, to be celebrated at a completely new kind of event: the rock festival. It was against this background that the 1969 Isle of Wight Festival of Music was conceived and staged. It was not the first rock festival in Britain, but it was the first truly big one... by far the biggest and most ambitious.

When it arrived at the end of August, it dwarfed anything seen in the country up to that point as 150,000 festival pioneers descended on the Isle of Wight, a tranquil rock just a few miles off the South Coast. The size of the crowd was comfortably more than the normal population of the entire island at the time – just 110,000.

So, what was the world like for the young, curious proto festival-goer in August 1969? Well, first of all, he or she had to get there. Very few motorways existed – for example the M3 London-Southampton did not exist at the time, and British Rail had only just consigned steam trains to history the year before. Having said that, hitch-hiking was considered a safe and cheap way of getting from A to B.

If you were lucky enough to have a car, petrol cost just six shillings and fourpence a gallon in 'old money' (less than 8p a litre) and 1969 was the year Ford launched 'The Car You Always Promised Yourself' – the Ford Capri – for £890, or £13,939 in today's money.

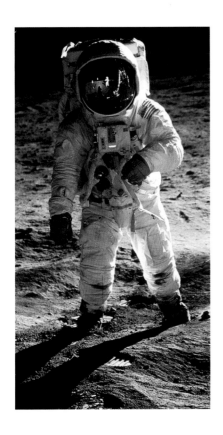

You could get a pint of beer for the equivalent of between 12p and 16p (outside London) although those were the days before CAMRA had its big effect on brewers and the demand for the return of real ale. You might have to put up with the likes of Double Diamond or Worthington 'E', Youngers Tartan or Whitbread Tankard on keg. For female festival-goers, this was long before the advent of shots or the contemporary fashion for flavoured gins and vodka. A glass of Cherry B, Babycham or Pony was the order of the day.

Few of the young festival-goers would have had the concerns of home buying or mortgages to deal with but their parents faced the slog of affording houses costing an average of £4,145 from a UK average wage of approximately £1,500 a year or £30 a week.

And cash was king. It's highly unlikely that any more than a tiny fraction of that 150,000 crowd had a plastic card in their wallet or purse. The UK's first credit card, Barclaycard, had been introduced in 1966 but not too many were in circulation by 1969. Wages were paid in cash, usually every Friday, in a brown paper wage packet. For larger items, you might use your cheque book for items costing up to £30.

In short, for everyone who lived through the period, life was simpler then. But to today's typical 2019 festival-goer, 1969 may seem so very much more complicated. Imagine a life without personal computers of any kind. No laptops, no tablets, no smartphones – no mobile phones at all. If you needed to reach family or friends, you wrote letters or used a landline telephone. If you were on the move, you had to make sure you had change to use a trusty payphone in a red GPO phone box.

Yet in many ways, the late Sixties seemed the ultra-modern age. In July, NASA responded to President Kennedy's 1961 challenge to land a man on the moon before the end of the decade by doing exactly that: Apollo 11 got Neil Armstrong and Buzz Aldrin there and back in a triumph of scientific exploration, bravery and endeavour.

Yet the Apollo craft's AGC computer system that helped guide it to the moon and back was, by today's standards, a pygmy. Even a modern iPhone is several thousand times more powerful.

And back in '69, it was virtually impossible to listen to your favourite music on the move. There was no downloading or streaming, no MP3 players; no personal headsets attached to mobile devices.

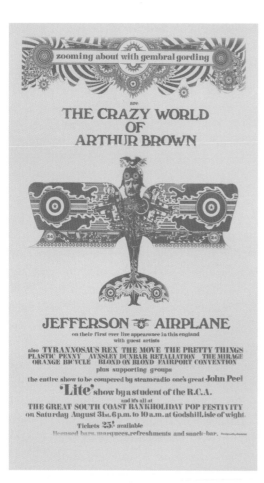

The first cassette tapes were introduced in 1968 but early models were of questionable quality and not too many people were aware of them. The Sony Walkman cassette player would not appear for another decade.

The only music-on-the-move came via a car radio or courtesy of a pocket-sized transistor 'tranny' radio, powered by a chunky 9-volt battery and tuned into a crackly, medium wave radio station.

There were no TV channels devoted to pop or rock music. The best music on offer was *Top of the Pops* on *BBC 1* every Thursday or the odd guest appearance by a band on a Saturday night variety show hosted by the likes of Lulu or Tom Jones. Indeed, there were only three UK TV channels on offer… *BBC 1*, *ITV* and the recently launched *BBC 2*. Most of the nation watched in rather less than 50 shades of grey on black-and-white sets. Mainstream colour TV broadcasting only made its first, tentative steps on *BBC 1* and *ITV* in 1969.

Broadband, satellite and cable TV? They were the stuff of science fiction fantasies, until the late '80s when the first fledgling satellite channels came along.

Against this backdrop, so very different to today, three brothers on the Isle of Wight had the temerity in 1968 to organise The Great South Coast Bank Holiday Pop Festivity, one of the very first pop gatherings, just a few months after The Beatles' *Sergeant Pepper* and 1967's legendary summer of love. Ronnie, Ray and Bill Foulk wanted to make an impact – on the back of zero promoting experience whatsoever.

Ronnie was the oldest of the brothers, the pushy salesman of the trio and an estate agent. Ray was the more studious sibling, a budding CND activist and an apprentice printer on the Island's newspaper, who quit to set up his own printing firm. Bill was the arty one, a student at the Royal College of Art.

Some 12,000 gathered on a farmer's field between Godshill and Niton to see Ray, Ronnie and Bill Foulk's presentation of a clutch of British acts, such as Marc Bolan's Tyrannosaurus Rex, The Move, Fairport Convention, The Pretty Things, Aynsley Dunbar's Retaliation and, the sole overseas act, San Francisco's psychedelic rockers Jefferson Airplane topping the bill.

It had been a start, 'A bit of a do in a field', as one contemporary review put it, but the Foulks wanted to do so much more. More than another singular 'all-nighter', such as their 1968 festival; a much bigger crowd, and much bigger acts to draw a mass across the Solent to the Island. Apart from anything else, their inaugural Island venture had not made money.

What to do? To establish their bona fides, the brothers set to creating a weekend rock venue in Lake, near Sandown, which they dubbed 'Middle Earth' after obtaining permission from the iconic venue of the same name in London's Chalk Farm Road. Soon, acts such as The Nice featuring Keith Emerson, Marsha Hunt and blues-rock rising stars Free (who boasted the precocious talents of Paul Rodgers on vocals and Paul Kossoff on guitar), were booked.

They – and several of the other bands who appeared at Middle Earth – would eventually be booked for the festival on 29-31 August. But a truly huge act to put the afterburners on ticket sales was still to be secured. Who could put the Island truly on the map of world rock?

The answer came gift-wrapped in a 1968 Christmas present – just nine months before the event itself – when the youngest Foulk brother, Bill, handed a slim package to elder sibling, Ronnie. It was Bob Dylan's LP *John Wesley Harding*. Ronnie played it endlessly and an idea, perhaps preposterous, was born. Why not invite Dylan – the man credited with turning pop into rock and the (albeit unwilling) leader of the Sixties counter culture generation – to be the face of the 1969 Isle of Wight Festival?

It was nothing if not hugely ambitious…

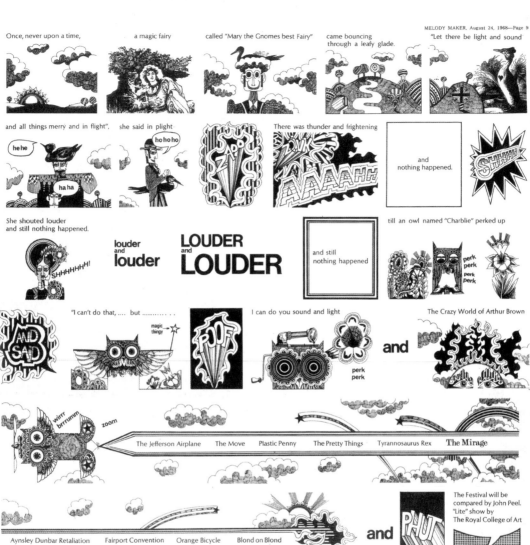

I was there!

Mike Thornley

I hitch-hiked to the festival with three 17-year-old friends, arriving in the field on the Wednesday. We found space in one of the dormitory tents and unrolled our sleeping bags before we set off to explore the area. When we got back, at about 7 pm, we found that this was also the disco tent with John Peel playing records and showing a 'light show'.

This was a projector with a small glass ring filled with different coloured oils rotating in front of the lens. To us it was magical. Our sleeping bags had been neatly rolled up to make room for the music fans but our stake was made and no-one tried to poach it.

We had tickets for the three days and used them, almost going without sleep for a week. We lived off fish and chips, burgers and music. I remember Jethro Tull, Dylan (of course), The Who, and all the others who just took it in turns to thrill us. I also remember the naked girl, who happened to be right next to us. It was no big deal, everything seemed so natural.

At the end of the festival we made our way down to Ryde and spent the night in the doorway of a chemist shop. The chemist woke us up in the morning without any complaint; he needed to sweep the doorway before opening for the day.

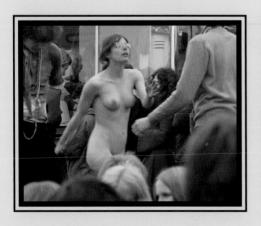
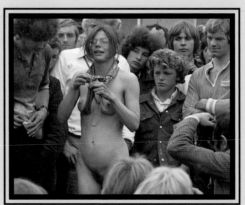

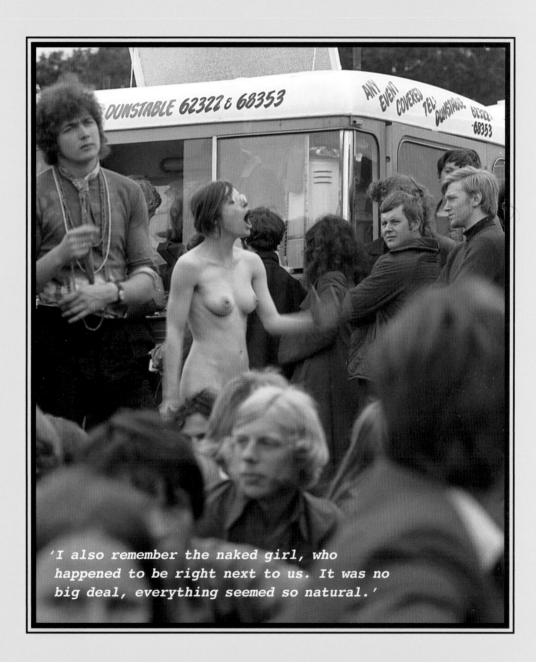

'I also remember the naked girl, who happened to be right next to us. It was no big deal, everything seemed so natural.'

It's got to be Dylan!

As Dylan himself would have had it, the times they were a changin' in 1969, in every sense and in every field. Music was certainly a case in point. Pop music was changing, but not yet transformed.

The charts were an odd, even laughable, confection made up of the new rock genre – neither pop nor rock 'n' roll – plus bubblegum pop, old-style crooners and novelty nonsense. I give you Rolf Harris (then decades away from his eventual disgrace) with 'Two Little Boys' and Lulu's Eurovision joint-winner 'Boom Bang-a-Bang'. There was Jane Birkin and Serge Gainsbourg's 'Je t'aime... moi non plus', supposedly an aural offering, in the era of free love, of two people lost in coitus. Really?

Such a clash of styles was summed up by Jimi Hendrix's appearance on the aforementioned Lulu's own *Happening for Lulu BBC* TV show on 4 January. The intention was for Jimi to play 'Voodoo Child (Slight Return)' followed, later in the show, by 'Hey Joe', when he would be joined by Lulu in mid-song for a duet!

Jimi and his bandmates, having had a smoke before 'Hey Joe', had other ideas. He'd no sooner got into his stride on his own song when he called a halt and announced he was doing a number to honour the recently disbanded Cream. Off he went into 'Sunshine of Your Love', ignoring wild gestures from the desperate TV crew, and they over-ran as the show crashed out of time. Lulu never did get her duet.

It was the year of The Beatles' last performance on Apple's London HQ roof, plus the release of their swansong LP, *Abbey Road*. Before the year ended, Paul McCartney would marry Linda Eastman, and John Lennon and Yoko Ono were also wed and recorded an anthem for the era: 'Give Peace a Chance'.

This was the mixed musical backdrop that fed into the Foulk brothers' deliberations for a big name to make a statement and set their 1969 festival apart.

So it's little wonder that Ray Foulk, the middle brother and the man who largely looked after the business end of their operation, initially mulled over the likes of Adam Faith and Billy Fury when considering a headliner for their first festival venture in 1968.

Neither was without talent. Faith's string of highly stylised vocals hits largely aped the style of Buddy Holly, while Fury, managed by the late 1950s equivalent of Simon Cowell, Larry Parnes, had a magnificent voice. But both were, frankly, irrelevant leftovers from the era before the Merseybeat revolution of the early 1960s.

'My knowledge of the music scene was sketchy', Ray told me. 'It came mainly from listening to pirate radio and for our first festival I'd had acts like Fury and Faith in mind, but by 1968 they were very passé. Suddenly, at our first event we had acts like The Move and Tyrannosaurus Rex. I'd got up to speed a little by 1969. I was aware of the American acts on our bill and I knew Joe Cocker because his hit, 'With a Little Help From My Friends', was everywhere'.

By 1969, something very different was required. Bill Foulk, who had handed Ronnie that Dylan album for Christmas 1968, was an art student at London's Royal College of Art and was fully aware of Dylan's status and the coup his capture might represent. The man who had forged a huge worldwide reputation as the voice of protest in the early 1960s had also become something of a man of mystery by 1969, following a motorcycle accident three years earlier.

He had been badly hurt and apparently broken his neck. He could still record but Dylan had not made a formal, advertised public performance since the crash. His stock, already huge, had risen further through the release of albums such as 1966's *Blonde on Blonde*; *John Wesley Harding* (1967) and *Nashville Skyline* (1969), without the promotion of live performances.

As Ray Foulk himself said, the 1969 Isle of Wight Festival 'Was situated in the middle of a period of more than seven years during which the Isle of Wight was Dylan's only pre-announced or paid performance'.

Other than The Beatles, the biggest band in the world, Dylan was the biggest name on the planet. But could he be available for a festival on a small Island in the English Channel? Surely not.

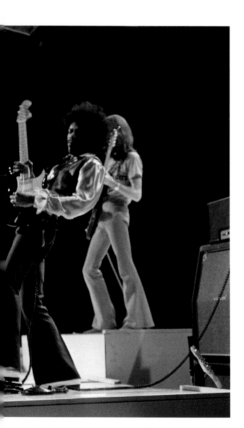

Jimi Hendrix performing on **Happening for Lulu**

The Foulk brothers did not even know the name of Dylan's manager, but Ronnie made a trip to London's University Bookshop in Charing Cross Road to find the info in an underground magazine article. Not long after Christmas, he placed a call to the reclusive Dylan's manager, Albert Grossman, in New York. The initial sounding was predictably negative. Dylan had turned down hundreds of offers to perform in the last three years, but Ronnie was at least invited to put in a check call in another couple of months.

It was brother Ray who followed up. After several fruitless attempts, he got hold of Grossman's partner, Bert Block – a former band leader who had represented giants such as Billie Holiday and Louis Armstrong, among many others. Several Transatlantic discussions ensued as Block sussed out the bona fides of these Limey whippersnappers.

When Ray spoke to Bert Block in mid-March, the first signs of genuine encouragement appeared like spring's green shoots. Block said they were forwarding the Isle of Wight proposal to Dylan and that they too wanted to get Bob out on stage again. Ray was advised to call back in April.

This was the signal for Ray, Ronnie and Bill to plot a campaign that would put any other offers in the shade, just in case Dylan could be lured. They had four weeks to devise and hone a perfect pitch to Dylan.

It was one of the brothers' trusty 1968 team, the site construction manager Ron 'Turner' Smith, who helped give the plan its focus. Smith, by no means a fan of the leader of the Sixties generation, urged the brothers to use the charms of the Island itself to secure any wavering talent.

He said to them in his Brummie twang, 'The oiland is your insurance, ya know. It's luvely. I don't think people really appreciate how luvely bits of the oiland are. It's a pull in itself'.

The hare was now running. So it came to pass, when Ray duly got back to Bert Block in mid-April, that Fiery Creations would offer Dylan and his family an all-expenses-paid two-week holiday on the Island and lodgings in a country house, Shalcombe Manor, whose origins were apparently recorded in the *Domesday Book*. It had a lake, woodland walks and the package would include a limousine with chauffeur, cook and an English governess for the Dylans' children.

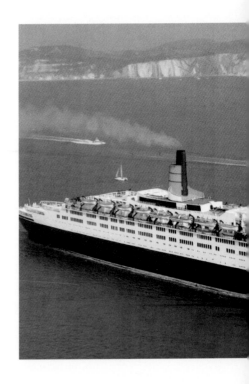

After that offer was made, the brothers added the coup de grace bait of an Atlantic crossing on the Cunard's glittering new flagship liner, the QE2.

Added to this 'luvelly' mix were many of the Island's other attractions dangled before Dylan, including Queen Victoria's Island home Osborne House, and the monarch's poet laureate Alfred Lord Tennyson's retreat, Farringford House, not far from Shalcombe Manor. It was a mix of olde England that the brothers packaged up into what was, effectively, a sales pamphlet that was despatched to New York. They reckoned it might, just might, appeal to Dylan.

A little later, Bert Block requested more details of the festival, the organising team and photographs of the site. Then a request for film footage followed – to be shot on Kodak Super 8 – of the proposed arena and Shalcombe Manor. Bill Foulk duly obliged and with Ray's help he shot the manor house, the festival site in Wootton and the nearby bay plus the monument to the poet Tennyson, towering above the stretch of downs named after him. It was rushed to New York.

Perhaps it was kismet, but the QE2 was due to sail from New York to Southampton, just a few miles across the Solent from the Island, on 15 August. Block promised to add the QE2 offer to Dylan. The only thing not yet on the table was the little matter of... the fee.

Ray was happy to steer clear of details about the cash as he knew he could not compete, dollar for dollar, with the major players in the business. He was, however, reassured by Bert Block's general view that they would not expect more from an event than was commercially practical. Block wanted a proposal that would suit Dylan – then the terms could be settled. It was an approach that was unusual 50 years ago and it's one that would be astonishing and almost impossible today.

RMS Queen Elizabeth 2

help Bob Dylan
sink the
Isle of Wight
on august 31st

There was much organising for the brothers to do, having settled on Wootton's Woodside Bay as the site. It had to be turned into an amphitheatre; the bill for the two-day event on Saturday 30 and Sunday 31 August had to be shaped. A plethora of other details, large and small, required attention.

But it was not until the evening of Wednesday 16 July, when Ray took a call from Bert Block, that the impossible dream started to morph into reality. Ray recalls that Bert's manner was initially one of irritation.

'He had been trying to get through all afternoon,' Ray said, 'but the Transatlantic lines were busy. He went on, "I've sent you a cable to say that Dylan will accept." I can remember shaking as he spoke. It seemed the booklet and the film had worked. He read out the yet-to-be delivered telegram.'

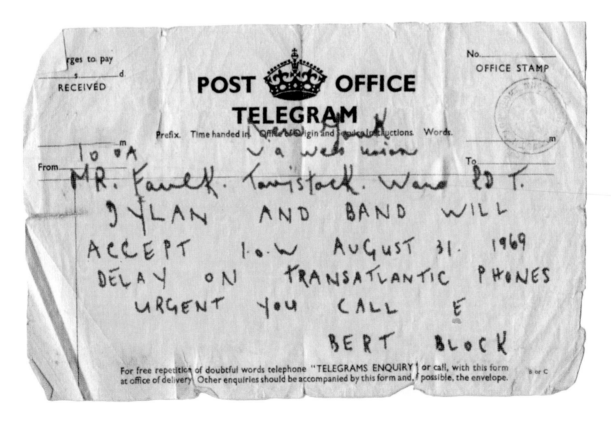

So, Ray was told, he would have to be in New York the following Tuesday to sign contracts. It was when Block said to Ray 'Bob wants to meet you' that the young man on the telephone in his mother's Island home in Totland Bay simply had to sit down. Because it was happening... Dylan WAS coming to the Island.

At this point, the invisible elephant weighing heavily on the Transatlantic line was addressed. Bert talked money. Dylan's fee was $50,000, or $342,000 at 2018 values. He would appear with The Band who would also perform their own set and charge $20,000. Dylan also wanted Richie Havens on the bill – for a fee of $7,000. Airfares for the party added $10,000. It totalled $87,000 – some £570,000 in today's sterling value.

The party's accommodation and UK transport costs would also have to be covered. 'That's it, we've got him. He's agreed to do it!' a jubilant Ray told Ronnie. The brothers knew it was a lot of money but, for the world's biggest festival star, it seemed reasonable. And those fees would be reflected in the cost of the tickets.

The festival tickets were to cost £2-10s (£2.50) for a weekend; £1-5s (£1.25) for Saturday only and £2 for Sunday (Dylan day) only. Bargain!

The deal had effectively been struck, if not sealed, on 16 July 1969. It was the very day that Neil Armstrong, Edwin 'Buzz' Aldrin and Michael Collins blasted off in Apollo 11 for the moon. It would take them another four days to get there but Foulks had already shot for it – and got there first by landing Dylan on the Isle of Wight.

I was there!

David S Halstead

The car was a clapped out Standard 10 filled with hippies, sleeping bags, camping equipment and a two-sleeper tent. It went downhill at over 70 mph and uphill at barely more than walking pace. But it made it to the ferry and we bought a ticket to Ryde — and had to sing the song, of course! On the ferry was a groovy white car painted over in pop art fashion with pictures and symbols and on the front it said 'Dylan or Bust'. I really hope they made it to see Bob.

I like to think my first single was 'Like a Rolling Stone', though in all probability it was probably something embarrassing to admit to today. I played it endlessly on my radiogram trying to write down the words.

I listen to Dylan more now than I did then. For us, the big attraction was The Who. Although we were freaks (we preferred to be called heads), it wasn't that far back when we'd been Mods. The movement from Mod culture to Love & Peace was accompanied by our change from speed, mandies and alcohol to cannabis and acid.

At the Isle of Wight we couldn't get any 'shit'... but we did have a supply of black bombers!

During this time I worked in a dairy and lived in digs with a milkman called Geoff and his overweight wife Anne. In her medicine cupboard there was a large bottle of amphetamines prescribed by her doctor to make her more lively, less hungry and lose weight.

Lemmy emptied the capsules into a handkerchief, replaced the contents with flour and put the bottle back. We huddled over the opened hankie in a marquee, provided free for those who didn't have a tent, licked our fingers and dipped into the pile of powder until it was all gone.

Another image remains of a beautiful young hippy chick smiling and gliding by with 'FUCK ME' written across her forehead. I had read about 'free love', but this shocked me.

Next problem was to get in without a ticket, or the means to buy one. We walked round the whole perimeter looking for a way in for free.

'That horror moment of being trapped inside the tent, like
kittens about to be drowned is my most vivid memory...'

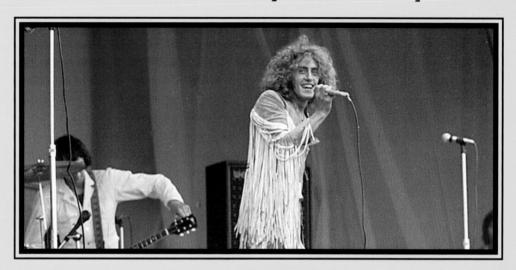

Lemmy collected some cash and gave it to a 'guard' who turned a blind eye while we went under the fence. I can't honestly remember much about the Saturday evening or even any of the songs, but I do remember seeing the finale of the set by The Who and Roger Daltrey in his iconic fringed, brown suede jacket.

Later on things started to turn really weird, punctuated by announcements to the effect that there was some bad acid out there, man. And if you were having a bad trip then go to the medical tent. BAD TRIP, BAD TRIP!

The last thing anyone wanted to hear was 'bad trip'. It took an eternity to get our heads straight and then the announcements started again. I wonder how many peaceniks had their serenity broken and their trip spoiled by this idiot... We couldn't find the medical tent. We were lost and remained so.

By Sunday evening we were hallucinating. What made it worse was we saw the same figments of our collective imagination. It had to be real, didn't it? The fiery cross fifty feet high in the cliff, the man in a cape with a cat on his shoulder?

'It had to be real, didn't it? The fiery cross fifty feet high in the cliff, the man in a cape with a cat on his shoulder?'

Was it a full moon, the lights from the arena and/or the sun low on the horizon that cast surreal shadows over the camping area?

Somehow we managed to score some black, the quality and strength of which we rarely see nowadays, and sat cross legged in the small tent and smoked it all. Not a good idea! The shadows got more sinister and we could feel vibrations from the earth approaching the tent from all sides.

Memories for me tend to be visual or auditory, but what happened next was physical. Our backs were tight against the outside of the tent when I felt a hand press down on me from outside. Sheer panic propelled me to dive out of the tent. So did everyone else. The tent pole buckled and the canvas belly

nearly burst with us inside screaming and scrabbling to get out. That horror moment of being trapped inside the tent like kittens about to be drowned is my most vivid memory of the summer of '69.

We could hear the music from the stage clearly from where we finally pitched ourselves on Sunday, but I can't remember a single song, except for one. In the evening we bumped into some beautiful Taunton chicks, one of whom took pity on me and I spent the rest of the evening in her sleeping bag in a platonic state of bliss.

The sweetest moment, and final memory of the decade, was feeling peaceful and safe, listening to 'Lay Lady Lay' phasing, swirling and curling away into the night.

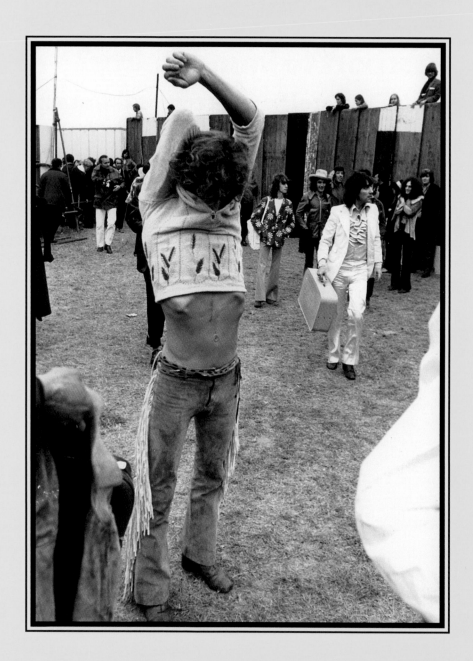

Passport to immortality?
Ray's first foreign trip secures the main man

In the 1960s, even towards the end of the decade, it was not common to travel abroad. Few people, other than executives, captains of industry or those with 'old money' travelled overseas. So it is far from surprising that 24-year-old Ray Foulk did not even own a passport. He was far from prepared to hop on a new-fangled jumbo jet and fly to the USA to seal this quite extraordinary deal.

But there was no time to lose. Quite apart from securing a passport in double-quick time, Grossman, Block & co. wanted proof of funds and the Foulks would have to show they had Dylan's money covered.

Ray would go on the trip with Rikki Farr, Portsmouth club owner, compere from the 1968 festival and the son of legendary Welsh boxing champion, Tommy Farr. Indeed, Farr senior had been on the QE2's maiden voyage from Southampton to New York a little earlier in the summer, filmed by British Pathé News sipping champagne on board. Rikki shared his father's confident persona and would provide the voluble front, Ray the more studious back-up.

They had only four days, from the next day – Thursday – to the following Monday to sort out airline tickets, a New York lawyer, Ray's passport plus US visas and cash for the trip. Friday was earmarked for the mind-numbing queuing at the Passport Office in London's Petty France, then at the US Embassy in Grosvenor Square.

Over the weekend, as Commander Armstrong took man's first steps on the moon, progress was made on the fund raising. An Essex printing firm, contracted to print the festival programmes, was secured to also invest £5,000 while Bill Foulk discovered that a friend of a friend was Vernon Burns: head of the European Division of Screen Gems, part of Columbia Pictures and associated with Columbia Records, Bob Dylan's label. Before Saturday was out, he was convinced to invest in their brightest star – a £20,000 investment for 25 per cent of the festival profits. Burns provided a letter of intent.

Take the
by the ta

Take an off-beat island. Take a way-out city. Take a far-flung
Call a Pan Am® Travel Agent and take off on the world's mo
Pan Am makes the going great.

airline.

Over in Essex, Ronnie got the printers to make their £5k available and the contract was overseen by a next-door neighbour, solicitor Peter Steggles, who decided to throw in £2,500 himself. Ray and Rikki Farr would fly from London's Heathrow to New York on a Pan Am 747 with guarantees for £27,500. It was enough, Ray recalled, to 'Brazen it out' in the Big Apple.

Documents safely pouched, they arrived at Grossman's office in New York in time for lunch on Tuesday. This was the day the Apollo 11 crew had to fire their engines mid-flight to re-align their craft for a safe return to earth... Ray and Rikki needed to navigate carefully, too.

Joining Grossman and Bert Block were the lawyers: Harold Orenstein representing Fiery Creations and Dylan's own lawyer David Braun. They left the Manhattan office for a Chinese restaurant at street level. Ray had not only never owned a passport until the end of the previous week, he had never been to a Chinese restaurant before!

After digesting sweet and sour ribs and yet more dishes Ray had never encountered, the lawyers got down to chewing over the contracts for Dylan, The Band and Richie Havens. No filming of any kind of Dylan was allowed, but audio recording was given the green light. Dylan's sole obligation was to give a one-hour exclusive performance and no other public performances would take place or be announced ahead of the Island event.

There was no drama over money. The Foulks discovered that, despite their youth and relative inexperience, they were trusted. The letters of intent were merely glanced at and payments were to be made in two tranches – guarantees for the full amount of $87,000 by 4 August and those guarantees would then have to be redeemed in cash or cleared funds by 15 August. That bought the Foulks time to generate revenue from advance ticket sales.

As they left the office, they bumped into rising star Janis Joplin. Next day, they were to meet Bob Dylan himself.

It was left to Bert Block to deliver the main man to the Drake Hotel where Ray and Rikki were staying. This hotel became famous as the base for many touring bands and was at the centre of the controversy surrounding Led Zeppelin in 1973. During the band's stay at the Drake, they had $203,000 cash stolen from a safe deposit box.

Dylan duly arrived wearing, Ray recalled, 'A black, neat-fitting leather jacket, jeans and black boots. He looked modest and ordinary even, quite unlike the familiar images from album covers and other pictures. He was friendly, though fairly quiet and business-like... I thought at the time Dylan was shyer than I was.'

Rikki's memory of the meeting with Dylan is rather different but there is no dispute from either man about the outcome: Dylan was happy and ready to cross the Atlantic and head to the Island. He raised general points about the festival and wanted to know about the sound system. Dylan clearly wanted to know who he was dealing with and what they were about.

There was one scare when Ray and Rikki met Grossman – without Block – later in the day. While Ray fretted about Grossman offering him a joint – drugs were alien to him – news came through that the headline 'DYLAN FOR THE ISLE OF WIGHT FESTIVAL' was splashed across the front of *Melody Maker*. Grossman was furious about the leak, but a call to London convinced him as to who was responsible.

Ray, who confessed to feeling 'Appalled', knew he was blameless and the fact the lead story included quotes from Rikki Farr left no room for manoeuvre. 'Grossman was very friendly to me but icy to Rikki thereafter,' said Ray. Once the intrepid duo were back home, the chaos of organising what was bound to be a very big festival duly ensued.

Because of the staged payments agreed in New York, Ronnie reckoned he could renegotiate his agreement with Vernon Burns since the promoters no longer needed instant access to cash. Burns was not impressed, arguing the brothers had used his guarantees to secure contracts, even if no cash had been drawn. Burns eventually agreed to cancel the deal, in return for a one-off payment of £2,500.

More deals along the way helped ensure all the funds were in place. This included a £5,000 pledge from the brothers' mother, Ella Foulk, and Romford's Labour MP Ron Ledger, the owner of the 70-bedroom Halland Hotel, in Seaview on the Island's east coast. The honourable member chipped in with a £2,000 guarantee. Later, the hotel would play host to Dylan's pre-festival press conference.

And so, by 15 August, ticket receipts were sufficient – just – to meet the deadline. Payment to New York was completed under the contracts and it was now, as Apollo's Mission Control would have said, all systems go...

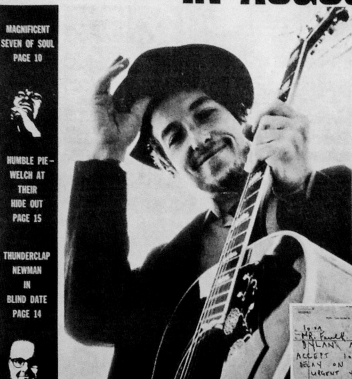

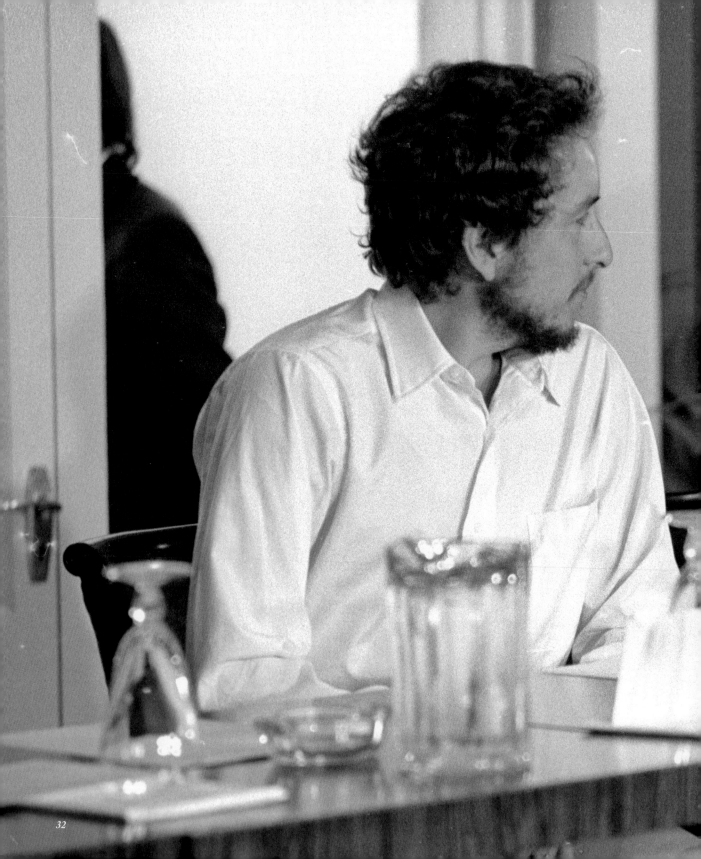

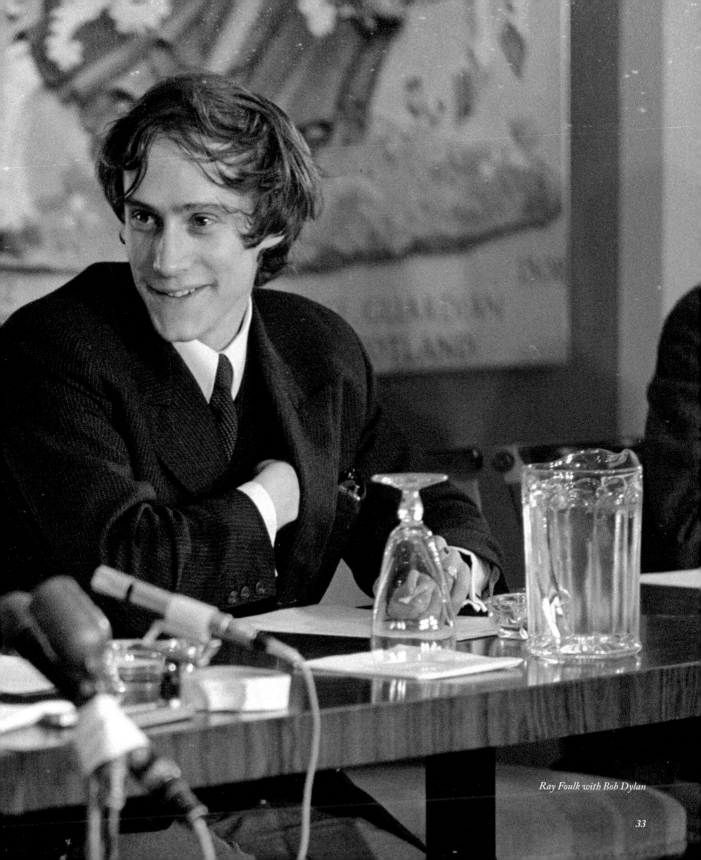

Ray Foulk with Bob Dylan

I was there!

Rikki Farr

I got involved with the original 1968 Isle of Wight festival late in the day when the Foulk family put on the event with *The Move*, *Arthur Brown* and *Jefferson Airplane* — and Marc Bolan's *Tyrannosaurus Rex*. It kind of worked but the site was horrible and the festival was sort of painting by numbers. The Foulks all wanted to do another one and we would have a full year to crack it.

I had something of a background in music with a couple of clubs in Portsmouth. I put on acts in the Kimbells Ballroom and South Parade Pier. I had Ten Years After, Fleetwood Mac, Free and other great bands there. Then I put a club in the old NAAFI club theatre ballroom — it had a great oak floor, perfect for dancing.

Ronnie, Ray and Bill had talks about what would happen next. For my part, I was used to booking big acts for my clubs like the Yardbirds and Stevie Wonder and I knew the booking agents, but it was clear Fiery Creations needed something really big for another festival in 1969.

Ray's right to say his younger brother, Bill, was pushing Bob Dylan, but Bob had suffered this motorcycle accident and told his aides, Al Aronowitz and Bert Block, that he could not do live dates. He retreated to Woodstock and The Band was up there rehearsing and playing. A lot of bands congregated in the area and Bob was happy to just sit down and play and get himself back into some sort of shape to play live again. He was getting closer, though in the sanctuary of his enclave.

Bob for the Island? It was difficult but worth a try. I had bits and pieces of information but I knew that if we could get Dylan, it would make the festival unique for a lot of different reasons.

The Foulks got their pamphlet out to Bob's camp, telling him this was the Island of poetry; the Island of Queen Victoria's home. We knew he was very anti-commercial at this point and hoped it would appeal.

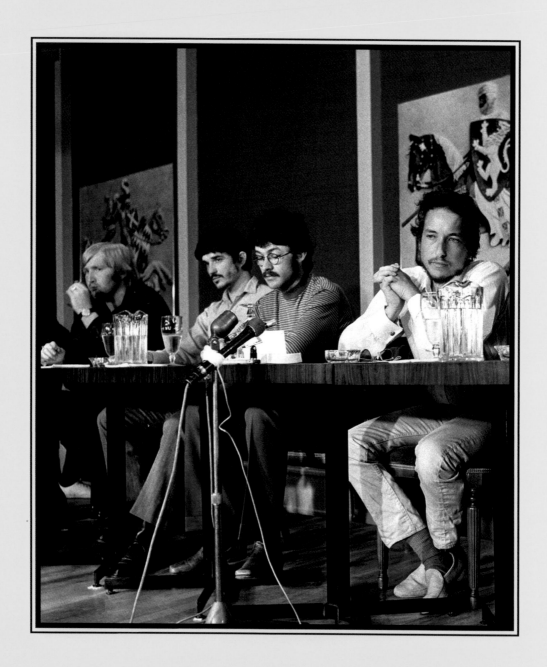

'I think it's appropriate to make your comeback on the Island of poetry and flowers.'

Ray was the thoughtful academic one while Ronnie, like me, was much more entrepreneurial. We had a wicked intent and Ray would be the brake man, which we needed. For a slight, almost frail guy Ray did, however, have real backbone and tenacity.

After Ray got the call inviting him to do business, he and I flew to New York. I just wanted to get out of the hotel room and talk to other people because I wanted to book American bands for my clubs. I'd already booked people like Marvin Gaye Ike and Tina Turner, Smoky Robinson, Clarence Carter and Sam & Dave.

Eventually, after we had done the business with the lawyers, we got the knock and opened the door. It was him... it was Bob Dylan. I recognised his curls.

Ray and the boys had made this film about the Island to tempt him to come and I told him: 'Bob, you're a poet and this is an Island of poets — Keats, Tennyson, Peel and Reynolds. I think it's appropriate to make your comeback on the Island of poetry and flowers.'

He wanted to know how people would get to the Island but we reassured him about that. I wanted it to be like a poetic Dunkirk. Bob thought that it was a good idea and that he would like to be backed with The Band supporting him.

We had a good chat about the Island, the great sound system from WEM, the super site we had found and the supporting bill including The Who, The Moody Blues and a lot of great folk artists.

Bob said, 'it sounds wonderful,' and we were delighted. I wanted it to be like a mediaeval carnival. I recall the deal being done at a Chinese restaurant. I also recall the chef was flinging the shrimps around. We were fearless.

Ray was the organised, precise, studious guy — typical of a printer — and I was the opposite, glass half-full as opposed to Ray's glass half-empty. But he is right to scold me about leaking the news of our deal with Dylan to Melody Maker.

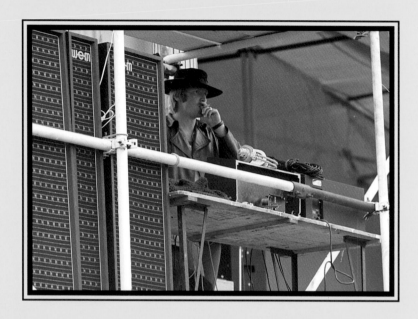

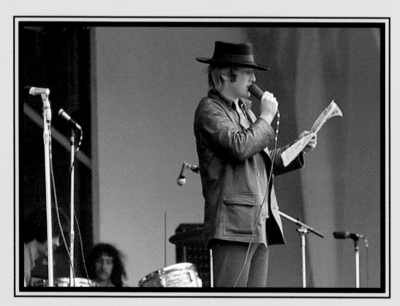

That was down to me but that has to be counterbalanced by the finished result. We only had a limited amount of time to get the tickets sold.

I'd spoken to my friend at Melody Maker, Chris Welch, and it was a front-page scoop. You need that to start shifting tickets. The moment Bob said he would do it, I knew we had to get the word out. There is a time when you just can't be cautious. You have to ask for a date and risk getting your face slapped, so to speak.

When it was time for the Dylans to come, they had to abandon the QE2 voyage, which he liked the idea of because his son Jesse was hurt as they were boarding the liner. We thought his appearance was going to get cancelled. However, Dylan did not cancel and he ended up flying over a few days later.

So I think my Melody Maker story was worth it. I was P.T. Barnum to Ray's Bailey. He made sure the animals were fed while I put bums on seats.

When Dylan got to the Island, George helped him settle at the farm at Bembridge and soon all the legends of the time were calling in. The Band were rehearsing in the barn and all these top music people were around. We knew we were going to put on a hell of a show. I remember flirting madly with Jane Fonda who was there with her French husband, Roger Vadim. My mood was ecstatic.

And the festival itself? I wish Bob had perhaps done three or four more songs, but, hey, this was Dylan and he had played for us. And what a vision he was on stage that night, dressed in that white suit.

The Band had played a great set and it all went well, we'd got the PA balanced and I was able to introduce Bob. That's when I realised why he had chosen that suit. When he appeared on stage in front of those great spotlights we had lighting the stage, he looked almost god-like with the lights bouncing off that suit. Even quarter of a mile back, he must have looked stunning.

Melody Maker

AUGUST 16, 1969 1s weekly

BIGGEST EVER MM

48 PACKED PAGES

DYLAN LATEST

New songs for Britain: 200,000 fans expected

BOB DYLAN is writing special material for his historic Festival appearance at the Isle of Wight on Sunday, August 31. And it is " more than likely " that his next LP will feature tracks recorded "live " during the event — which is acting like a magnet for artists and fans from all parts of the world.

The response, in fact, has been so phenomenal, that promoters Fiery Creations Ltd. are now staging an additional concert on the Friday evening, August 30.

It will be a free concert starring the Nice, Bonzo Dog Band and Edgebloe, plus another star name now being fixed. The Forth coast of Hale is also flying in specially.

Other groups and folk artists are also offering their services for a free show on the Friday afternoon. "We've had so many offers from artists who want to be present on this big occasion," said a Fiery Creations spokesman on Monday.

GOOD VIEW

When Dylan arrives for "D-Day," he will be bringing in a retinue of some 500 American pressmen and photographers. And he personally is likely to stay on the Isle of Wight for at least five days. "He has fallen in love with the place from a colour movie he saw," added the spokesman.

Site of the concert at Woodside Bay has been extended to 100 acres. "Everyone will be able to get a good view," says promoter Raymond Foulk.

Meanwhile, applications for tickets continue to pour in from all parts of the world. Special ticket agencies have been set up in New York, Melbourne, Sydney, Tokyo and Libya.

Hundreds of American fans are flying in in 15 charter planes, and it is expected that the total number of people converging on the Isle will be around 500,000 — nearly three times the local population!

Special catering arrangements, including health foods, are being made, plus camping arrangements. The organisers emphasise that prices will be kept to a moderate level.

A 2,000 watt PA system is also being flown over specially from the States. Rolling Stone Keith Richard will be living in a yacht moored off the Isle, and other members of the Stones are expected to be present.

Fiery Creations Ltd. emphasise that this will be Dylan's only appearance in England for quite some time.

DYLAN FOOTNOTE:
The Bob Dylan film, "Don't Look Back," made by one of America's foremost documentary film makers, D. A. Pennebaker, will be shown at the Institute Of Contemporary Arts on Saturdays, Sundays and Mondays from this week at Nash House, The Mall, SW1.

VENUTI: for London

VENUTI FOR EXPO '69

VETERAN jazz violinist Joe Venuti has been added to the bill for Jazz Expo '69, which is being presented in London from October 25 to November 1. Venuti, who was born aboard the ship bringing his parents from Italy to the USA in 1904, is acknowledged to have been the first great jazz fiddle player.

He will appear in Expo with George Wein's Newport All Stars at the Hammersmith Odeon on October 27. Joe Venuti was last in Britain in 1934.

Another Expo change will see Kenny Burrell in place of Grant Green in the Guitar Workshop on October 27. Lineup will be Burrell, Tal Farlow and Barney Kessel.

TRADE FAIR— SPECIAL SUPPLEMENT

SAGA OF THE BEE GEES CONTINUED— PAGE 5

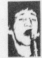

PLUMPTON FESTIVAL— FULL REPORT PAGE 17

HERBIE HANCOCK'S LAST HURDLE-P8

ROBIN GIBB'S BLIND DATE PAGE 10

TALKING DRUMS WITH GINGER BAKER PAGE 22

'I told Keith Moon, their drummer, that he could have been killed but he thought it was the funniest thing ever...'

Dylan's first four or so songs were over in a blur. Perhaps that's why people thought he did not play long enough but he played a good set. Then, afterwards, I had to tell the crowd that was it. It was over.

And the delay? I'd heard there was somebody underneath the stage trying to make a bootleg recording and that had affected the impedance of the PA which in turn affected the mics. When it was sorted, I had to take to the mic to get some of the biggest names in the history of rock to sit down in the VIP area so the crowd seated behind them could see the stage. I yelled: 'Sit down or he is not coming on stage. Please realise the paying public are behind you!'

I don't know if Bob had any other songs up his sleeve that he could have done. I guess he was contracted for an hour and he did that — but the audience does not read contracts. Even so, we went for Bob Dylan, got Bob Dylan and he played the Isle of Wight. It was a great festival, and a festival that

history has not treated kindly in comparison to Woodstock. Woodstock has been revised as some kind of triumph because of the film that followed it. But Woodstock was a disaster. The 1969 Woodstock promoter, Mike Lang, is putting on a 50th anniversary show in 2019 but there is no getting away from it — the 1969 event was disastrous. By comparison, the Isle of Wight 1969 was a classic in many ways. The promoters were in harmony; the acts who played there were in harmony and the fans were in harmony.

Isle of Wight '69 was emblematic of the culture coming together in a lovely field, hearing great music and experiencing events that resulted in everyone have a great, close time. And it had Dylan.

The only near-disaster was when The Who arrived by helicopter and had a scare on landing. I told Keith Moon, their drummer, that he could have been killed but he thought it was the funniest thing ever. He smiled and said: 'What a way to die!'

'He smiled and said: "What a way to die!"' (see page 101)

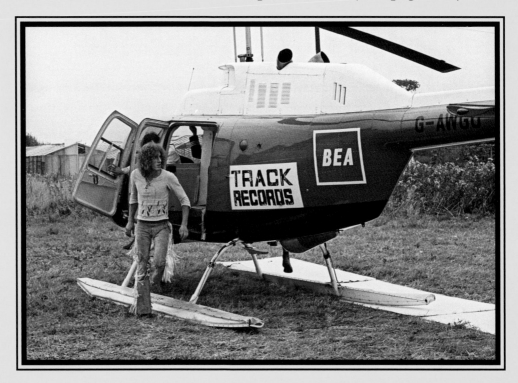

I recall the after-party at
Bembridge. I remember treading
over a lot of superstars. When
it was all over, Fiery Creations
were a happy bunch because they
had some money — enough to create
the foundations for something
bigger for more people over a
longer period of time the follow-
ing year. We had done it and the
sky was the limit.

Bob Dylan's off to Woodside Bay, not Woodstock!

It was one thing deciding to go bigger, better, indeed massive in 1969, with a headliner such as Dylan, but Ray, Ronnie, Bill & co. had to pin down a venue. And it had to be bigger, better and more accessible than Hell's Field in the south Wight's coastal hinterland the year before. Better, much better, if a site could be secured closer to one of the ferry terminals.

Not long after Ray Foulk had opened up a fruitful channel of communication with Bert Block, he was able to flesh out the plans to hold the August festival at Woodside Bay, just to the north of Wootton Creek and a short drive from Ryde's ferry and hovercraft connections to the mainland. It ticked a lot of the right boxes.

It still required a little resource to find, tucked away at the top of Palmers Road, north of Wootton Bridge, just at the junction of Lower Woodside Road and Upper Woodside Road. It was roughly a pentagon in shape and some 150 yards from the shore at Woodside Bay.

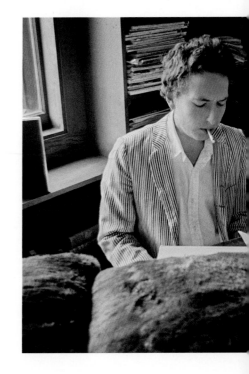

Ray recalled he was able to inform Bert Block they had signed up a wonderful 'amphitheatre' site at Woodside Bay, overlooking the Solent. The arena field – this time in lush green pasture – lent itself to the purpose and came complete with a number of adjacent fields for camping and car parking.

In fact, the site was earmarked for a main arena for the stage, press area and main viewing area; a services field for first aid, additional toilets, catering, shopping and offices, plus two camping fields. An agreement was initially struck in June with farmer Ron Phillips to rent the 41 acres for £250 with a £25 deposit due within a month. A second parcel of land belonging to neighbouring farmer Albert Thackham amounted to no more than a couple of acres, but was secured to house the stage itself and backstage working area.

When Bert Block requested Kodak Super 8 film footage of the arena, Bill Foulk, already a TV and film student, secured the correct model of camera from his college and some stocks of film. The brothers were concerned that Block insisted, in the interests of a speedy despatch, on the film being sent to New York unprocessed... but at least Bill knew what he was doing.

After filming Shalcombe Manor, Dylan's proposed home for the duration, Bill and Ray drove to Woodside Bay, filming the oh-so-English country lanes around Wootton Bridge from the bonnet of a jeep. A good vantage point enabled the brothers to get a decent shot of the field where Dylan would make his first pre-announced public performance since he walked off stage at London's Royal Albert Hall on 27 May 1966.

The Foulks did not know it then, but Dylan's festival appearance on the Island was to be something of a sparkling oasis in a desert of live performances. After he left the Isle of Wight stage, Dylan would not commit to another full concert appearance for another four years.

So, these fields on the north-eastern edge of the Isle of Wight were to witness something historic in popular culture. This was Dylan, the man who was rightly credited with transforming the credibility and profile of contemporary music, writing and popular culture, at the crossroads.

Later, when Bert Block arrived on the Island – more than a week ahead of Dylan – he was driven to the festival site by Ray Foulk. The Fiery Creations team was by now proud of the work to transform the farm fields into an arena and Woodside Bay was bathed in glorious sunshine, the Solent seascape transformed into a turquoise backdrop. Ray felt good as he guided Bert towards the Bill Foulk-designed Partheonesque stage, but the light mood was shattered by a sudden outpouring of angst from the American.

Block's venting was the first time Ray or his team had heard the word 'Woodstock'. Bert Block's anxiety had been triggered by an overnight call from the States describing mayhem at a festival in upstate New York. 'A quarter, or half a million, hippie kids moved in on a little place in upstate New York. It was total mayhem,' he told Ray. '... People just left their autos on the highway and walked, causing gridlock for three days'.

Dylan at his home in Woodstock NY, 1968

Bert painted an apocalyptic picture of hundreds of casualties being air-lifted to hospitals with at least one fatality. The chaos was exacerbated by the festival being almost washed out by storms, leaving a multitude on site with no cover. He was very concerned of a repeat at Woodside Bay damaging the reputation of his main man, Dylan.

It is a measure of the different world we now live in that this American event was not even on the radar of Fiery Creations. In fairness, in a world where there was no internet, no mobile phones, no 24-hour news stations, why should it have been?

Completely in the dark, Ray asked, 'Whose festival was this?'

It was, of course, Woodstock – named after Bob Dylan's home settlement in New York although actually staged at least an hour's drive away at Bethel Woods. On the bill was a plethora of Stateside talent including festival closer Jimi Hendrix; Janis Joplin; Melanie; Arlo Guthrie; Dylan's one-time mentor Joan Baez and his current musical partners, The Band; Santana; Grateful Dead; Creedence Clearwater Revival; Ten Years After plus Crosby, Stills, Nash and Young; but also big British names including The Who and Joe Cocker.

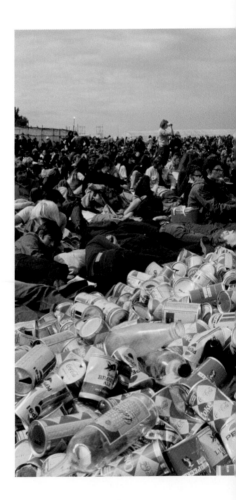

What Ray did not know was that Michael Lang, the main Woodstock organiser, had chosen the name and location of his big bash in a bid to lure Dylan out of semi-retirement to take the plaudits of the Sixties generation in his own backyard.

Dylan, who was always reluctant to accept the mantle of 'leader' of anything from the counter culture movement to the hippie generation, had refused the offer. He also had deep reservations about the invasion of his home area where he and The Band had settled and musically bonded. Instead, he was accepting the offer from Fiery Creations to play in this field on the Isle of Wight. No pressure there, then.

'Remember I told you about some guys pitching for Bob Dylan for a big rock festival and he you chose you instead?' Block reminded Ray Foulk. 'Well, they called it "Woodstock" and had most of the big American and English talent.'

'The main guy was Mike Lang... he hassled every which way to get Bob on the bill, but he wasn't having any of it. In fact, he was privately mad about the whole damn thing.'

Block disclosed that once the word was out Stateside about

'Woodstock', Dylan fans started 'camping out in Dylan's yard', i.e. breaking into his property. Intruders had even been found on Bob's bed. Dylan had teased the possibility of doing the Woodstock event without ever intending to do so – he hated the idea of it. His stance hardened when Lang chose to call it 'Woodstock' after Dylan's home town, even though the Bethel Woods site was some 60 miles away.

The fact that Block's partner, Albert Grossman, had offered Dylan's collaborators (The Band) and stablemate Richie Havens to Lang only made Bob more determined not to show up and to opt for the Isle of Wight. He felt soured enough to quit his Woodstock home and move back to New York City soon after his return from the Island.

Ray Foulk was alarmed at such last-minute jitters in Dylan's camp. He reassured him that such weather storms in late August were highly unlikely on the Isle of Wight and the barrier of the Solent, stretching out in front of him now as they examined the site, would militate against highway gridlock.

Dylan was due to arrive just a few days after Bert's Woodside Bay meltdown but the panic, it seemed, was over.

Bill Foulk made a trip to Pinewood Studios to rent props to decorate the pediment-style stage he had designed and which Turner Smith was about to execute and fabricate. Woodside Bay was coming together rather nicely. Woodstock? Who needs Woodstock?

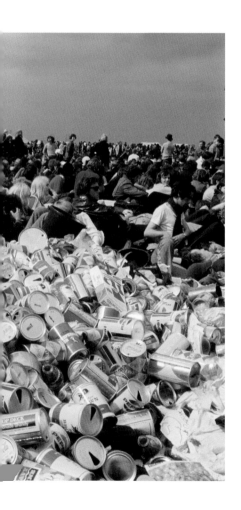

I was there!

Paul Roberts

My mate and I had finished sixth form and were waiting to start Uni at Reading and York respectively. The line-up looked too good to miss — so many of our favourite bands in three days for a few quid. We left our home town in the Midlands on Thursday morning to hitch to Portsmouth. The people I was riding with took us to a pub near the ferry, where a guy in a flying jacket offered us acid. We stuck to pints.

Late ferry to the Isle of Wight and a bus ride to the site — all very well organised. But then a problem. We had been told there would be marquees to sleep in and sure enough there were. But they were full already, the day before the festival started. So there we were, no tent and a weekend of sleeping in the open to look forward to. Luckily in the four nights we were there I think it may have only rained a little on one night. This was late August and things could have been so much worse.

The first afternoon session in the arena with a band called Marsupialami. Never heard of before or since. No idea why I even remember the name, but the whole event was so mind-blowingly good that the opening is still vivid in the memory. Each day's gig began with an instrumental version of 'Amazing Grace' at full volume on the huge WEM PA (I'd never seen or heard anything like it) and I can still hear it now. Then Rikki Farr coming on, obviously well up for it but even to a naïve 18-year-old seeming a bit too 'Woodstock' for an English audience.

Only a few thousand people were there for the first day and we were pretty near the front. By the Friday, there were many more and we were further back but still in a good position. By the Sunday, Dylan was a dot in the distance. Highlights of the music for me — The Nice, The Who (on Saturday afternoon and absolutely brilliant) the Bonzos; Julie Felix trying to be Joan Baez but eventually giving up and responding to crowd's demands for 'Going to the Zoo'. Too many to mention but just looking at the line-up after all

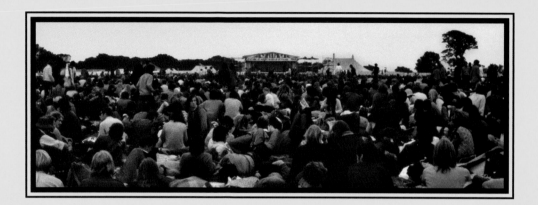

these years brings it all back... Dylan? He was a let-down, but by then it had all been too awesome to be a problem.

Other memories — going swimming in the bay nearby one morning — mainly for a wash. The crowd — so varied, from youngsters like us, hippies by the thousand, a couple of mad older guys from London (looked and sounded like builders) who sat near us getting totally pissed and who wandered off separately into the crowd in the dark. Pretty cold on the Saturday evening session — glad we'd kept a couple of bottles of wine to warm us up. Someone calling out 'Wally' in a very loud voice after every song to attract someone they'd lost

— eventually most of the crowd were joining in.

I also recall wandering through my home town on the Monday afternoon on the way home. There was some sort of minor carnival on which, after the Isle of Wight experience, looked so flat and boring. Life for me had changed and moved on a lot in just three days.

One footnote. On a recent break on the Isle of Wight I found a strange little shop in the middle of West Cowes that has all sorts on rock memorabilia, including a 1969 ticket with the line-up listed. I'd completely forgotten Indo Jazz Fusions. What were they all about? I must have been asleep.

Woodstock... magic or myth?

The visionary planner behind Woodstock, Michael Lang, had something in common with the Foulk brothers. Like them, he had cut his teeth with a smaller-scale 1968 event. He co-promoted the Miami Pop Festival where a crowd of 25,000 attended a two-day event.

Woodstock came about after Lang combined with Artie Kornfeld, Joel Rosenman, and John P. Roberts. Roberts and Rosenman, who financed the project, were New York City entrepreneurs in the process of building Media Sound, a large audio recording studio complex in Manhattan.

Lang and Kornfeld's lawyer Miles Lourie (who had supplied legal work on the Media Sound project) suggested that they contact Roberts and Rosenman about financing a similar, but much smaller, studio that Kornfeld and Lang hoped to build in Woodstock, New York, where Bob Dylan and members of The Band were living, jamming and recording together.

But Roberts and Rosenman counter-proposed a concert featuring the kind of artists known to frequent the Woodstock area, with Dylan at the top of that exclusive community. Kornfeld and Lang agreed to the new plan, and Woodstock Ventures was formed in January 1969. The company offices were located in an oddly-decorated floor of 47 West 57th Street in Manhattan.

The quartet rarely sang from the same song sheet. Roberts was disciplined and knew what was needed for the venture to succeed, while the laid-back Lang was far more relaxed. When Lang was unable to find a site for the concert, Roberts and Rosenman, growing increasingly concerned, took to the road and eventually came up with a venue at Bethel Woods. Roberts and Rosenman more than once considered pulling the plug on the event.

The original site under consideration was at Wallkill, New York State, but local opposition scuppered that before the Bethel site was secured some 25 miles away, on Max Yasgur's 600-acre dairy farm near White Lake.

Once Woodstock Ventures was up and running early in the year, there was no doubt Lang & co. wanted to coax Dylan to perform at the event. So much so that the festival had been given the name of the town where by far the most famous of the coterie of local artists lived.

Dylan was no doubt lured, in part, to this part of New York State by its reputation as a retreat for musicians and artists. Woodstock itself played host to numerous Hudson River School painters during the late 19th century. Later, the Arts and Crafts Movement came to Woodstock in 1902, with the arrival of Ralph Radcliffe Whitehead, Bolton Brown and Hervey White, who formed the Byrdcliffe Colony.

It then became a haven for landscape artists and from then on, Woodstock was considered an active artists colony. From 1915 through to 1931, Hervey White's Maverick Art Colony held the Maverick Festivals, 'In which hundreds of free spirits gathered each summer for music, art, theatre and drunken orgies in the woods.'

A series of Woodstock 'Sound-Outs' were staged at Pan Copeland's Farm just over the town line in Saugerties over three years from 1967 onwards. These featured folk and rock acts like Richie Havens, Paul Butterfield, Dave van Ronk and Van Morrison, all of whom helped mould and bolster Woodstock's reputation as a summer arts colony.

These Sound-Outs inspired the newly-formed Woodstock promoters to plan their concert at the Winston Farm in Saugerties but the town turned down their permit, hence the dash to find a new venue and, eventually, the land at Max Yasgur's Bethel farm.

But Dylan, who was seen as the fulcrum for the festival's geographic plan, was far from impressed either by the general scheme of holding a major gathering in 'Woodstock' or the eventual chosen site at Bethel. Al Aronowitz, New York journalist and a friend of Dylan who was part of his team on the Island, told the New York Press in 1991, 'Sticking the festival in Dylan's backyard was like shoving it in his face. The whole point of the show was to get Dylan to headline it. In essence, the Woodstock Festival was nothing more than a call to Bob to come out and play'.

Woodstock Festival, 1968

Ray Foulk reckoned the Woodstock plan was seen by Dylan as an attack on his privacy and spoiling 'his otherwise reclusive home town for the event and ruining it forever as a place of discreet artistic seclusion.'

His status as a Sixties icon also invited intrusion at his home from the demanding and the curious. This rattled Dylan. Just how rattled became apparent in 2004 in *Chronicles Volume 1*, when he wrote, 'Goons were breaking into our house all hours of the night.'

On one occasion, Dylan discovered a couple who had just finished having sex in his and Sara's bedroom. 'What are you doing?' he asked. 'We're leaving,' they replied. On another occasion, biographer Howard Sounes revealed that Dylan and Sara woke up to find a man in their bedroom, watching them. It led to Dylan buying a gun and he increasingly resented that such interlopers identified with him.

Even so, he mischievously flirted with the Woodstock promoters, responding to rumours that he may attend by declaring to Aronowitz just five days before Woodstock kicked off, 'I may show up if I feel like it. I've been invited so I know it'll be okay to show up.'

Yet both Dylan and Aronowitz knew at that stage that the deal was done with Fiery Creations and his participation at Woodstock was not going to happen. Aronowitz was convinced this was Dylan's desire to turn his face against what was expected. It's a trait that Dylan has displayed many times.

'Not only did he not go to Woodstock,' said Aronowitz, 'but he created his own Woodstock [on the Isle of Wight].'

So why did he choose to be contrary in the face of Woodstock's plea for the local boy to come out and play? 'Y'gotta be different,' was Dylan's summing up to Al.

Meanwhile, with fans shelling out $18 for all three festival days or $6.50 for a day ticket, a large proportion of them figured Dylan would turn up at the last minute. It was not to be. With almost perfect symmetry, as Woodstock's three-day event got underway amid chaotic scenes on Friday 15 August, with Richie Havens taking the stage as an extended opening act to cover for no-shows, Dylan and his party were boarding the QE2 in Manhattan, bound for Southampton and the Isle of Wight.

That he left the liner soon after because of an injury to his three-year-old son, Jesse, may have left some on the other side of the pond

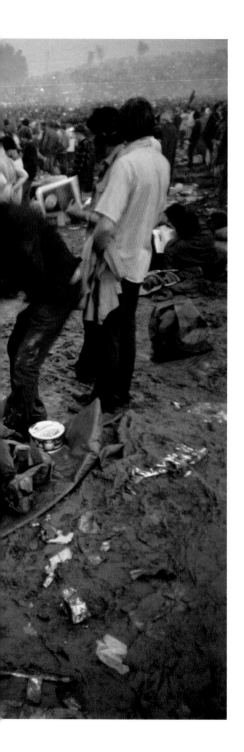

with a severe case of the jitters, but it was merely a blip. Dylan was still on his way to the Island. He would fly the following week instead, leaving Jesse behind.

Back in Bethel, planning had progressed without the main man. In April, Creedence Clearwater Revival, at the height of their fame and creativity, became the first act to sign a contract for the event, agreeing to play for $10,000 (equivalent to $68,000 today). Led by guitarist and songwriter John Fogerty, they had a distinctive, Southern 'swamp rock' sound with songs from the bayou which defied their Californian roots.

The promoters had experienced difficulty landing big-name groups prior to Creedence committing to play. Once they were on board, the acts began to bite. Ironically, given their delayed 3am start time on day two – and their removal from the Woodstock film at frontman John Fogerty's insistence – Creedence band members have expressed bitterness over their festival experience.

By July, the festival roster was largely in place although there were several big names that allegedly slipped the net or passed up the invitations. These included, first and foremost, Dylan himself. There was a clutch of others: Simon & Garfunkel, busy on their seminal album Bridge Over Troubled Water, declined the invitation; The Jeff Beck Group passed with Beck declaring: 'I deliberately broke the group up before Woodstock. I didn't want it to be preserved.'

His vocalist, Rod Stewart, on the brink of a stellar career, is dismissive 'Ah, well,' he wrote in his autobiography a few years back. 'Seen one outdoor festival you've seen them all.'

Led Zeppelin was apparently asked to perform. 'We were asked to do Woodstock and Atlantic were very keen', said their manager Peter Grant, 'and so was our U.S. promoter, Frank Barsalona. I said no because at Woodstock we'd have just been another band on the bill.'

The Byrds were invited but said 'No', rating Woodstock no different from the other Stateside festivals that summer. Bassist John York recalls, 'So all of us said, "No, we want a rest" and missed the best festival of all.'

Chicago had initially been signed on to play at Woodstock, but their tour promoter Bill Graham moved their concerts to the Fillmore West, San Francisco, forcing the band to back out of the festival.

Graham's move allowed Santana, who he managed at the time, to take their slot at Woodstock.

The Moody Blues were included on the original Wallkill poster as performers, but decided to back out after being booked in Paris the same weekend. And they were to follow Dylan's lead and opt for the Island at the end of the month.

Frank Zappa and The Mothers of Invention got the call but didn't fancy the terrain. Frank was quoted, 'A lot of mud at Woodstock… We were invited to play there, we turned it down.'

Brit blues rockers Free, who had been Stateside just a few weeks earlier supporting Blind Faith, were asked to perform and declined. They too chose to play at the Isle of Wight Festival, a week or so later.

The Doors cancelled at the last moment. Guitarist Robby Krieger claimed they turned it down because they reckoned it had the makings of a 'Second class repeat of Monterey Pop Festival' and apparently later regretted that decision. Their big festival day would come – a year later at the Isle of Wight 1970 mega-festival.

Jethro Tull (another to play the Island in 1970) considered Woodstock but declined because frontman Ian Anderson did not like the idea of a lot of mud, drugs and naked hippies.

The Beatles? John Lennon's immigration status was an issue, apparently, plus the band was effectively in breakdown mode. Three quarters of them made it as supporting spectators at the Isle of Wight Festival at the end of the month. The Rolling Stones? Mick Jagger was away in Australia shooting the *Ned Kelly* movie, and Keith Richards' girlfriend, Anita Pallengburg, had given birth to their son Marlon that very week.

Procul Harum, another major British band, decided they were too exhausted after a long tour – plus the festival clashed with the due date of guitarist Robin Trower's baby.

This is an impressive chronicle of what-might-have-beens, missed opportunities or, frankly, rank indifference about what was about to happen at Bethel Woods. Even so, the promoters did manage to assemble a fine bill, albeit missing the very artist it was designed to attract.

So this was the roster that Havens kicked off.

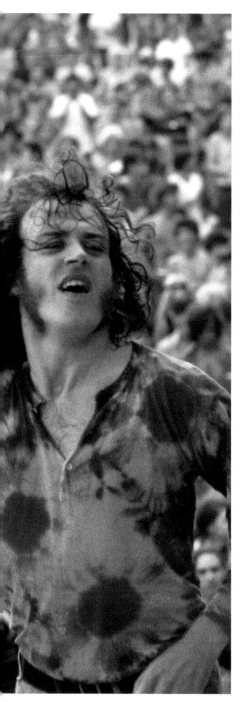

Joe Cocker

Day One: Friday 15 August 1969

Richie Havens; Sweetwater; Bert Sommer; Tim Hardin; Ravi Shankar; Melanie; Arlo Guthrie; Joan Baez.

Day Two: Saturday 16 August 1969

Quill; Country Joe McDonald; Santana; John B. Sebastian; Keef Hartley Band; Incredible String Band; Canned Heat; Grateful Dead; Leslie West & Mountain; Creedence Clearwater Revival; Janis Joplin with the Kozmic Blues Band; Sly and The Family Stone; The Who; Jefferson Airplane.

Day Three: Sunday 17 August 1969

Joe Cocker and The Grease Band; Country Joe and The Fish; Ten Years After; The Band; Johnny Winter; Blood Sweat and Tears; Crosby, Stills, Nash and Young; Paul Butterfield Blues Band; Sha Na Na; Jimi Hendrix's Gypsy Sun and Rainbows.

The chances of the event itself being a commercial success were torpedoed, despite the massive turnout, by poor organisation. The promoters completely failed to restrict access to the site while the arena's preparations were finalised. That meant around 50,000 fans had already arrived before the fences were completed. Realising it would be impossible to clear the arena then check tickets at the gate, the decision was taken to declare that it would be, henceforth, a free festival. This guaranteed that the promoters would lose money on the event.

Ravi Shankar played through the rain on day one during a festival first delayed, then punctuated by storms and logistical problems. After Joe Cocker's set on the final day, the on-stage action was suspended by the weather for more than three hours. The delays all meant that the latter acts were pushed back beyond midnight with the festival finale by Hendrix pushed back until 9am on the unscheduled fourth day.

By then, the festival hordes, put at 400,000 at one point, had diminished to just 50,000 or so hardy souls. There looked to be more rubbish on site than audience as Hendrix let rip.

In truth, the Hendrix postscript to Woodstock became iconic only in retrospect when it was captured on celluloid, notably his twisting, bending, tune-stretching bastardisation of the 'Star Spangled Banner' which came to be interpreted as a scolding missive from the younger generation to the Nixon administration's conduct in the Vietnam War.

The highlights? Havens, who would be on the Island days later, filled in as the event's opener with a long set while LA band Sweetwater were stuck in traffic. For his seventh and final encore, Havens improvised 'Freedom', which then became his signature tune and one of the festival's lasting key themes.

Joan Baez, six months pregnant and a vision in a flowing turquoise top, was on stellar form with a quasi-religious set featuring mainly anthem-like covers such as 'Oh! Happy Day', Dylan's 'I Shall Be Released', 'Joe Hill' and 'We Shall Overcome'.

There were numerous stellar performances to follow including Janis Joplin, arguably at her peak, producing a ballsy set that included George Gershwin's 'Summertime' as he never imagined it and the wonderful 'Piece of My Heart'.

The Who arrived in a foul mood having flown by helicopter into Woodstock – rather than the actual site at Bethel – and so had to trek through the heavy traffic by car to reach the festival site.

Pete Townshend recalled, 'Well, I immediately got into an incredible state and I rejected everyone. I wouldn't talk to anyone. And I was telling really nice people like Richie Havens to fuck off and things like that… It took about six hours to get there. Well, we got there and then we waited another ten hours in the mud; the first cup of coffee I drank had acid in it. I could taste it.'

That was bad enough only for the promoters to tell the band that, since Woodstock was now a 'free festival', they did not have the cash on hand to pay them, but could write them a cheque. Not impressed, The Who and the promoters had a 14-hour standoff with the band refusing to take the stage.

The impasse broke when a bank official was flown in with money, the standoff ended and The Who took to the stage after 4am.

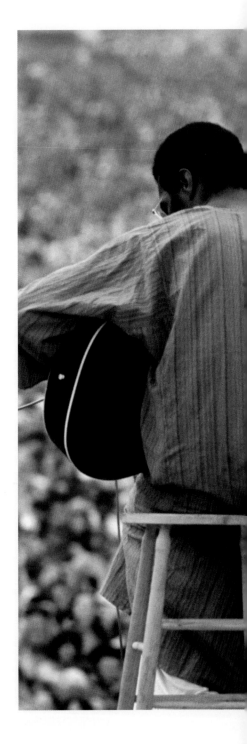

Richie Havens

Townshend let out some of his fury by kicking out at documentary maker Michael Wadleigh, on stage filming the acts as part of his festival film.

The Who zipped through 'Heaven and Hell' and 'I Can't Explain' before launching into *Tommy*, their new rock opera album. All the fury and tension was released through their instruments as The Who blazed through the new album in a spectacular performance – captured by Wadleigh's cameras.

As they finished 'Pinball Wizard', radical firebrand Abbie Hoffman ran out and grabbed Townshend's microphone to announce, 'I think this is all a pile of shit while John Sinclair rots in prison,' referring to the manager of the Detroit rock band MC5, who got ten years jail for possession of two marijuana joints.

Townshend was in no mood for interruptions, 'Fuck off my fucking stage!' he yelled, and poked Hoffman in the back of the head with his guitar neck, causing Hoffman to retreat and give up the microphone.

Pete admitted the following year, 'Quite honestly, I mean knock for knock, everything Abbie Hoffman said was very fair. Because I did hit him, he must have felt it for a couple of months after.'

It all meant The Who had something of an edge and used the platform to present a rocking 24-song set, showcasing the best of *Tommy*. Townshend, dressed in an early version of his boilersuit uniform, was in prime shit-kicking, windmilling form with Roger Daltrey a striking frontman – more tassels than a Soho stripper – and Keith Moon and John Entwistle, respectively demonic and restrained, providing a fine rhythm foundation.

Other highlights included Crosby, Stills and Nash, taking the stage for only their second gig. They were joined by Neil Young five songs in and, according to Stephen Stills, were 'Scared shitless', but regarded the festival as their defining gig.

Johnny Winter's rapid blues playing impressed; Joe Cocker, a commanding figure sporting an orange, brown and blue tie-dyed shirt, was magnificent – notably on 'With a Little Help From My Friends'… all outstretched arms, dancing fingers and doing a pretty good impression of a drunken sailor playing air guitar.

Woodstock stood out from other festivals because of its sheer scale and impressive roster of talent, even without Dylan. Apart from Crosby, Stills, Nash & Young, acts such as Sly and the Family Stone, Santana and Richie Havens regarded their performances at Woodstock as career-making.

In a contrast-and-compare scenario, there is no question that the 1969 Isle of Wight Festival would turn out to be better organised and better blessed by the weather. If 1969 was the definitive coming together of Beautiful People and the Peace and Love generation, then that was better demonstrated at Woodside Bay, not Woodstock. There was no trouble on the Island: no-one was killed, no-one hospitalised.

At Woodstock, though undoubtedly largely peaceful, there was one confirmed death, possibly three, one from insulin usage, and another caused in an accident when a tractor ran over a sleeping fan in a nearby hayfield.

The quality of the Woodstock bills is undeniable, the size of the crowd huge, but having Dylan emerge from three years of seclusion, arguably gives the 1969 Isle of Wight a cachet and exclusivity that even Woodstock, whose organisers yearned for his inclusion, cannot match.

Where the Island event is not better blessed, however, is how the events are viewed in retrospect and that, almost certainly, comes down to one simple difference. Woodstock was filmed and it produced an iconic movie. The Island 1969 festival was not, and it didn't.

'Perhaps my biggest regret is that the Dylan set was not filmed,' Ray Foulk told me in early 2019. 'We couldn't do that as we had given an undertaking in signing the contracts with him. There is a bootleg film in existence, out there somewhere, but it would have been terrific to have had an official release. Just look what a film did for Woodstock.'

More recently the emphasis and myth favouring Woodstock was further perpetuated by the Victoria and Albert Museum with their crowd-pleasing exhibition that opened in September 2016. 'You Say you want a Revolution: Records and Rebels 1966-1970' was a six-month V&A 'blockbuster' exhibition put on in partnership with Levis. It gave over a whole room dominated by Woodstock while largely overlooking the significance and the legacy of the Isle of Wight Festival of the same summer.

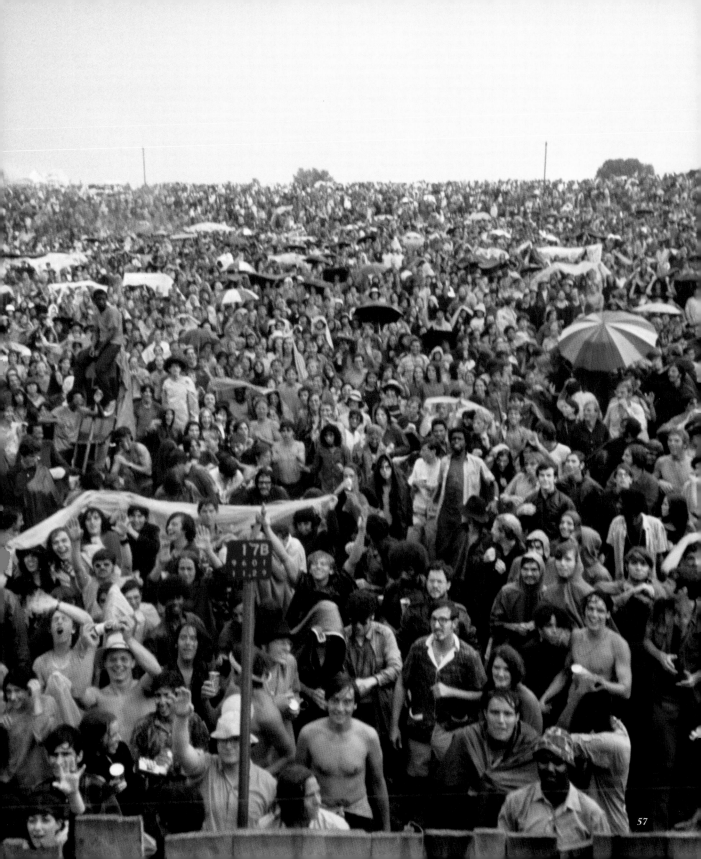

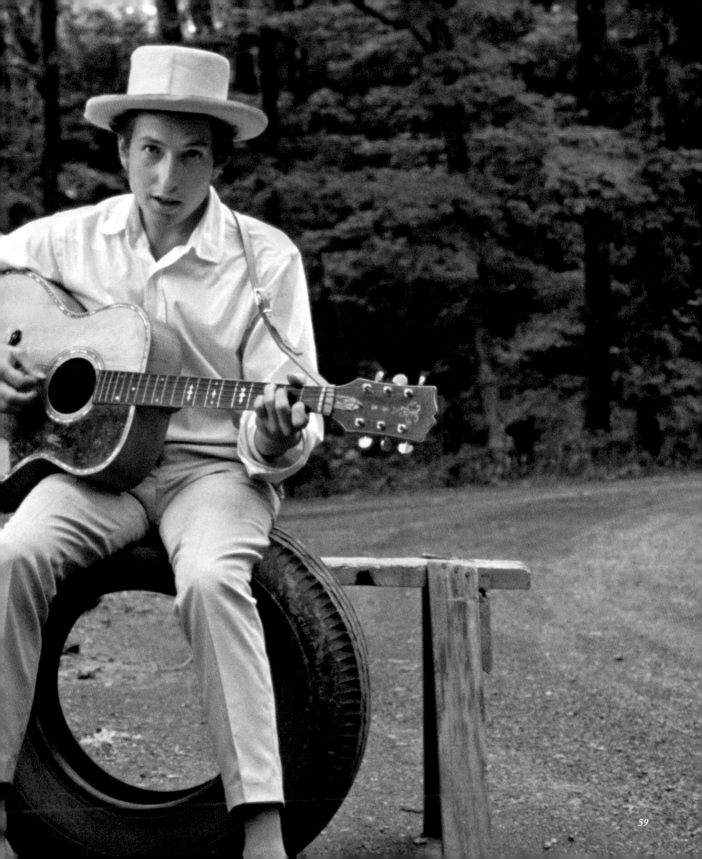

I was there!

Von

I was there at the Isle of Wight to see Bob Dylan. It's the best concert I've ever been to.

We found out where Bob was staying and out of all those people there was just four of us who knew where he was.

Every night we would listen to Bob rehearse the show in a converted barn on the property where he was staying. We had our very own concert, it was amazing. He came out and caught us one night and had a chat and gave us autographs. I still have mine to this day.

Mike

I was walking along a lane and met this guy with a big hat. He said, 'Do you want a job?'

So, I was on stage crew and under the stage when The Band practiced...

★ *Saw Tom Paxton stuffing money into his jerkin.*

★ *Told to keep people away from climbing over the picket fence.*

★ *Tried to stop a big bloke from coming in — Al (Dylan's manager) Grossman! — as there was no room. And then saw who was behind him. God! How embarrassing.*

★ *Stepped on Pattie Boyd by mistake and got a dirty look. Ringo Starr was sitting in front of me.*

★ *Used the money to make a record, went travelling and ended up as a radio producer.*

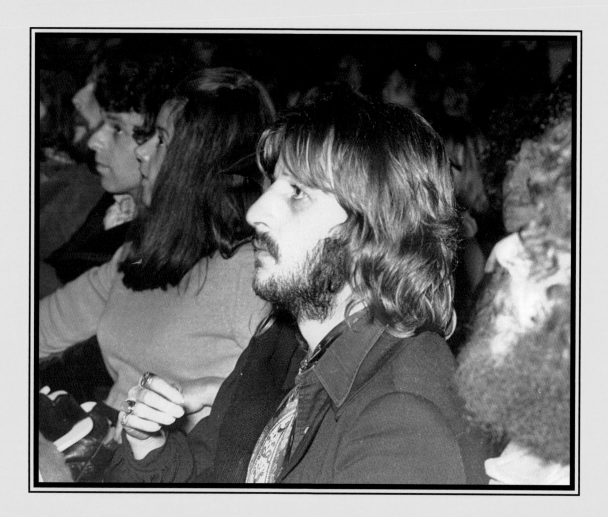

Selling the Island for Bob to sink it

The *Melody Maker* scoop about Dylan, served up mischievously by Rikki Farr, had made Ray Foulk almost choke on his slice of Big Apple. It effectively fired the starting pistol for ticket sales back in Blighty. Fiery Creations had worked wonders against the clock to secure the guarantees to seal the contracts in New York, and now they needed to shift tickets by the shedload to ensure the event's success.

The team knew once the acceptance telegram arrived on Thursday 17 July that Dylan was effectively in the bag. But once the ink was dry on the contracts in New York the following week, a new sense of drama and urgency ensued.

When Ray and Rikki got back from the States on Friday 25 July, they discovered letters and phone calls already flooding in, thanks to *Melody Maker* printing the promoters' Island address and phone number on the front page. The national newspapers and other areas of the media were quick to follow the music weekly's lead and Peter Harrigan (the brothers' friend and then a Birmingham University student) went into overdrive as the Festival's press and publicity manager to further publicise the event.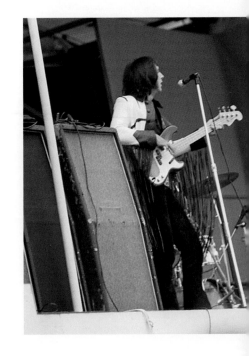

Tickets had to be organised: designed, printed and distributed to myriad agencies to generate hard cash. There were just 38 days before Dylan was due to take the stage at Woodside Bay... a tad over five weeks to sell the festival to the Island, to Britain... to the world.

Or, as the hype put it at the time, to 'Help Bob Dylan Sink the Isle of Wight!'. 'What on earth had we got ourselves into?' Ray Foulk later pondered. 'If Godshill had been like a poorly organised village fête (in 1968), we now stepped up to an international concert arena in all senses of the word.'

A print run was set for 200,000 full-colour double-sided security tickets featuring the Foulks' trusty artist Dave Roe's design, of a King

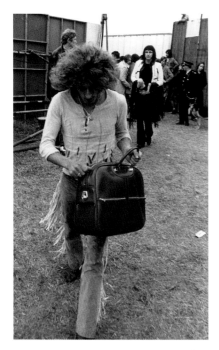

Roger Daltrey

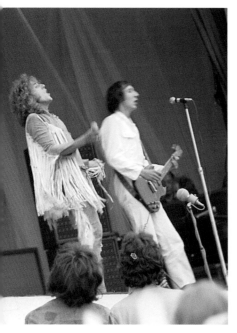

The Who

Kong gorilla figure with fairy wings atop a jukebox. And those prices, so ridiculously tempting to 21st century eyes: £1-5s (£1.25) for Saturday only; £2 for Sunday (Dylan day) or £2-10s (£2.50) for a weekend pass with the bonus of a 'free' Friday roster of acts.

Dylan himself, of course, was the huge draw Fiery Creations had sought to underpin tickets sales for such a massive event. He would be the greatest driver of interest. To ram the message home, and in that far-off era before the internet, social media or even multi-channel TV, Ronnie Foulk set about designing an image to advertise the festival's main asset.

Graphic design was far from his main forte, but Ronnie produced an iconic, punchy design, utilising a classic silhouette of Dylan in shades, contained in a bold black box with the festival details appended below. And that slogan, 'Help Bob Dylan Sink the Isle of Wight' was coined. A huge number of stickers bore this legend.

In the summer of 1969, there were other reasons – quite apart from Dylan's massive reputation and his already extensive body of work – why this superstar would prove a huge draw and have tickets flying off the agencies' shelves by the bucket load. First and foremost, as the Sixties drew to a close, this was an opportunity to pay homage and witness the latest incarnation of an artiste who simply refused to stand still, yet who had rationed – indeed, basically halted – his public performances since his motorcycle accident more than three years earlier.

Dylan, interviewed later, gave this explanation about the accident: 'I was blinded by the sun for a second,' he said. 'I just happened to look up right smack into the sun with both eyes and, sure enough, I went blind for a second and I kind of panicked. I stomped down on the brake and the rear wheel locked up on me and I went flyin'.'

Dylan was reported to have suffered a cracked vertebra, spending weeks in recuperation, then months in seclusion.

His last pre-announced public performance anywhere in the world before that had been in May 1966, at London's Royal Albert Hall on his controversial British tour. Controversial, of course, because of the appearance of Dylan on that long, international trek backed by The Hawks, a band that had honed its skills with rock'n'roll musician Ronnie Hawkins. The Hawks comprised four Canadian musicians: Rick Danko, Garth Hudson, Richard Manuel and Robbie Robertson, plus one American, drummer Levon Helm.

Dylan's audiences had bought tickets to see a folk music icon and reacted with hostility to the sound of their hero backed by a rock band.

Yet now he was back, with news breaking that Dylan had snubbed the offer to appear at Woodstock in favour of a return to the UK for his first appearance anywhere in what seemed an age.

Since the last notes of his Albert Hall show drifted into the dome of that famous old venue, Dylan had released three studio albums: *Blonde on Blonde*, a double LP, in June 1966, just a few weeks after his tour closed; December 1967's *John Wesley Harding* and then *Nashville Skyline*, released in the spring of 1969 itself.

In addition, during 1967 as Dylan recuperated after his accident, he got together with his 1965-66 Hawks backing group, now dubbed simply The Band, to make a series of recordings in their Woodstock base that first saw the light as bootleg releases and covers, before the man himself officially released them as The Basement Tapes in 1975.

Throw in Dylan's first official compilation album, March 1967's Bob Dylan's Greatest Hits, and the maestro had released a lot of work, showcasing different writing and performance styles without the promotion of live performances. In short, Dylan's legions of fans were hungry, very hungry, to see their man and hear his latest songs and style come August 1969.

Dylan's draw cannot be underestimated. Yet this was no one-man show. The Foulk brothers' drip-feed trick of bringing acts to the Island at the Middle Earth Club in Lake was bearing fruit, as they assembled a two-day festival roster of top drawer acts. And there was enough to spill over to that unofficial third day – Friday 29 August – fashioned as a bonus free admission day for those ticket-holders with weekend passes.

Ray Foulk, who admits his contemporary music knowledge was restricted before their festival adventures began, saw the Lake offerings as a chance to get up to speed. 'I did have something of a musical education because of our 1969 club nights in Lake,' he told me. 'We had booked all these acts, such as The Nice with Keith Emerson and Julie Felix.'

Top of the list below Dylan and The Band was The Who, at the height of their creativity as they progressed from a Mod ensemble to fully-fledged rockers. They had broken through from being merely

British stars to scoop international acclaim at the 1967 Monterrey Pop Festival and in 1969 had just released *Tommy*, their fourth studio album that was to catapult them up to a different strata in rock history.

The first single released in March was a classic: 'Pinball Wizard' sold well all through spring and beyond with more than 250,000 sales clocking a silver disc. Fiery Creations had them booked into Middle Earth that summer. In retrospect, The Who were already worthy of a far grander venue than the club at Lake's Manor House Ballroom.

But they were joined on the booking list at the cabaret-style venue by 1968 Island festival veterans The Pretty Things, rising blues-rockers Free, Marsha Hunt and White Trash plus Keith Emerson's pre-ELP outfit The Nice. All, like The Who, were to grace Dylan's festival stage at the end of August.

But there was drama afoot before the already famous quartet of Pete Townshend, Roger Daltrey, John Entwistle and Keith Moon could be confirmed.

Ronnie Foulk was captivated by 'Pinball Wizard' earlier in the year and set about trying to pin down The Who for a Saturday night date at Middle Earth. He pencilled them in for Saturday 30 August, knowing that was also the projected Saturday of the festival and they could be switched to Woodside Bay, something that was activated when the band insisted on a 20ft stage. That was not possible for a club night gig, so it was agreed they would switch to the festival stage. The £450 fee agreed for Lake remained in place.

As the weeks rolled by, with the critical and commercial success of *Tommy*, it looked like a shrewd piece of business by the promoters. That The Who also rolled up at Woodside just a fortnight after rocking the Woodstock Festival was yet another bonus.

The Moody Blues were initially regarded as Saturday's top of the bill, but by late summer there was no doubt about Saturday's biggest draw. Not even The Who's late afternoon set time would alter that, and yet it almost never happened.

With the festival only days away, Ray Foulk was with the Dylan party at Forelands Farm when he got an urgent message to get to the promoters' Totland office on the other side of the Island – and fast. He tried calling but with all the office lines constantly engaged, Ray hit the road. When he arrived, the news was not at all good.

Marsha Hunt

Ronnie imparted it: The Who were pulling out unless their fee was hiked to £5,000. The band's manager, Kit Lambert, was livid after seeing TV coverage speculating on Dylan's £35,000 fee. Lambert backed his claim by suggesting his boys had just helped attract at least 250,000 fans to Woodstock.

The brothers unpicked the issue and, while Ray initially suggested calling their bluff, Ronnie was keenly aware that The Who were Saturday's biggest draw. It was agreed a modest increase should be negotiated – but not so much as to upset the Moody Blues, the other big British beasts on the Saturday.

The brothers deputed Rikki Farr to negotiate with Lambert, but it wasn't until 2am next day – the day before the festival opened – that the answer came. It was not good. Lambert was pulling The Who from the festival.

Apart from losing The Who, the dramatic withdrawal also meant the scuppering of a *Daily Mirror* joint venture with The Who to provide free coach travel from Portsmouth as a way for penniless festival-goers to get back home. This was a serious problem, the loss of a major band and a PR own-goal with the fans.

None of the promoters had an easy solution but, with time slipping by, The Who's tour manager Pete Rudge called on behalf of Pete Townshend and the rest of the band. Ronnie had dealt with Rudge on the original £450 deal. Rudge apologised but stressed that Lambert was only looking after the band's interests. He insisted there had to be an increase but not necessarily as high as £5,000.

To everyone's relief, after further discussion, an agreement was reached for The Who to appear and receive double the original fee: £900 plus £200 expenses. This was not less than any other Saturday act and not more than the Moody Blues.

It all came too late to rescue the free coach travel... but the festival's bill was intact. Ray Foulk told me, 'The Who were originally booked there (the Manor Ballroom, Lake) before we switched them to the festival. We'd had that dispute with them over the £450 fee and that was eventually doubled... but they had got $10,000 two weeks earlier at Woodstock.'

The rest of the bill also served to woo the British Sixties generation for their last big blast of the decade.

On Friday, the bonus day ahead of the main event, the main attractions were Eclection, Bonzo Dog Band and The Nice.

Saturday's roster was to include Thunderclap Newman, a band mentored by Pete Townshend who had scored a big summer hit with 'Something in the Air'; Aynsley Dunbar's Retaliation; The Pretty Things; Blonde on Blonde; Marsha Hunt and White Trash; Gypsy; Family, featuring the raucous vocal talents of Roger Chapman; Joe Cocker and The Grease Band – another hit at Woodstock; the rising talent of Free, and the melodic Moodies.

Sunday boasted an array of more laid-back talent, including Julie Felix, Garry Farr, Indo Jazz Fusions, Liverpool Scene, Third Ear Band, Tom Paxton, Richie Havens, The Band and, of course, Dylan himself.

If it wasn't enough to sink the Isle of Wight, it was enough to attract numbers to the festival that outstripped the entire population of the Island itself and to make one hell of an impression on the contemporary music scene.

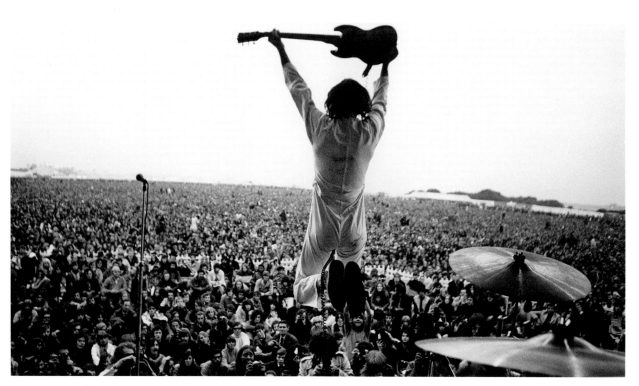

Pete Townshend of The Who

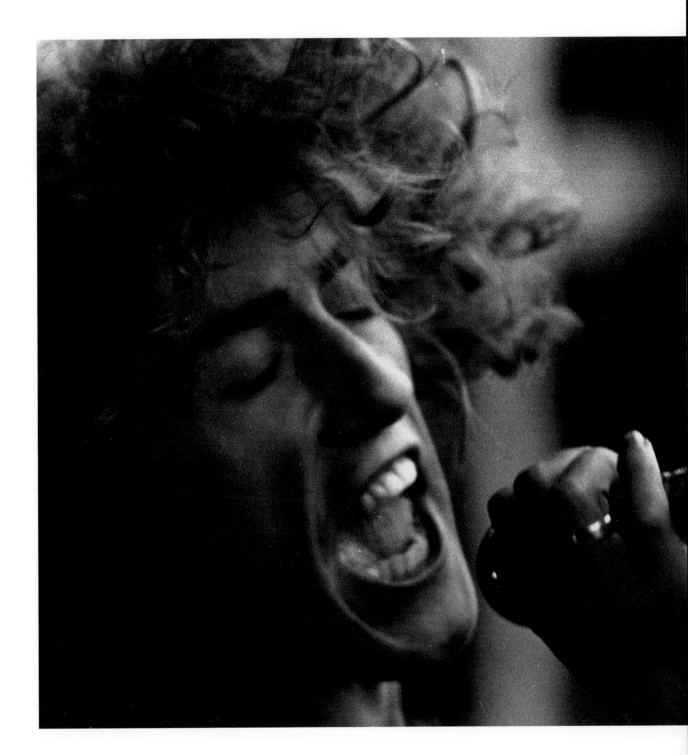

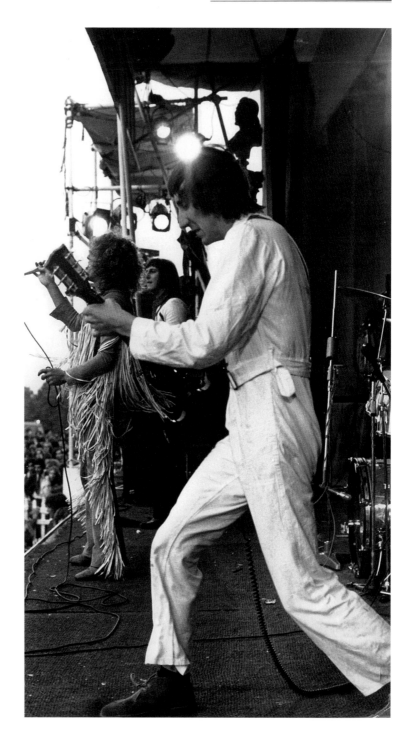

Roger Daltrey and Pete Townshend of The Who

I was there!

Terry Phelps

This was my first festival but perhaps the best and most memorable. I had just turned 18 and some of my favourite groups were to be performing — The Nice, The Who, The Bonzos, Julie Felix, Tom Paxton, Moody Blues, Family — I had albums by all of them. And of course, the greatest songwriter of the 20th century was headlining — this was unmissable.

The tickets were ridiculously cheap by today's standards — £2-10s for the full pass (though my wages were only £8 a week as a trainee draftsman). But cost was unimportant; I would have sold my soul to be there. People had started gathering at the site more than a week before the concert began and the newspaper articles and TV reports on the aptly named 'Desolation Row' only served to excite me further — I knew this was where I belonged.

The week leading up to the concert I was holidaying with my family and cousins in Cornwall, so I only had to catch the coast train to Portsmouth and from there it was a quick ferry ride to Ryde, with its more than mile-long pier. It was almost a homecoming for me as I had spent three years growing up on the Isle of Wight at a boarding school in Ventnor, run by nuns for children with severe asthma (country air and all).

I arrived at the site on the Thursday in the clothes I wore, no tent or blanket and the remains of my holiday money in my pocket - so I spent a bit of it buying a large plastic sheet and a Mexican blanket, found a couple of sticks and draped the plastic over it to form a makeshift tent. Luckily it never rained and, wrapped up in my blanket, I was actually quite warm and comfortable for the duration. On Saturday morning I took a bus into Ryde and had lunch at a Chinese restaurant.

I didn't stop long as I didn't want to miss a minute of the stage activity, but I do remember seeing Nashville Skyline on sale for the first time and wondering if Dylan would be performing any tracks off it.

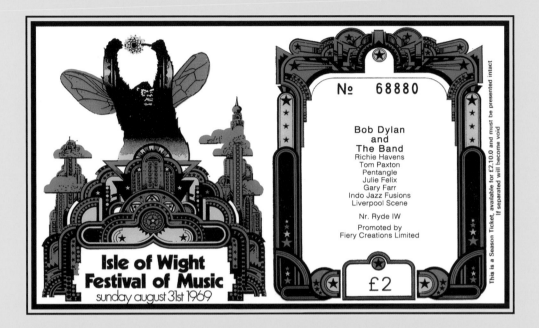

№ 68880

**Bob Dylan
and
The Band**
Richie Havens
Tom Paxton
Pentangle
Julie Felix
Gary Farr
Indo Jazz Fusions
Liverpool Scene

Nr. Ryde IW

Promoted by
Fiery Creations Limited

This is a Season Ticket, available for £2.10.0 and must be presented intact
If separated will become void

£2

Isle of Wight
Festival of Music
sunday august 31st 1969

Apart from Dylan and the Band, there were some very memorable performances and this is where I heard and became an instant fan of Third Ear Band. Other acts I have great memories of were the Bonzos with their inimitable stage performance, The Moody Blues, and The Nice (who I was a great fan of). I was also a great fan of The Who at the time and their set just blew me away. Apart from a few songs at the start and end, the main body of the concert was given over to an almost complete performance of Tommy. Fantastic!

I was pretty close to the stage for the final evening. I was really looking forward to seeing Richie Havens as I wasn't very familiar with his music, but someone had told me that his appearance was one of the conditions laid down by Dylan before he'd agree to come. Whether there was any truth in this I have no idea, but it was a great performance either way.

I had just struck up a bit of a friendship with an American couple, who had come across on a charter flight just to see Dylan, and this is where I had my first taste of cannabis (which I took to like a duck to water).

The Band followed Richie Havens and then suddenly it was time for the culmination of three great days of music, fun and festivity. An hour or so later and it was all over, and I was left with this overpowering feeling of what now? Suddenly my home-made tent didn't seem so appealing and I just wanted to get home to a warm bath and bed.

So, I abandoned my plastic sheet, wrapped my blanket round my shoulders (I still have it) and joined the great mass of humanity wending its way to Ryde Pier. I caught the train to the end of the pier and I could see the pier was just jammed. Some people from the train tried to jump the barriers to the head of the queue and were unceremoniously turfed back out.

I had just decided to walk back into Ryde and find somewhere to doss when I was asked to help a girl back out over the barrier as she was about to faint. To my eternal shame, while helping her I managed to get one leg over the barrier. I stood straddling the barrier until ten minutes later someone else needed helping out and in the process my other leg made it over.

I didn't get on the next ferry, but I just made the one after. From there a quick train ride to London where I slept on the platform along with about a thousand others until the police woke us and the first train to Derby saw me safely home.

I emigrated to Australia the following year so missed the Hendrix concert. I must have been to around 30 open air concerts since then, but Isle of Wight '69 was my first, and to my mind, still the best one ever.

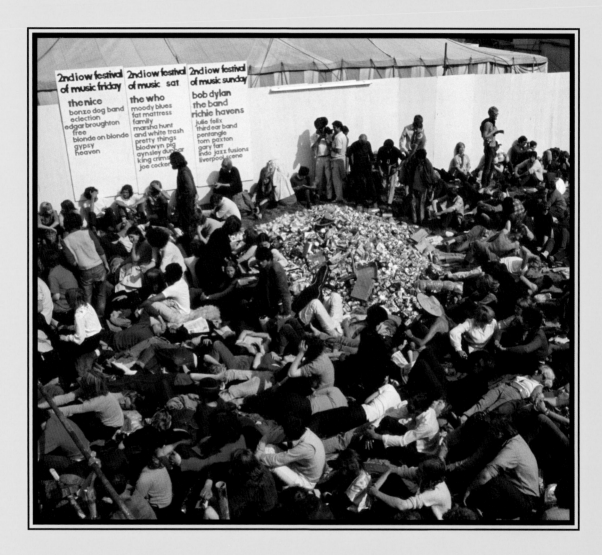

Star man overboard
Dylan jumps ship and flies in

Only Bob Dylan knows how much the Foulks' Island prospectus – complete with text, photography, 8mm film and the bait of a manor house and return cruise from New York on the world's most luxurious liner – contributed to his decision to place his tick in the Isle of Wight box instead of Woodstock.

But the fact his manager, Bert Block, had asked for the additional film footage suggests Dylan was certainly weighing up all the aspects of the deal on offer. So when, on Friday 15 August, the Foulks were told Dylan was not on the Southampton-bound QE2, another bout of the jitters ensued.

This was the very day Fiery Creations completed their payments under the Grossman contracts. The deal was well and truly done but Dylan was not in his cabin, not on the ship for its maiden voyage. He and his family had certainly got on board, just in time for his three-year-old son, Jesse, to get a crack on the head from a swinging cabin door. The ship's doctor was not happy to take responsibility for the child so Dylan and wife Sara disembarked for a hospital check for Jesse, and the liner sailed from Pier 92 down the Hudson River without them.

It was Bert Block's turn to do be reassuring now: there was no problem; Bob was still on his way after the 'precaution' of the hospital visit. They would now fly over the following week, without their children, and would still arrive around the same time the ship would be docking.

The media picked up the story. It was meat and drink to those who doubted Dylan would ever show up on that little lozenge-shape island 75 miles and a ferry ride away from London.

Ray Foulk recalled: 'As well as the national press, papers from Dublin to Dunstable and Aberdeen to Andover suggested that Dylan had cancelled.' It all laid bare how exposed the event was – everything hinged on Dylan honouring the deal.

FIERY CREATIONS LIMITED TAVISTOCK HOUSE WARD ROAD TOTLAND BAY ISLE OF WIGHT

Telephones: Freshwater 2460, 2730 and 2445

That same Friday 15 August was also the day Dylan's stablemate Richie Havens strode on stage with his guitar to open the Woodstock Festival, an event the Foulks knew nothing about until it was all over. The Band were also on the Bethel Woods bill and both Havens and The Band were part and parcel of Dylan's Island contract.

So much was at stake. So, it was with a considerable sense of relief that on Monday 25 August, Dylan and wife Sara flew into Heathrow at 10pm along with his personal roadie and aide de camp Al Aronowitz. Ray Foulk and Bert Block were there to meet them and the star emerged wearing trademark sunglasses and a white leather jacket. There were members of The Band's party on board, too. Two limousines took them 70 miles south to Portsmouth.

The party waited in the dark on Southsea promenade. It was already past midnight – when finally, after 20 minutes, a specially chartered Hovertravel SRN6 hovercraft rumbled on to the shingle beach. Dylan and the other Americans were nonplussed as they had never seen anything like this roaring, Isle of Wight invention. The magic carpet ride took them to the Island where The Band party decamped to The Halland Hotel in Seaview and the Dylans headed to the fine house they had been promised.

Except that it was not Shalcombe Manor, as initially discussed, the home featured in the Foulks' persuasive prospectus.

Indeed, the Foulks knew Shalcombe was a non-starter even before the package of promises was mailed to New York. That's because its owner, Steve Ross – chartered surveyor, Liberal county councillor and later Island MP – having initially said his home was available for rent, later withdrew it because another deal had been struck. Suddenly, it was not available, Ray Foulk remembers being told, 'Not even for the Queen of Sheba'.

For a while the brothers contented themselves that something would turn up but, with time pressing, an estate agent contact introduced the owner of Forelands Farmhouse in Bembridge, just south of Ryde – very handy for the festival site. It was a substantial period home, recently renovated for contemporary late-60s living. It was not quite on a par with Shalcombe Manor, but did boast advantages of its own, including a swimming pool, tennis court, walled gardens and a fine stone barn, just refurbished and ideal for rehearsals.

A housekeeper and gardener came with the house and it was swiftly snapped up by Fiery Creations. A children's governess was part of the contract, too, and even though the Dylans had left young Jesse behind, it was decided the chosen employee, Judy Lewis, would be kept on as an ambassador-cum-hostess.

Chris Colley, friend of the Foulks, was taken on as Dylan's chauffeur and he cut a tall, striking figure. A black Humber Super Snipe – think Mercedes S-Class today – was hired for the Dylans' exclusive use.

Security guards were stationed on the gates and Ray Foulk left Bert Block in charge, backed up by the household staff.

And so it was to Forelands Farmhouse that the Dylans were now despatched... the new home for their Island adventure.

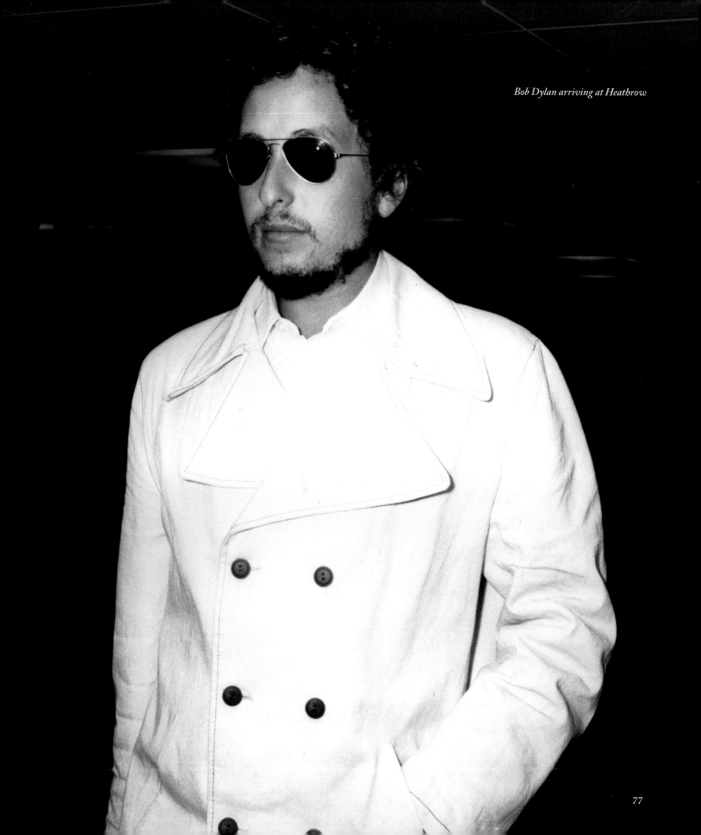

Bob Dylan arriving at Heathrow

I was there!

Chris Colley

I knew all about the 1968 festival even though it had apparently lost money, and I knew Ronnie Foulk and used to go to his Mum's house, Tavistock, in Totland, to listen to music. One day he put me on notice: 'Hey Chris, we have another festival coming up. I've a job for you'.

I was 21 and just finishing my apprenticeship at Plessey at Northwood as an electrical engineer and the thought of a little extra money was nice. I asked what the job was and Ronnie said, 'I've a driving job for you,' but he did not give any details. I immediately imagined that I'd be driving a van or truck around the site, maybe with scaffolding poles or fence panels.

Then I got a message from him that he wanted me to collect some guys from a band. Would I go to Wight Motors, then based in Ryde, and pick up a hire car for this job? It was a big limo, a Humber Super Snipe, and I was asked to take it over to meet a chartered hovercraft at Ryde.

For me, that was quite a car. I think, at the time, I was driving an Austin A40 Somerset and the Humber was a big step up. I duly got to Ryde and the hovercraft disgorged its cargo. I remember Ronnie and Ray were there and the members of a band, who I later understood were The Band, got in the car and I drove them to Daisy Krishnana's house in Newport.

What happened next wasn't great... these guys were extremely rude and ungrateful and did not want to be there. Ray was quite upset by their behaviour. They would not stay and ended up going to the Halland Hotel, in Seaview. I may have been 21, but I was nothing like a modern-day 21-year-old because I was so naïve and had none of the worldliness of today's kids. I was more like a 15-year-old and this behaviour shocked me.

One day I'd taken The Band somewhere and then returned with them to their hotel. I went with them to one of their rooms. They started taking spoons out and what looked like a dog turd and straws. I had no idea... I thought it was some sort of religious ceremony.

Then I saw them getting merry and they invited me to join in, but I flatly refused. 'No thanks, it's not for me.' I wanted nothing to do with it.

Another time I was driving Jon Taplin, The Band's roadie, and he started smoking. At the time, I smoked roll-ups with my Virginia tobacco and to my surprise, Jon took out a baccy tin and started rolling. I thought 'How nice of him, he wants to show me he can smoke the basic stuff too.' But when he started smoking, well, the smell was very different! It was like a bonfire and I thought it was some funny American tobacco.

Then he handed the cigarette to me, which I thought was odd, but I did not wish to be ungrateful. I thought the smoke was terrible, to be honest, but then he suddenly snatched it back off me, which I thought was even more odd!

We then came to a sharp bend and I found myself up on the pavement. On the next bend, I was on the wrong side of the road. Jon roared with laughter — I was smoking weed!

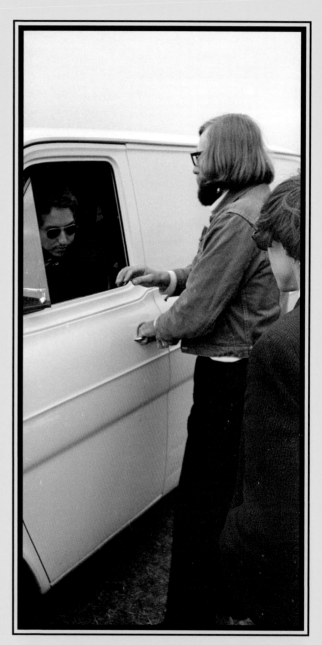

Mal Evans and Ray Foulk greeting Bob Dylan

'To be honest, I thought George was a bit arrogant and he was in awe of Dylan.'

Ronnie Foulk was a bit of a joker. On the same night I first picked up The Band, Ronnie told me, 'You are Dylan's chauffeur.' I just did not believe him and laughed out loud. There I was, a nipper from Northwood, suddenly a hippie.

Dylan did not arrive for another week or so after The Band first came. Ronnie had wanted a Rolls Royce for him but Dylan rejected that. He did not want to draw attention to himself and simply wanted something comfortable. That's how we came to have the Humber.

As for Bob Dylan, what can I say? I was really struck by how polite and well-mannered he was. There was no big-I-am with him. A lot of my time was just spent hanging around Forelands Farm in Bembridge, waiting to do whatever he fancied, his next instruction. He would often start a conversation by saying, 'Chris, are you busy?' I'd say no, of course, and then it would be, 'Oh, would you mind... ' He was so polite.

I recall John and Yoko Lennon arriving to see Bob at the farm and they were like teenage lovers. They were so wrapped up in each other it was as if the rest of the world did not exist. And I recall The Band rehearsing for the festival in the farm's barn. I remember the keyboard player, Garth Hudson, in there with his organ played through massive Leslie speakers. He was in there hour after hour and rarely spoke. He was not aloof, just focused.

With Bob, although he was polite, I also saw a firm side. I was driving through Yaverland on the Island towards Bembridge and I think his wife, Sara, was in front with me, with Bob and George Harrison in the back. They were chatting away. Then George said, 'You know Bob, when you're as famous as us, you can bring out any old crap and it will sell...' He was swiftly cut short by Bob.

Dylan turned on him and said, 'No, George, they are our fans. You can't say or do that.' He was quite firm and was scolding George, who looked a bit sheepish.

To be honest, I thought George was a bit arrogant and he was in awe of Dylan. On another occasion, I was saying something and George simply spoke over me and Dylan said, 'George, George... Chris is talking. What were you saying, Chris?' That was a nice surprise.

I was not too taken with Dylan's personal roadie, Al Aronowitz, who was a journalist with the New York Post. I was surprised Dylan had any time for him. I'd taken him somewhere in the Humber and on the way back, he asked me if he could drive the car. I refused but he kept on and on about it so I relented. Of course, he was all over the place and soon ended up on the wrong side of the road. In the end, I had to insist he pull over, thankfully he did.

I recall the day Bob said to me, 'Is it all right with you if we go to Osborne House?' I knew that Bob had received details of Queen Victoria's home in the Foulks' pitch that had been sent to him when they were trying to sign him for the festival.

I took Bob and Sara to Osborne and as I pulled into the car park, I asked if they wanted me to wait for them. Bob insisted they did not need me to do that, so I took the car to Wight Motors as it had a bit of a problem starting when the engine was hot.

Once that was sorted, I returned to Osborne to pick up the Dylans. When they got back to the car, I asked them if they had enjoyed their day. 'We've had a great time,' said Bob. 'We've toured the house, we've enjoyed some food and — d'you know the best thing? No one knew who we were! It was wonderful.'

They had so enjoyed being out in public but totally anonymous. That must have been so rare for him at that time and I think that's what Dylan enjoyed more than anything.

As for the music, I was pretty ignorant about Bob. The Beatles, of course, meant something to me — I liked them and whatever impressed me on the radio. I didn't even own a record player

when I met Bob Dylan. If I had spare time, I'd be fixing up a car or be down the pub.

Looking back, they were simpler, different times. Take the security for Bob Dylan, down at Forelands Farm, for example. I can really only recall a chap who was an old boy of about 60 and looked like an ex-major. It was all so low key. If there had been a couple of likely teenagers, they could have seen him off.

I remember being in the garden when there were some youngsters trying to get in to see Bob. One young girl said to me, 'Can you get me in to see Bob. I'll do anything... anything. Do you understand?' I understood all right.

Another time, an older lady, wearing a tweed skirt, arrived on an old upright bike with a basket up front. She was delivering a telegram from the local Post Office and announced herself by saying, 'Do you have a Mr Dye-lon here?' I said 'No, but we do have a Mr Dylan.' Always remember that.

On the day of the festival, Bob was to go up to the site incognito in a Ford Transit van with his wife and The Beatles party. I was already up there, with the Humber, with the idea of getting him out of there smartly at the end. So I was there when he arrived in the van.

Before he went on stage, he was so nervous. I was in the backstage area. It seemed to me that he was out of his comfort zone in a foreign country not having performed live for some time. He was walking up and down with his wife. Sara was trying to reassure him and Bob had his guitar around his shoulders. 'Bob, it is going to be fine', she kept telling him. He looked absolutely frightened and was showing severe nerves. All the while, he was doing this non-musical strumming of the guitar strings. This seemed to go on for such a long while as he waited to go on.

I must say, where was Bert Block, Jon Taplin or Albert Grossman when all this was going on? I thought he needed them. I did not see much of the action.

I do recall spotting a young woman in the Press/VIP area who looked drugged up. She was screaming at the stage, 'Bob, **** me, **** me!' Ronnie told me she was a reporter on one of the national newspapers!

Reflecting now, my thoughts were that I was a hired help and I was there to do a job, not to enjoy myself. My job was to keep out of the way. I was a servant and I was in the background. But these were great times, I can't even remember what I was paid — but it wasn't much dosh. I reckon it was about £30 a week — and that was a reasonable amount of extra money to pick up for a 21-year-old back then.

I don't think I got a tip, as such, from Bob, but he did leave me a gift. His manager, Bert Block, handed me a drum-shaped Sony radio Bob had with him at Forelands. He said that Bob wanted me to have it and I kept it for many years. In later years, it was in my shed and I eventually passed it on to a friend's son who was a huge Dylan fan. He was so, so grateful.

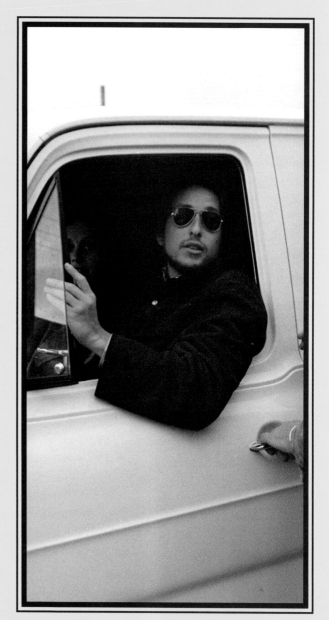

The Beatles, Stones & co. pay homage

A week is a long time in politics – Harold Wilson, prime minister at the time of the 1969 festival, apparently coined the phrase in the mid-60s. Maybe so, but in the world of celebrity, especially the melting pot of that same decade, a day or two could seem like an age.

Celebrity is ephemeral, here today and gone tomorrow, especially in popular culture. Yet there is no doubt that Bob Dylan's status, even back in the dying embers of that decade, meant his pulling power was assured both at the gate and beyond. His arrival on the Isle of Wight had excited some of the more established celebrities of the era to join the throng heading for the Island to pay homage.

The only other acts that could have matched Dylan's drawing power were The Beatles and Elvis Presley. The Beatles, however, were in break-up mode, already moving on to solo projects and mopping up the detritus of their final recorded outputs as a recording group. Elvis, no doubt the King of rock'n'roll, was divorced from the new music of the period and barely relevant to the festival generation, despite his successful 1969 comeback as a live performer in the United States.

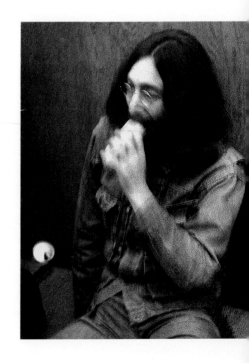

The Beatles, however, were big fans of Dylan and three of them, John Lennon, George Harrison and Ringo Starr, came to rub shoulders with the man of the moment. Paul McCartney didn't, but he had a good reason to absent himself, as his wife Linda gave birth to their daughter, Mary, on the Thursday of festival week.

Other celebrities who made it into Dylan's inner Island circle included Eric Clapton, Rolling Stone Keith Richards, Charlie Watts and Bill Wyman, Traffic's Jim Capaldi and Eric Clapton, just back from a Stateside tour with his new band, Blind Faith.

Pink Floyd's departing front man, Syd Barret, and his replacement, David Gilmour, were at Woodside Bay. They are pictured, separately, at the festival site just a short time after working together on what

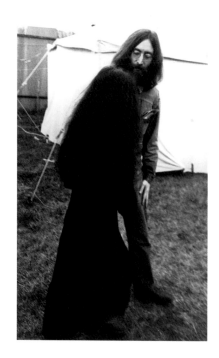

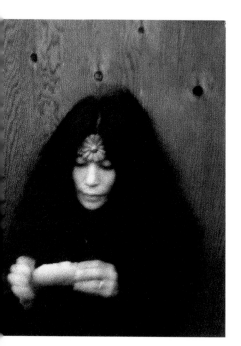

John Lennon and Yoko Ono

would become Barrett's solo album *The Madcap Laughs*. Stunning French chanteuse Françoise Hardy, singer Julie Driscoll, pop star Cilla Black and actors Jane Fonda – with husband Roger Vadim – and Elizabeth Taylor were among those in the VIP seats out front.

Elton John, a couple of years away from breaking through on the British circuit, was not on the VIP list or back stage. He is pictured deep among the crowd at the festival.

The idea of Forelands Farm becoming a magnet for rock's royalty was established almost the moment George Harrison decided to join his friend at Bembridge shortly after Dylan had flow into Heathrow from New York. And there is no doubt that, of all The Beatles, Harrison was closest to Dylan

As Ray Foulk points out, in *Stealing Dylan from Woodstock*, 'The relationship between Dylan and The Beatles is more than a footnote to the Isle of Wight story, and the Isle of Wight is also more than that to the relationship. This was also manifest in his long professional association with George Harrison'.

Harrison arrived at Forelands Farm the day after Dylan. He came with wife Pattie Boyd, and former Beatle roadie Mal Evans, apparently complying with a request from Dylan's bag man, Al Aronowitz, to bring supplies of 'smokables' for himself and Dylan. Harrison and Dylan were immediately at ease with each other, not surprising as George and Pattie were house guests at Dylan's rambling Woodstock home, Hi Lo Ha, at Thanksgiving the previous year.

Apart from the smokables, Harrison also brought a newly minted acetate copy of *Abbey Road*, The Beatles' last work together. The album would not be released for another month and although a further album, *Let it Be*, was to be released in 1970 after the band's split had been announced, all the recordings for that LP were completed before the band assembled to craft *Abbey Road*.

The album featured Harrison in top form, contributing 'Something' and 'Here Comes The Sun', now regarded as among the finest Beatles songs and standouts on the album. He played the album to Dylan and they spent hours together on acoustic guitars, jamming and harmonising – including renditions of Everly Brothers songs.

Ray Foulk kept a weather eye on his No. 1 artist at Forelands Farm between trips from and to the Fiery Creations' office in Totland.

'Activity at Forelands was frenetic,' he noted, with Harrison and wife Pattie enjoying time with Dylan before John Lennon and Ringo Starr completed what would have been a stunning supergroup line-up, or at least a top-drawer jamming combination.

There had been more than a suggestion in the music press, in the build-up to the Island festival that The Beatles would join Bob Dylan in a jam to end all jams at the end of his set. For various reasons, not least the delay in setting up the sound for the festival's crowning act, it did not happen. But Dylan and Harrison, at the very least, did make music together at the farm ahead of the gig.

Ray Foulk walked through the Forelands Farm sitting room at one point to witness their tribute to the Everlys. 'What an astonishingly beautiful rendition,' he remembers, 'and what a tragedy it was not recorded.'

The celebrity bubble wrapped around Bob and Sara Dylan was at its fullest and most colourful on the Sunday of the festival as preparations were made to move from the farmhouse in Bembridge to the festival site.

This was the day John and Yoko arrived by helicopter, with the craft's rotor blades creating a downdraft so powerful that the farmhouse's tenderly nurtured flowers were ripped out by their roots.

Ray Foulk arrived there to see a game of tennis in the grounds coming to a conclusion. It was an all-star match-up of John Lennon and Dylan playing against George and Ringo. The watching Pattie Boyd, a celebrity of some standing herself, was impressed – or perhaps confused – enough to dub it 'The most exclusive game of mixed (sic) doubles in the world.'

All of the players were dressed in their normal casual clothes rather than tennis kit and none, in truth, were terribly good. Concert producer and MC Rikki Farr later dubbed it 'Stumbledon, not Wimbledon' and he had a point, as Lennon stipulated he would play only 'On the condition that nobody else knows how to play.'

It had been agreed that Dylan would transfer from Forelands to the festival site incognito in an unprepossessing Ford Transit van, piloted by driver Dave Parr, rather than an oh-so-obvious limo such as the big Humber in the care of Chris Colley.

But there was a problem. The Transit was a plain and simple commercial van, not a mini-bus, and when the festival party climbed aboard their humble transport, there was no proper fixed seating behind the front seats.

There was rear seating of sorts, a front bench seat from a Ford Zodiac bolted onto planks of timber to make it more rigid, but it was not secured to the floor. Behind that was the even more bizarre arrangement of loosely placed folding directors' chairs.

At least the main cargo, Dylan, was sat securely in a front passenger seat next to wife Sara and driver Dave. Behind, on the Zodiac seat, were John Lennon and Yoko Ono with Ringo and Maureen Starr. Further back, in the directors' chairs, were Dylan's roadie Al Aronowitz and Apple's Mal Evans.

Health and safety? Pah! At one point, as the van negotiated a hill in Ryde, Dave struggled with the clutch as he checked if the road was clear and the van suddenly lurched forward. Cue shouts and screams as the bench seat tipped backwards, depositing John, Yoko et al on their backs. The party dissolved into laughter, Dylan included, as Dave pulled over to right the errant Zodiac seat.

Imagine, in 2019, a Bruce Springsteen or a Lady Gaga – or indeed Dylan himself – arriving at a huge festival with a coterie of A+-list celebrities in similar fashion! Has there ever been a more famous white-van-man than Dylan on the Isle of Wight?

While Dylan and his lawyers had been adamant on ruling out any filming of his Island comeback, the audio recording of it was both provided for in the agreement and then strenuously pursued, using the Pye mobile recording studio. It was the determination to get the sound just right for Dylan on the night that, in part, led to the frustrating delay between the departure of Richie Havens and the penultimate act, The Band, who reappeared with Dylan after the conclusion of their own set.

Technical gremlins aside, problems in the press and VIP area also contributed to the delay because of the rush to find a prized vantage point in those seats immediately in front of the stage. It led to the area first being cleared so that new, freshly-vetted passes could be issued and then re-filled with those lucky enough to have a pukka pass.

Jane Fonda

But when Dylan did eventually appear to perform before 150,000-plus expectant festival-goers, he had a VIP enclave just feet from the edge of the stage, jam-packed with five-star rock royalty and liberally sprinkled with a raft of celebrities from film, TV and the arts.

Everything was set for the main event.

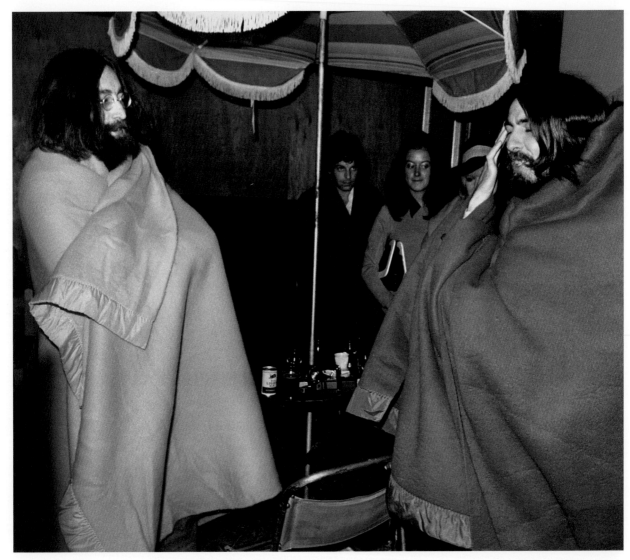

John Lennon, George Harrison and Ringo and Maureen Starr

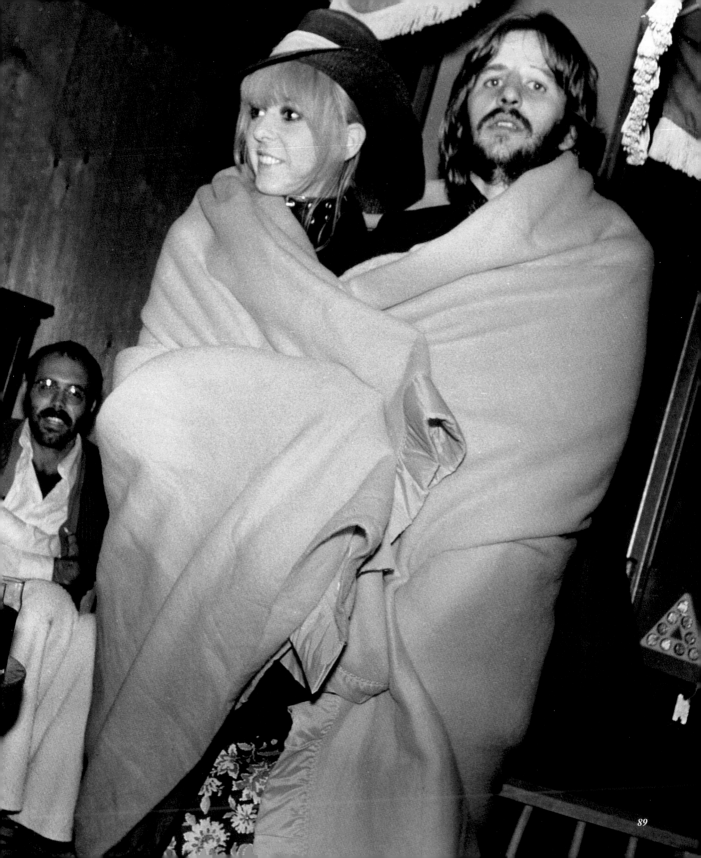

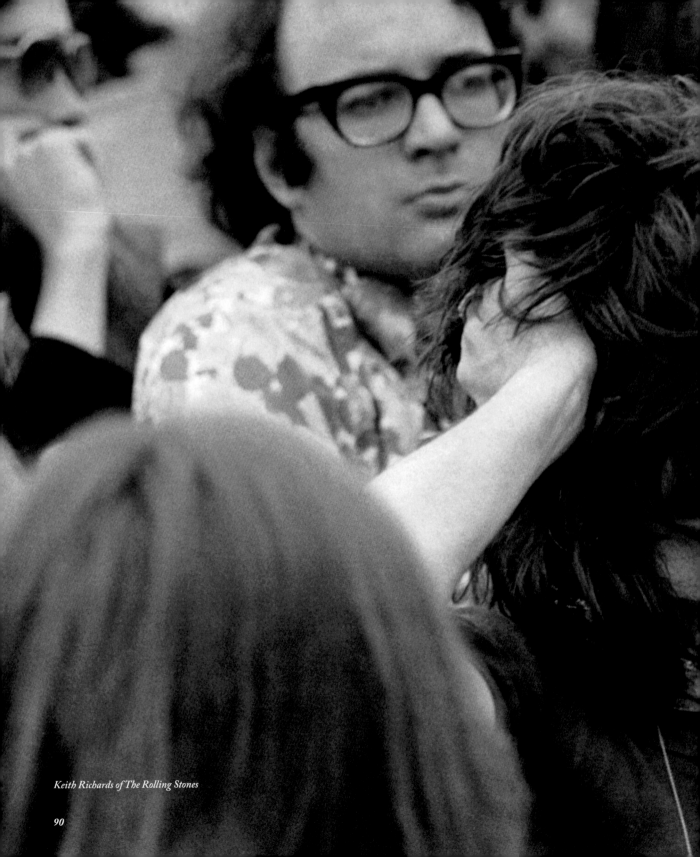

Keith Richards of The Rolling Stones

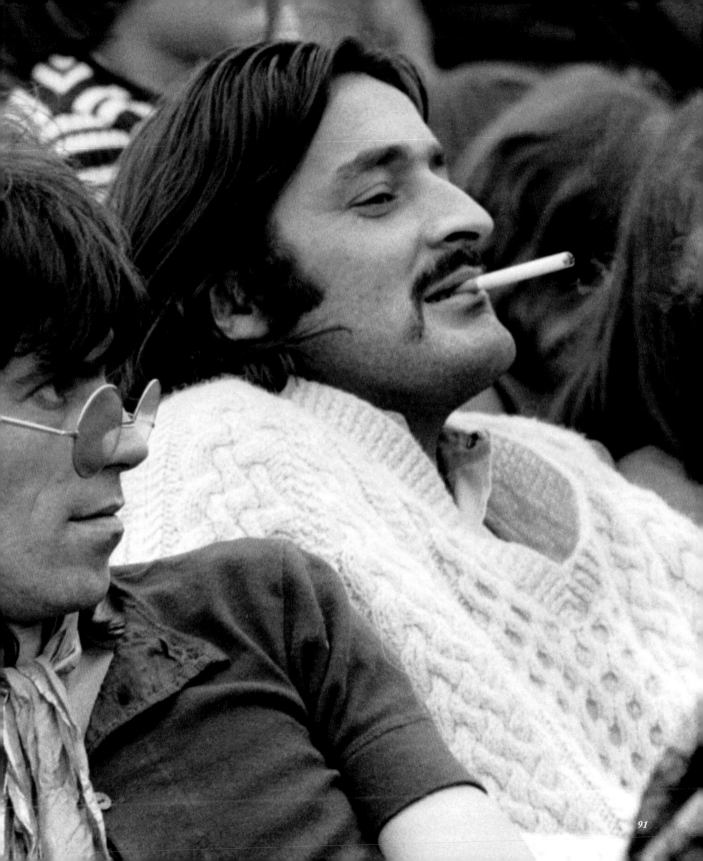

I was there!

Penny Warder

I had lived on the Island, in Yarmouth, with my parents Barbara and Pip Wavell. In 1969, I was studying at Oxford Training College on my way to becoming an occupational therapist. The music was one thing but the big festival draw for me was my boyfriend at the time, Vernon Warder, later to become my husband. He was going, so I wanted to be with him.

He is the chap sitting next to me in the front row of the picture. Vernon was from Cowes and was at art college in Cardiff and had long student holidays. He knew Jo Foulk, whose brothers were promoting the festival. Jo had been to school with us and Vernon knew all the guys in the pub in Totland, too, so he got work at the festival, doing artwork for the signs on the front of the stage and helping with security and management. As a result, he had a VIP pass and, being his partner, I got one, too. Otherwise it was £2 for a ticket.

For older people, like my parents, the festival was a shock-horror thing, they were totally against it. Once I knew we were going, I just recall it being a real hassle getting there from Yarmouth and getting back — it's one side of the Island to the other. I was lucky enough to get lifts on more than one occasion from Ray Foulk because Totland, where they were based, isn't far from Yarmouth.

The Foulks had managed to pull off the amazing coup of getting Bob Dylan to headline. Woodstock, which had taken place two weeks earlier on his doorstep in upstate New York, had tried to persuade him but he'd turned them down. He'd been in semi-retirement for three years after a motorbike accident, and this was his comeback... on the Island!

In the picture, Vernon and I are sitting in the VIP area just below the stage waiting for Dylan to come on; it took about two hours after Richie Havens' set because there were problems with the microphones. Vernon was totally into the music, me less so, but I remember the strains of Amazing Grace being played before the bill got underway.

'I remember being really excited about going into a portable toilet after Yoko Ono had been in there.'

I was barely out of my teens and a bit cossetted but there were a lot of full-blown hippies there.

We just rocked up without thinking about eating or drinking whereas today, if I was to venture to a festival, I'd need to pack all my snacks and supplies.

On that Sunday night at Woodside Bay, I was aware that Ringo Starr, George Harrison, John Lennon and Yoko Ono were sitting behind us. The talk of the festival was that they might join Dylan on stage. It never happened. I was a huge Beatles fan, but had not seen them live; I kept turning round to look at them. We were about three rows from the front and I could smell the hash that someone was smoking behind us.

We'd also had access to the VIP backstage area where The Beatles and other celebrities had congregated but I can't remember much about who I spotted. I do remember I once bumped into Lennon and remember thinking, 'Oh, he's not very tall, is he?'. I remember being really excited about going into a portable toilet after Yoko Ono had been in there.

I wasn't even aware of the celebrities: Jane Fonda, Eric Clapton and apparently Elizabeth Taylor were all there. That's how young and naïve I was.

If I was stoned (was I?), I blame the hash someone was smoking in the VIP seats!

When Dylan finally came on, he was barely 10 feet away from me. It was so exciting. He played for only an hour, for which he got some stick in the press, but it was incredibly exhilarating. He did two encores.

After he finished, I went back to my parents' house where I grew up. Even though I had been away at college for two years, there was no way they would allow me to stay out all night.

I first saw this photo just a few years ago. One of my friends, Felicity Garcia, had spotted the picture in Ray Foulk's own account of the festival, Stealing Dylan from Woodstock, and texted me, 'Were you sitting in front of the Beatles at the 1969 festival?' I said yes, and she wrote back, 'Your photo's in the book!'

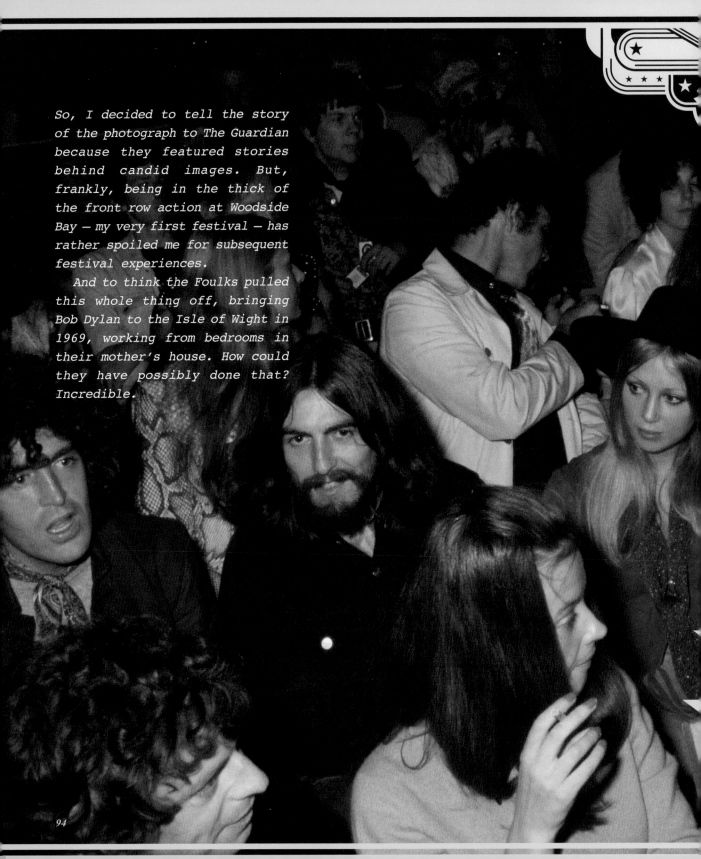

So, I decided to tell the story of the photograph to The Guardian because they featured stories behind candid images. But, frankly, being in the thick of the front row action at Woodside Bay — my very first festival — has rather spoiled me for subsequent festival experiences.

And to think the Foulks pulled this whole thing off, bringing Bob Dylan to the Isle of Wight in 1969, working from bedrooms in their mother's house. How could they have possibly done that? Incredible.

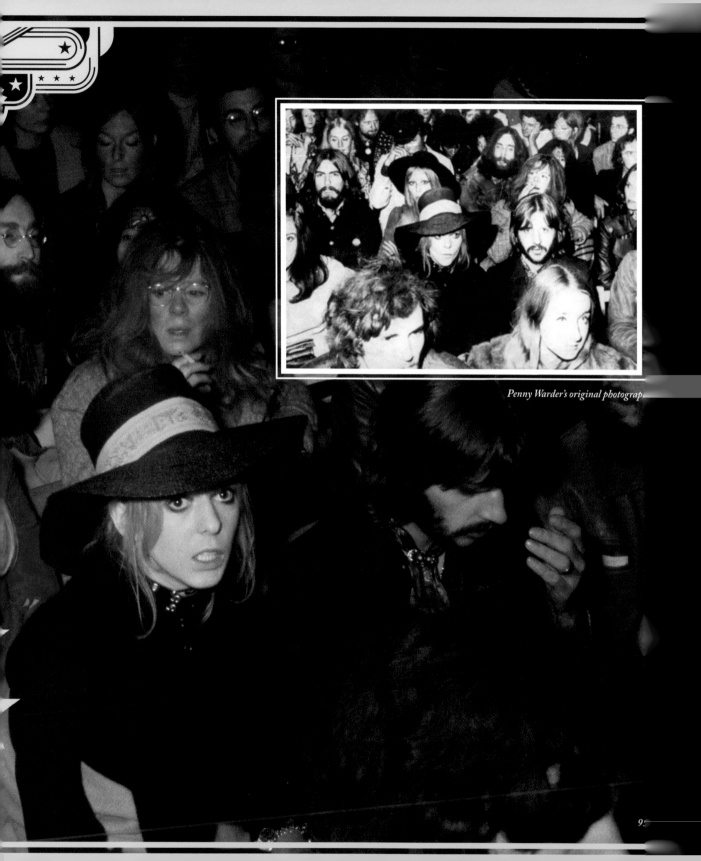

Penny Warder's original photograph

The festival begins...
11 days after Woodstock

The undoubted lure of Dylan, coupled with an impressive largely British-based supporting bill and the extensive PR campaign driven by Fiery Creations' Peter Harrigan and Dave Hill had done the trick. There was already a considerable throng on site when the 'free' first day got underway on Friday 29 August. By Saturday, well over 100,000 were on site and many tens of thousands more with Sunday-only tickets were still to come.

As *Rolling Stone* intimated in its 1969 post-festival edition, 'To place the festival in its proper socio-political context... three times as many came to Ryde as had attended the huge anti-Vietnam demonstration at Trafalgar Square a year ago – one of the largest British tribal gatherings of its sort prior to the festival.'

It was a huge assembly, drawn from throughout the UK, across Europe, Scandinavia, the United States, Canada, Australasia and beyond. The 100-acre site was transformed into a concert amphitheatre and a huge tented city. One area of makeshift shacks built by Brits, Americans and Canadians was dubbed, appropriately enough, Desolation Row, after the Dylan song of the same name – the closing track on his sixth studio album, 1965's *Highway 61 Revisited*.

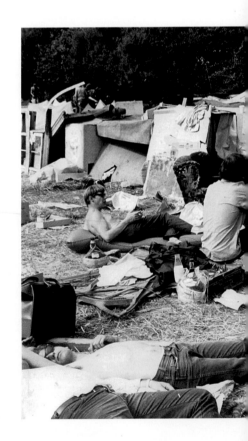

The sense of anticipation was palpable. After months of pitching, persuading and gambling backed by meticulous planning, the Foulks' brothers' event was a reality.

When Ray Foulk and Fiery Creations' company secretary Dick Clifton drove across the Island on Friday from the company's offices in Totland to Woodside Bay, the gathering crowds lining the route between Wootton Bridge and the festival site provided a clue to what they would find further up the country road. After struggling to get through their own security, Ray was taken on to the stage by festival producer Rikki Farr and then, suddenly and magnificently, the scales fell from his eyes.

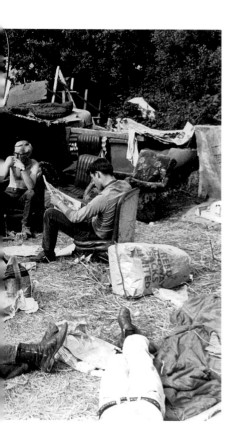

'In front of me, engulfing my whole field of vision and stretching out all the way to the horizon like Neptune's kingdom, was the assembly, swelling and rippling before me,' said Ray. 'Twenty acres of people! I was shocked, stunned. This was a crowd the like of which I had never seen in my life. Overwhelmed with awe, my instant reaction was, "Christ Almighty, we've really done it! We're responsible for this?!" Slowly but surely reality set in: "This is the result of landing Bob Dylan.'"

The bonus extra starting day's entertainment began after Rikki invoked a quasi-religious blessing from the stage. He called on everyone in the massive crowd to hold hands as he offered a simple dedication, 'To World Peace'.

Then first on stage, in a delightful example of a bunch of chancers seizing the moment came heavy rockers Marsupilami, unscheduled, unscripted and unexpected. They had arrived early, blagging their way backstage and claimed to have lost their contract as they convinced Rikki they were on the bill and ready to play.

And play they did, getting the audience fired up before the scheduled opening act, five-piece outfit Eclection, nicely set the tone for the rest of a varied bill by offering a set with broad influences and styles, taking in blues, folk-rock, gospel and jazz.

They were followed by Portsmouth poet Christopher Logue, a pacifist and anti-war campaigner, who was also a playwright and actor. His poetry was set to music by both Joan Baez and Donovan but his recital at Woodside Bay would be before the biggest audience of his life.

The evening's bill closed with two of the biggest British bands of the day, reserved to wind up the first-day crowd into a sense of heightened anticipation for the weekend: The Bonzo Dog Band and The Nice.

The Bonzos had, by summer '69, shed the 'Doo-Dah' element from their name but they remained as off-the-wall as their former monicker. So off-the-wall that their drummer, Legs Larry Smith, was on the razzle with Keith Moon and drank himself AWOL for the start of the set – Traffic drummer Jim Capaldi was just one of the stick men who answered the call from the VIP area and took over the drums in his place.

Eclection drummer Gerry Conway recalls, 'To be honest, I can't remember anything about the Island festival in 1969... except the Legs Larry Smith thing. I can definitely recall some kind of dash to the stage and being relegated to a sort of percussion role! So, I'm sure I must have been there!'

And when Legs Larry finally recovered his bearings, Capaldi was unceremoniously relegated to tambourine-thumping duties as a clearly refreshed Moon joined in on congas.

The set included favourites 'Urban Spaceman' and 'Monster Mash' as well as their single 'Mr Apollo', the latter taken from the recently released *Tadpoles* album. The finale was provided by The Nice, a fine band and arguably the first prog-rock ensemble. They were fronted by keyboard virtuoso Keith Emerson alongside bassist Lee Jackson, guitarist David O'List and drummer Ian Hague. They initially combined in 1967 to back soul singer P. P. Arnold on the condition they could play a set beforehand as her warm-up act.

Offering their keynote fusion of rock and classical music, The Nice's excerpt from Sibelius's 'Karelia Suite' (then popular as the theme to current affairs TV show *This Week*) rocked this slice of the Island and was apparently heard ten miles west by the inmates in Newport's Parkhurst prison.

Remarkably, The Nice had played on the Island just two months previously at the intimate Middle Earth Club for Fiery Creations in front of just a few hundred fans. This was beyond comparison and on an utterly different scale.

Saturday dawned and the weather was again kind, a late summer warmth greeting the early risers as a steady stream of hundreds – no, thousands – added to the throng by the hour.

DJ Jeff Dexter, a staple of the festival scene and a former primary school chum of Marc Bolan in Stoke Newington, got things under-way with an anthem that was to become synonymous with the festivals: 'Amazing Grace' by the Great Awakening set the tone before a Krazy Foam event got the newspaper photographers' attention. Thousands of cubic feet of fire-retardant foam gushed from a pumping machine to create a sea of bubbles, inviting the revellers to frolic, dance and gyrate.

Some immersed themselves wearing bikinis or just jeans, others fully clad, while one couple captured the mood of many by stripping off completely, then making love with gusto before a crowd made up of variously fascinated spectators or indifferent onlookers. Certainly the photographers were captivated!

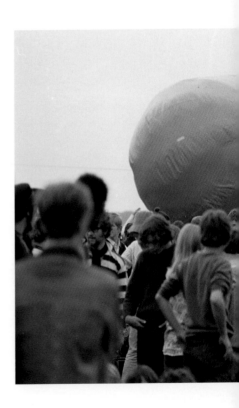

Coverage of the saucy sideshow would give the promoters a few headaches later but it was, in retrospect, not much more than a blip. On with the show and Saturday's first band, Gypsy, were charged with setting the tone for the day by Rikki Farr. The Leicester five-piece, who were to release two albums on United Artists and support Led Zeppelin on one of their tours, obliged with a fluid and competent set.

They were followed by Blodwyn Pig, a blues-jazz band, formed by ex-Jethro Tull guitarist Mick Abrahams. Their set was largely composed of songs from their current *Ahead Rings Out* album and it went down well with the crowd, especially Jack Lancaster's trick of playing two saxophones at once, one in each hand.

During the Edgar Broughton Band set, a second dose of excitement erupted in the photographers' ranks. The blues-psychedelic rock band from the Midlands, promoting their new *Wasa Wasa* album, had barely finished 'The Psychopath' before a slim, naked teenage girl emerged dancing into the VIP/Press area just in front of the stage.

Edgar Broughton seemed taken with her, shouting 'Do your thing, baby!' before launching into 'Out Demons Out' as the cameramen flocked to their auburn-haired quarry, undaunted as she continued her free-spirited performance for some ten minutes. Eventually, stewards intervened to cloak her and usher her away. Not before the episode was captured countless times on film for posterity.

The EBB, already well experienced at outdoor events, had radical underground credentials and their set was well received as the audience continued to swell, fed by double-decker buses ferrying in the crowds.

Next up was The Aynsley Dunbar's Retaliation – drummer Dunbar already a blues veteran having worked with John Mayall and Jeff Beck before forming his own band. Tommy Eyre, on keyboards, had joined from Joe Cocker's Grease Band where he had contributed the distinctive intro to their classic interpretation of 'With a Little Help From My Friends'.

They were followed by an act that had the paparazzi switching lens from the VIP area's naked interloper to a singer who ticked all the celebrity boxes. Marsha Hunt had become a gossip column staple after her role as Dionne in the West End rock musical *Hair*, coupled with a well-publicised affair with Mick Jagger. Necks were craned in the crowd before she even reached the microphone.

Not only was she the only female on the bill, but she was the only girl rocker, a stunning black American vision, dressed in a revealing singlet top, skimpy leather hot pants and knee-high boots, all topped off with a very full Afro halo.

It was a spectacle full of sexual promise and her performance did not disappoint on that score, liberal use of the microphone as a phallic prop combined with suggestive body movements. Appearances can be deceptive, however, as she later revealed she was 'scared' once she saw the massive throng before her. 'When I stepped forward from behind a stack of speakers, I very nearly wet myself. A slow pulsating wave of motion almost made me seasick.

'I heard my bass player say, "fuck me", as he looked out. There was nothing more you could say!'

Her set included 'Wild Thing', a Chip Taylor song made famous by Jimi Hendrix's cover and a huge hit for The Troggs; 'Sympathy for the Devil', a 1968 song written by her lover Jagger with Keith Richards for the Rolling Stones, and Dr John's 'Walk on Gilded Splinters'. Her man Jagger was not in the VIP area, of course, he was in Australia, shooting the *Ned Kelly* movie.

It all went down well, the huge crowd greeting her performance with quite an ovation, a far cry from playing to a few hundred hardy fans at her recent visit to the Island's Middle Earth Club. She owed her place on the bill to that gig and the fact she was managed by The Who's manager Kit Lambert. The Who, of course, would follow later in the day.

Despite her fears and alarm, the Island experience had a lasting impression on Marsha. She later said, 'The encampment of music lovers made history by their sheer number and swarmed that tiny Island. One could have imagined that our revolutions in music, sex, fashion, drugs and alternative cults were all there was in the world – we were the ruling class.'

Up next, The Pretty Things were, like Hunt, recent refugees from the Middle Earth Club. Their set was in vogue, pyschedlic rock featuring Phil May on lead vocals, Twink (who went on to play with The Pink Fairies) on drums and Dick Taylor, briefly a member of The Rolling Stones in their early days, on guitar.

Much of the material was drawn from *S.F. Sorrow*, a concept album that predated The Who's *Tommy* by several months. It was fine psychedelic rock and the band did not disappoint.

Family followed, raw, unbridled and powerful, led by the unpredictable but charismatic Roger Chapman. The band had drifted from soul and blues to psychedelic rock and back again and arrived hard on the heels of a US tour laced with controversy followed by an appearance at The Rolling Stones' free summer gig in Hyde Park. They had a recent hit album, *Family Entertainment*, and hit single, 'Weaver's Answer', to promote.

Chapman showed off his rasping, warbling vocal delivery while also managing to smash a mic to pieces during what looked like an attempt to lasso photographers below the stage's apron. The pulsating performance garnered fine reviews. Drummer Rob Townsend remembers the day mostly for getting up close and personal to fellow drummer Keith Moon, who was having his glass topped up constantly with whisky and coke.

Between acts, DJ Jeff Dexter kept the crowd entertained with a stellar selection of rock records as the crowd sought out sustenance and the best vantage points.

The Who's noisy arrival by helicopter meant that one of the best rising bands of the day had to curtail their own set. Free were hitting their stride with their debut album *Tons of Sobs* released earlier in the year and their eponymous follow up, *Free*, ready for release a few weeks after their festival appearance.

It was to be another year before their all-time classic, 'All Right Now', became a world-wide hit, but Free were already a big draw on the live circuit. Incredibly, the quartet were all kids. In 2019 terms, this was a boy band but without 21st century string-pulling, artificial manipulation or hype.

Vocalist Paul Rodgers was 19; lead guitarist Paul Kossoff 18; drummer Simon Kirke, 20, and precocious bassist Andy Fraser had only just turned 17 a few weeks earlier.

They gave notice of their talent with a thumping twenty-minute set of blues rock that included their signature live crowd pleaser, 'The Hunter', followed by two songs from their new album: 'Trouble on Double Time' and 'Songs of Yesterday'.

Rodgers may have been 19 but sounded closer to 39 and his ability to send the mic stand into orbit was noted by Ray Foulk who reports Free's was a 'much appreciated performance'. But Rikki Farr was forced to bring it all to a premature conclusion as The Who descended: 'The Who are coming down now in their usual, inimitable, outrageous style,' he said, as the noise transferred from the stage to the skies above. 'They've hired thousands of pounds worth of helicopter for us.'

The Who had fancied landing on the stage itself – that was never going to happen – so instead they had asked for an 'H' to be mapped out close behind it. DJ Jeff Dexter helped organise security staff to mark out the H-spot with 8ft x 4ft plywood sheets.

But as The Who's craft descended and hovered 20ft above the ground, the downdraft sucked the boards into the air and one struck the tail rotor, causing the helicopter to twist and pitch. Ray Foulk, watching on, thought the chopper might crash-land but 'Miraculously, it touched down on its skids in the nick of time.'

Virtually none of the crowd was aware of this late, late travel drama that so nearly deprived the world of The Who, and the band dashed out of the helicopter pretty damned quick. Pete Townshend told the audience later, 'Our manager hired a nice helicopter for us to ride in and when it landed it did something terrible to its rear end. My faith in the aeronautic world rapidly dwindled.'

It did not put the band off their stroke and The Who brought a blossoming world-class reputation and their instantly-acclaimed new concept album, *Tommy*, with them to Woodside Bay from Woodstock. The audience was not to be remotely disappointed.

Townshend, Roger Daltrey, John Entwistle and the apparently compos mentis Moon ripped through 24 songs including an extensive 16-song showcase of their new album. First came a four-song aperitif including their big 1966 single hit 'I Can't Explain' and 'Young Man Blues', featuring stunning Townshend guitar, before the *Tommy* numbers were extensively aired.

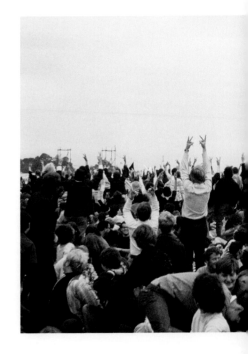

Daltrey and Townshend looked like they simply unpacked their Woodstock stage clothes and stuck them back on, the former in a lattice work of tassels and the latter boiler-suited once again. The band were on top form and thrilled both the huge crowd and watching critics, with *NME* declaring they 'Must be rated one of the world's

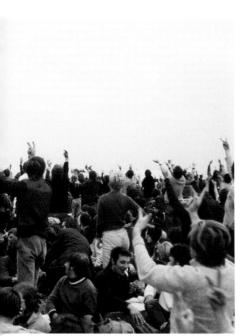

best groups by now'. Jane Fonda gushed, 'They are fantastic, an audio-tactile experience. It's the best thing we have heard yet.' Towards the end of their set, the crowd's demands for 'My Generation' were answered with a blistering rendition. 'Shakin' All Over' was then a fitting encore.

Pete Townshend appeared to enjoy the Island experience far more than their nocturnal triumph in washed-out Woodstock just days earlier. He said, 'What was incredible about the Isle of Wight thing was that The Who were totally and completely in control.'

Their superb sound, too, was testament to the band's PA and sound system, courtesy of Charlie Watkins' superb WEM (Watkins Electric Music) amplification system. It was maintained and usually stored by Charlie and most of the acts utilised it at the festival.

Brand new folk-rock outfit Fat Mattress had the onerous task of following The Who and reviews were, at best, mixed. Much antici-pated and much hyped, the band was formed around ex-Jimi Hendrix bassist Noel Redding, reverting to lead guitar alongside a couple of Engelbert Humperdinck side-men and vocalist Neil Landon. They had released their debut album, *Fat Mattress*, only days earlier but the band was not to prosper and they split the following year.

Townshend had earlier promised the crowd that Joe Cocker – a fellow Woodstock act – was soon to follow and would be 'Very, very exciting'. There was no doubt that bluesman Cocker had been a star performer at Bethel Woods and he was at the top of his game.

He perhaps took a song or two to get fully into his stride but 'Do I Still Figure in Your Life', an earthy version of a hit by pop merchants Honeybus, hit the mark – as did his cover of The Coasters' 'Let's Get Stoned'. But Ray Foulk reckoned Joe's already classic, slow, disman-tling version of The Beatles' singalong 'With a Little Help From My Friends' was a 'Movingly evocative tour de force'. It was the title track of his debut album and became the song most associated with Cocker. Indeed, Sir Paul McCartney would later salute Cocker for transform-ing the song into a 'Soul anthem'.

For Saturday's finale, the Moody Blues were a fine alternative as the closing act to The Who. Townshend & co. wanted to arrive in style by chopper during daylight, which left the prestigious last slot open for the Moodies.

Not a single act, arguably, sounded better through the WEM sound system during the weekend but then the Moody Blues had a reputation for masterfully reproducing their intricate studio sound in live performances.

And so it was with the likes of 'Dr Livingstone, I Presume', 'Never Comes the Day', 'Peak Hour' and 'Tuesday Afternoon' before 'Ride My See-Saw' signalled the band moving up another gear. Even that was eclipsed when they went into overdrive with 'Nights in White Satin'. The throng, now perhaps 120,000 strong, erupted and gave such an ovation that the band made an exception to their no-encore rule. 'We've waited five years to hear that!' Justin Hayward told them.

The Moodies surely did not mind taking the premier, closing spot. As Justin Hayward revealed in a 2002 *BBC* documentary, *Return to Rock Island*, festivals – including this one – had a tradition of flexibility.

'The first thing you realise when you get there is that the running order pinned on the wall goes straight out of the window', Hayward smiled. 'Because nothing takes five minutes to set up and, at the change-overs, people always over-run or someone gets stoned and does an incredibly long solo or something like that. You are supposed to be on at one o'clock in the afternoon... and at one o'clock the following morning you are probably still waiting.'

Indeed, the final strains of The Moodies' encore faded around 2am, much of their set taken from their current hit album *On The Threshold Of a Dream*. It seemed fitting as the huge crowd, buoyed by great music and infused with a little drink or some such, headed for their tents or makeshift dens to dream of another day...

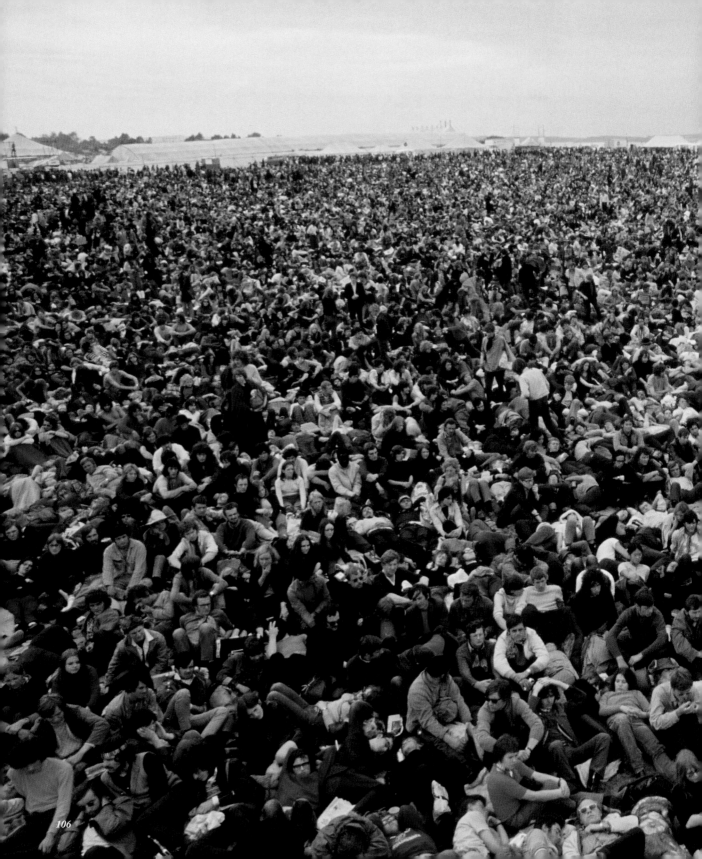

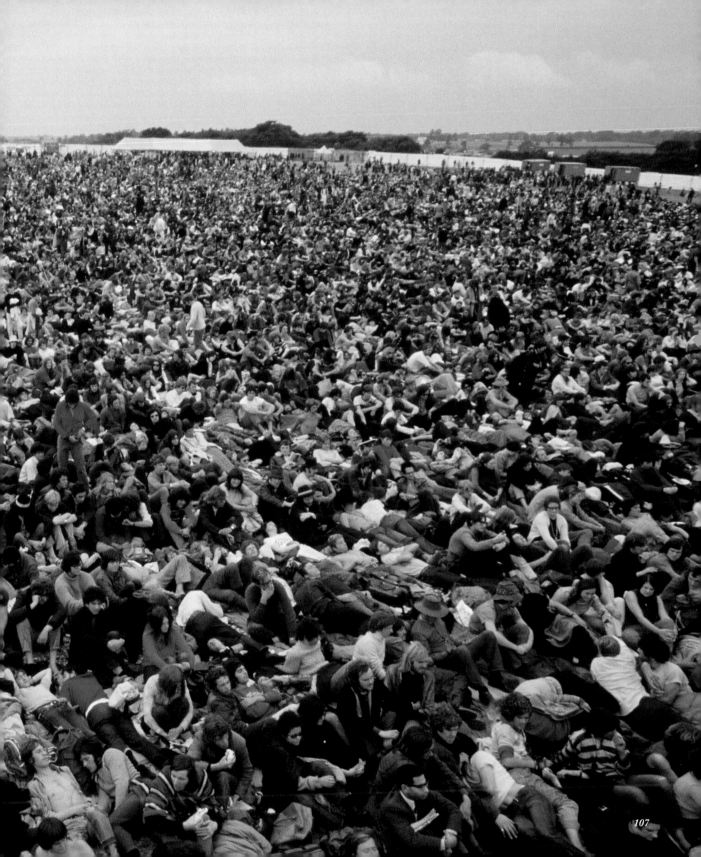

I was there!

Vernon Warder

I got to be at the festival, both as a worker and in the audience, quite by chance. I'd come home to the Island from college, absolutely broke, and I got a summer job at the Island Bakery, near Ryde, and was living in a tent on the Recreation Ground in Totland, near to where the Foulks lived.

I'd been at school with the younger of the Foulk brothers, Bill. He was older than me and I also knew his sister, Jo, from school, so I knew the family. I'd also been to school with Peter Harrigan, who was working on the publicity side at the festival.

One day I bumped into Peter in Ryde as he was about to cross the Solent. He told me about the festival and that he was off to talk to Lord Montagu of Beaulieu about finance for the event. I did not even know about the festival until then. I told him about my miserable job at the bakery and he told me to come and work with them.

As an art student, I could help with Dave Roe, who was Fiery Creation's graphic designer.

What a time it was, first in the Foulks' shed at their home, Tavistock House, in Totland, and then in a room at the house — basically a front-room 'studio' with Letraset type-lettering, no computers then. I also helped with the signage for the stage area. Upstairs were Ray Foulk and Peter and company secretary Dick Clifton with endless lists of work pinned to the walls, while Ray's mum would pop her head around the door offering tea.

I find it quite remarkable the festival was pulled off but, in the spirit of the time, anything was possible.

Later we moved across to the festival site in Wootton and worked on the stage itself and once that was done I was co-opted on to stage security for the acts.

How lucky was I? To be working at a festival where Bob Dylan was to appear? I had gone to art college in London in 1967 so I was very aware of Dylan and the cultural and political movements of the time. To be involved in an event like this was so exciting and I couldn't believe it when

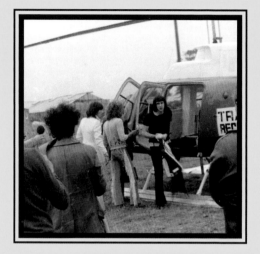 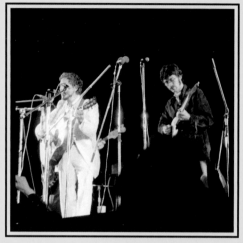

Peter said they had got Bob Dylan to come. It was all pulled together, it seemed, on a wing and a prayer... I don't think Ray had even been off the Island before he flew to New York to seal the deal.

We must have moved away from Totland and down to the festival site two or three weeks before the opening day. I remember the stage being constructed and all the fencing going up.

The festival itself? Brilliant. I was working on site, of course, but I was into my music and I'd been a Mod a little earlier — I'd been into the scooters and

all that. So I was interested in The Who, who were great, but I'd moved on to the hippie thing by 1969. Even so, I was incredibly impressed by Pete Townshend's capacity as a guitarist when I saw him on stage.

I also remember being very impressed by The Band. I had been involved a little, because of my help with security, as they were found a place to stay in Brading. They were great.

And then, what do you know, I actually got to meet Bob Dylan because I was working at the place he was to stay, at Bembridge, when he first arrived with

'I do recall how much fun Keith Moon was back-stage. He was always ready to stop and chat...'

Sara and the rest of his party after their midnight hovercraft ride from Portsmouth. Someone introduced me to Bob Dylan and I said 'Hello'. There was no long conversation — but I met THE man!

On the night when he took to the stage I thought he was great. I admired him, anyway, because of his writing, the poetry in his songs. It may not have been the thrashing guitars of earlier acts but it was just great — and so very different. There he was, the man — who cut such a small figure — up there in his white suit.

The VIP area and backstage was full of people, famous people, from all over the world. I remember a lot of running around before Dylan came on, lots of anxiety, delays and being involved in pushing lots of stuff off and on stage. And I remember ripping the arse out of my trousers and having to get changed!

I was there with Penny, my girlfriend at the time, but I don't remember particularly star-spotting any of the famous names. But I do recall John and Yoko Lennon, George Harrison and Ringo Starr sitting behind us as we waited for Bob to play! And I do recall how much fun Keith Moon was backstage. He was always ready to stop and chat — he was fun and got on really well with our chief electrical contractor Harry Garrood. They loved each other's company.

After that memorable night I was involved for a couple of days, tearing things down, but then I had to get back to college. What a time. What a brilliant, brilliant, time.

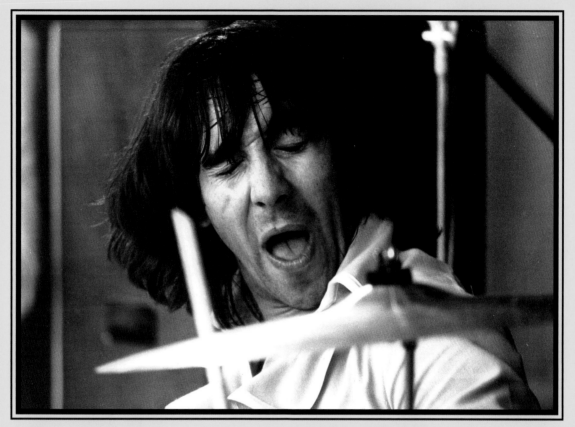

Keith Moon

D-Day
The build-up to Dylan

And so, to D-Day... this was the big one, the day the master himself was to perform. As another late summer day dawned, already thousands more fans with Sunday-only £2 tickets were heading for the Island festival site. 'Amazing Grace' was reprised like an Age of Aquarius call to prayer, as the pioneers of latter-day festival camping (certainly no glamping, back then!) got themselves up, abluted, fed and ready to face the special day... the day Bob Dylan would make his comeback.

There were other big events on the news schedule that day. One of the biggest names in the history of boxing, Rocky Marciano, died in a light plane crash at Newton in Iowa, the day before his 46th birthday. And, near New Orleans, there was another music festival going on.

In Prairieville, Louisiana, a few very decent names assembled including The Byrds, Canned Heat and Janis Joplin. Tyrannosaurus Rex waved the flag for the UK and the crowd was estimated at more than 25,000. But the eyes of the rock world that Sunday were firmly focused eastwards, 4,600 miles across the Atlantic, on what was – for a few days – Bob Dylan's favourite island retreat. His return to concert performing, before more than 150,000 fans, was on.

Breaking in the audience with the first set came poetry rock band The Liverpool Scene, at the height of their powers in 1969 as they fused music, poetry and satire. They released their second album, *Bread On The Night*, toured the UK with Led Zeppelin and Blodwyn Pig... and opened the bill on the day Dylan played the Isle of Wight.

Burly, bearded front man Adrian Henri decanted song-poetry in broad Scouse to a jazz-rock backdrop. The impromptu 'Do The Dylan Rock' was both fun and timely and the crowd loved it. Their 'Bat'-poem incorporated the TV *Batman* theme and both anti-Vietnam war invective and pro-Liverpool FC sentiments. Today, it would be a mash-up.

Henri found time to urge the crowd to wake up Dylan 'In his castle on the other side of the Island'. Cue a huge cheer, of course.

The fun, satire and wit gave way to 'music of the druids' – at least that's how Third Ear Band described their blend of ethereal, folky, psychedelic rock with Indian overtones. They were championed at Woodside Bay by John Peel, the DJ having made an appearance on their Alchemy album, playing Jew's harp.

Poet Christopher Logue was back with fellow scribes Anthony-Haden Guest and Jeff Nuttall, punctuating the musical acts to offer genuine diversity to the festival bill.

Indo Jazz Fusions amplified the Indian ragas offered by Third Ear Band. IJF were made up of some ten musicians led by saxophonist Joe Harriott and conducted by composer John Mayer. Jazz and Indian music came together with both styles open for broad improvisation. The music had the perfect accompaniment in the arena... the sweet smell of incense and the ganja rising from the heat and dust.

The acoustic-folk overtones of the afternoon session were perfect for Gary Farr, the fair haired, good-looking brother of compere and show producer Rikki. No nepotism was required – his bona fides and pedigree were worthy enough as he had worked with, among others, Keith Emerson in mid-60s band The T-Bones and also Julie Driscoll.

His urgent, folk-rock style lent itself nicely to the rather more restrained tempo of Sunday's roster. His set included 'Good Morning Sun' and 'The Vicar and The Pope'. The latter appeared as the B-side of a single, released that same year.

A spike in the atmosphere and festival quality came next with American Tom Paxton, a contemporary of Dylan and fellow performer in Greenwich Village's bars and coffee shops of the early Sixties. His was a memorable contribution and it was to leave a lasting impact on him.

Tom had arrived on the Island on the hovercraft from Portsmouth to Ryde, travelling with The Moody Blues, but when he got to the site the scale of the crowd, way bigger than anything he had performed to before, left him struck by nerves. At 31, he was a few years older than most of the other performers on the bill and he cut a rather dated figure with denim shirt, peaked cap and neckerchief. Not only that, he was an artiste alone, his six-string acoustic his only prop with no backing musicians.

Ray and Ronnie Foulk with Bob Dylan

He could have been swamped and overawed but, digging into his experience and stagecraft, Paxton's solitary figure swiftly won over the huge audience. His beautifully rounded 12-song set included, 'I Wonder Where I'm Bound'; 'Ramblin' Boy'; 'The Last Thing on My Mind' and 'Wish I Had a Troubadour'. One of his new songs, 'Crazy John', was particularly well received – referencing none other than John Lennon, who was on the VIP list. The song shone a light on the stick Lennon received from the media following his campaign for peace in Vietnam. As Ray Foulk pointed out in his festival volume, the lyrics were both topical and sadly prescient:

> *Crazy John you tell them what they don't want to know*
> *They never can hear you, John, they have no desire*
> *They're beginning to fear you, John, and the hate's getting higher...*
> *When the people get lost, they start building a cross.*

Paxton was incredible and with a pre-Dylan sense of anticipation building, the crowd gave him a rousing standing ovation and two encores followed. His reception eclipsed everything seen so far – even The Who. He returned to the stage a third time simply to offer sincere thanks as he wept tears of joy.

Shortly afterwards, Dylan introduced Tom to John Lennon backstage. 'Crazy John?' cracked Lennon, and Paxton said that made his perfect day complete. And the lasting impact? Paxton felt instantly at home and he moved to England shortly afterwards, staying for the next five years.

The Paxton feel-good factor transferred to Pentangle, the next band on stage, an acoustic folk-rock band at the height of their success with a hit album, *Basket of Light*, and a single, 'Light Flight', receiving wider reach as the theme of *BBC* TV series *Take Three Girls*.

Vocalist Jacqui McShee and the band had to battle a series of distractions, notably increasing noise from air traffic, prompting furious fist waving and V-signs from the crowd, and a commotion in the press area greeting the arrival of Rolling Stones' Keith Richards and Charlie Watts. They gamely battled on.

Californian Julie Felix was, by 1969, well settled in Britain and well-known through stints on David Frost's *The Frost Report* and her

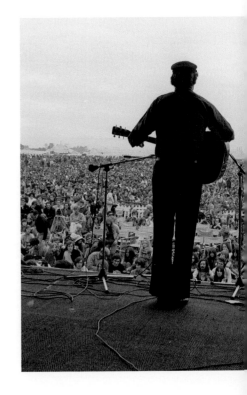

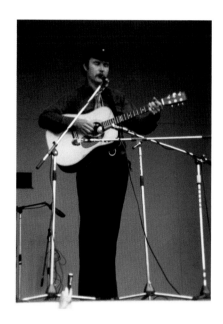

own *BBC* TV show. In 1965 she was credited as the first folk singer to fill the Royal Albert Hall. And here she was, at the festival, alone – like Paxton – with her acoustic guitar.

Slim and dark haired, she cut a similar figure to Joan Baez and she too favoured Dylan covers. With the man being driven to the site from his Bembridge base, 'Masters of War' and 'Chimes of Freedom' were well timed. She also included her friend Leonard Cohen's 'Bird on a Wire' and her own 'On a Windy Morning'. She drew a truly warm reception from the crowd, now boosted by Dylan to its maximum. The encore demands included repeated shouts of 'Zoo' and Felix duly obliged with her best-known song, Tom Paxton's 'Going to the Zoo'... cue a Sunday singalong to the children's favourite.

Backstage, the artists' dressing rooms were actually small white tents although Dylan had his own area reserved with a caravan. It included trailers, pub tables with large umbrella shades and an upright piano. He was now in residence, so to speak. On stage, Richie Havens, the man who kicked off Woodstock, was the prelude to the appearance of The Band and then Dylan himself.

Havens was there because of the Dylan contract, part of the package negotiated by manager Grossman, but his soul-folk style was certainly in vogue – witness Woodstock and his appearance at the Blind Faith free concert in Hyde Park two months earlier. His style was as wild and unorthodox as his appearance, a seam of Afro angst running through the bedrock of protest folk.

Havens presented an impressive vision, clad in white with contrasting bright African sashes and beads. He was smart enough to cover Dylan's 'Maggie's Farm' – just as Dylan and his party congregated backstage. He also served up a highly stylised 'Strawberry Fields Forever'/'Hey Jude', with John Lennon now also on site.

His own new song, 'Freedom', had been an early Woodstock highlight and it was lapped up at Woodside Bay. He meshed it with the Negro spiritual 'Sometimes I Feel Like a Motherless Child'.

Along the way, his intense, simple and aggressive guitar technique cost him two strings but won him countless new admirers, including on-site poet Christopher Logue. He said, 'Havens is big, gentle, commanding; his image fills the stage... he set a clear strong rhythm going and sang plain, almost single word riff-lyrics to it.

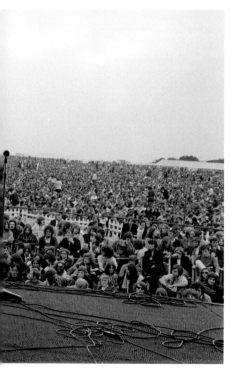

Tom Paxton

While he sang, the sun came out and made a sunset glorious enough to delight Turner.'

Less delightful – and a sign of very different times – was that the tumultuous reception Havens received from the crowd was not replicated when he arrived at the Island hotel where he was booked in with Tom Paxton. Havens and his band were refused admission because they were black. Outraged, Paxton said if Havens was not welcome, he was leaving too. It was left to Peter Harrigan to hurriedly arrange alternative digs in Lake in the dead of night.

When Havens finally left the stage after a second encore, the show was bang on schedule and there was an hour for the changeover before the scheduled 8.30pm appearance of The Band. The heat had gone out of the sun and the air had turned nippy. Backstage, Dylan and his guests, a party of perhaps a couple of dozen, were hanging around, talking and drinking. Ringo appeared with a tray of hot dogs from the press bar and passed them around.

As Jeff Dexter kept the crowd entertained from his turntables, Fiery Creations' official photographer captured an iconic shot of John and Yoko munching on Ringo's treats, sheltering under blankets as the temperature dipped. Sara Dylan, heavily pregnant, was filming her own record of the occasion on Bob's 8mm cine camera. He was still in his black jacket, surveying the scene behind his shades as he checked his watch. It would soon be time to prepare for his set and get changed.

At about the same time, as The Band prepared to appear, countless others decided it was time to get ready and take a prized seat in the VIP/Press area for the forthcoming main attraction. As indicated earlier, this rush for a privileged view was to cause chaos.

A few pass holders had left the area – a section protected only by a low picket fence – after Richie Havens' set, but they were immediately replaced as the mad scramble ensued for the very best vantage point. The incomers were made up of other performers, VIP celebrities, official guests, Fiery Creations' team, Dylan's management staff and accredited press, plus many more non-accredited gatecrashers. The fenced-off area had a capacity for some 400 people in ten rows of 40 chairs. Passes had been issued 'To anyone who seemed entitled', according to Ray Foulk, who confessed their organisation was 'Lamentable'.

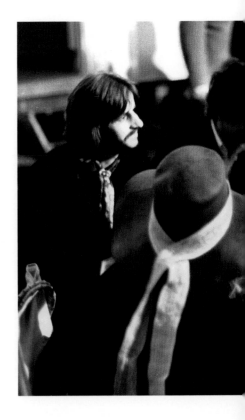

The crush became serious and *Disc* reporter Bob Farmer over-egged it by claiming 'they sardined 2,000 of us into the press pen, 1,500 of whom looked like unauthorised gatecrashers.' A swift crisis meeting, involving Ray and Ronnie Foulk, Rikki Farr and Peter Harrigan, ended with the sensible decision to clear the VIP/Press area and then re-issue fresh passes, thus flushing out the gatecrashers.

Justin Hayward & co. may have closed Saturday's entertainment, but he was back next day for the main event. He could see the funny side of the VIP melee when speaking to the *BBC*'s *Return to Rock Island* some three decades after the events of 1969.

'There was a roped-off area at the front,' Justin recalled, 'with the lah-de-dahs of the rock industry like the Stones – or whoever was hip that particular week. And none of the rest of the people who had actually played at this concert could get in. We all wanted to see The Band – I wanted to see Bob Dylan and The Band – and we got: "Oh, you can't come in 'ere mate, you'll have to go round the back," and all that.'

'So I took one sort of run and hurled myself into all of these rock aristocracy people and "Hey – there's Bob Dylan". And I got chucked out again!'

It all created quite a delay but this masked another problem lurking behind the blue velvet stage curtains. The stage crew were having technical problems but whether it was the amps or mic wiring, no-one was sure at first. What was certain, with problems either side of the curtains, was that The Band's 8.30pm slot came and went. And went by some distance.

Dylan, in his trailer with Sara, was apparently not amused by the delay in getting The Band punctually on stage. Now in his stage garb of crisp white suit and bright yellow shirt, he took out his frustration about the delay and the lack of a WC in his quarters on his bag man, Al Aronowitz.

'Go find out why The Band ain't on stage yet,' Dylan urged Aronowitz, 'Go ahead out there and find out!' And so he did, but Aronowitz could learn nothing more than it was a problem with the sound system. Dylan, stone-faced, was far from impressed as his first major appearance for more than three years was on the line.

Aronowitz shunted between Dylan and chief roadie Jonathan Taplin, but little was forthcoming. Eventually Dylan was caught short

by another problem. He by now needed a pee but his caravan did not boast its own lavatory. He did not fancy a walk through the masses to the nearest toilet and so, on the advice of Aronowitz, he did what any desperate man would do at such a time. He peed out of the window of his trailer.

Nine o'clock soon rushed towards ten o'clock. 'I want The Band to go on NOW! RIGHT NOW,' Dylan curtly told Al. Meanwhile Ray Foulk pondered on the diminishing chances of any jam session at the end of Dylan's set. He was not contracted to do so – the contract was for an hour's show – but Dylan had not discouraged the pre-show hype and nor did the promoters. But time was now of the essence.

The hype about a supergroup jam had curried interest. *Melody Maker* had it from the Foulks that John and Yoko were invited to the festival even before Dylan was confirmed and it prompted the headline: 'John and Yoko Invited to Dylan Concert'. The music weekly trumped that in the week of the festival with a banner proclaiming: 'Dylan, Stones, George Harrison, Blind Faith – Supersession At Isle of Wight'. If you looked again, carefully, a much smaller strapline added: 'If Bob Approves'.

But backstage Dylan was by now seriously agitated, telling Aronowitz, 'Now I'm really getting into a bad mood. This is spoiling everything. This is ruining everything that I came here to do, everything I wanted to accomplish!'

Meanwhile, with chaos directly in front and hidden behind him, Rikki Farr did his best to quell the growing unrest and impatience among the crowd. So what was going on? Why did it take so long? The explanation was simple. Sort of.

After Havens cleared the stage, the roadies not only had to configure the sound system for The Band, initially, and then Dylan, but also share the area with an influx of Pye Mobile Studio technicians ensuring everything was set up to record what was to follow for a possible live album. The complete set up for recording had to be done before The Band came on stage.

It was shortly after 10pm that a big clue was dropped and the audience anticipated action at last. The murmuring began as The Beatles present and their partners took their seats in the now cleared VIP area. Then, at 10.20pm, two hours and 50 minutes after Havens departed,

Rikki Farr announced The Band. They were hotfoot from Woodstock but this was their first British appearance since 1966, their first under this name and as a group in their own right.

Guitarist Robbie Robertson, drummer Levon Helm, bassist Rick Danko, organist Garth Hudson and pianist Richard Manuel took the stage. As the first bars of the urgent 'We Can Talk' drew applause across the arena, the tension and angst was lifted. Dylan had emerged from his trailer and Ray Foulk, who was in the compound backstage, said, 'The expression of relief on Dylan's face was mirrored by the rest of us left in the enclosure. We could all draw breath again.'

The Band had much to overcome: the lateness of the hour, the growing impatience of the crowd for Dylan himself and their own reservations about their brand of rock being suitable for a big outdoor festival. But they responded brilliantly, the funky sound of their *Music from Big Pink* jam sessions back home was the order of the evening. Drummer Levon Helm's fine lead vocal on the first song was complemented by backing vocals from Robertson, Danko and Manuel as the class of the band immediately shone through.

The country ballad 'Long Black Veil' with Robertson on lead vocal was followed by the guitarist's own 'To Kingdom Come' before he told the crowd they were heading into country rock with Leadbelly's version of 'Ain't No More Cane' and Dylan's own humorous 'Don't Ya Tell Henry'.

Another Robertson song, 'Chest Fever' from *Big Pink*, came next with Hudson to the fore on organ. This was one of the band's favourites and they had opened with it at Woodstock.

'I Shall Be Released', written by Dylan during the *Big Pink* sessions, helped underline the crowd's fretful anticipation for the main man. The Band's superb delivery only served to whet the appetite still further. Their own song 'The Weight' was next, recently covered in the hit movie *Easy Rider*, showing The Band more than capable of surfing the now palpable clamour for the troubadour himself.

There was still time – just – for a rousing run through of Stevie Wonder's 'Loving You Is Sweeter Than Ever', but after that it was time to withdraw to the back of the stage. No encore. Just a brilliant display of craft and virtuosity with six of their nine songs taken from the *Big Pink* album and eight of them from the Woodstock set. They were a well-oiled machine and quite brilliant.

The Guardian critic Geoffrey Cannon said, 'The voice of The Band, dexterously intimate, became an amplified version of old stories told round a fire... like Paxton and Havens before them, they created a marvellous setting for Dylan.'

The delays front and backstage coupled with the clever choice of complementary Sunday acts meant the clamour for Dylan was now tangible. It was not merely that the voice of his generation, the troubadour himself was about to play that piqued such interest. It was the hunger of his fans to see what kind of Bob Dylan was about to play.

Despite his extended break from concert performing, he had recorded freely in the years since his motorbike crash and the albums *John Wesley Harding* and *Nashville Skyline*, in particular, had presented a very different sound to the ultra-nasal folk protester of old. As the Dylan disciples in the 150,000-plus crowd nudged and jostled themselves and craned necks for the best vantage points, what kind of Dylan would they see? What, indeed, would they hear?

Chauffeur Chris Colley was standing backstage. He later revealed just how much it meant to the main man in the moments before he walked on stage:

'He was walking up and down there, with Sara hanging on to him, strumming his guitar in a manic and tuneless fashion. He seemed really anxious and Sara was comforting him. "Bob, it's gonna be alright. They want to hear you. Really, you're gonna be great." Sara had her arm around him. It was really shocking, as he was such a big star.'

Ray Foulk's brother, Ronnie, joined him in the wings at this point. Ray confirms both were 'As excited as any other fan,' but of course, the pregnant wait had seemed much longer for them. It was what they had toiled over many months for; what they had staked so much on; the trials and tribulations had all led to this...

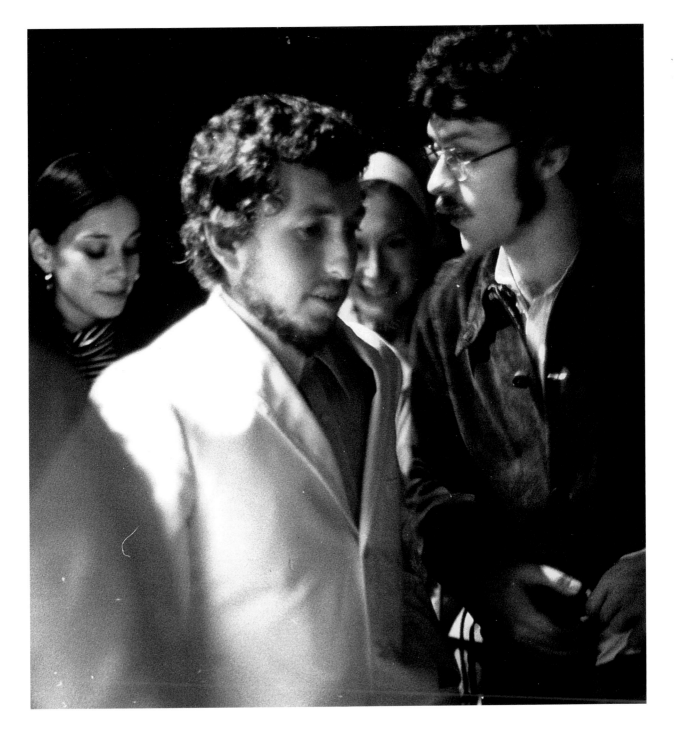

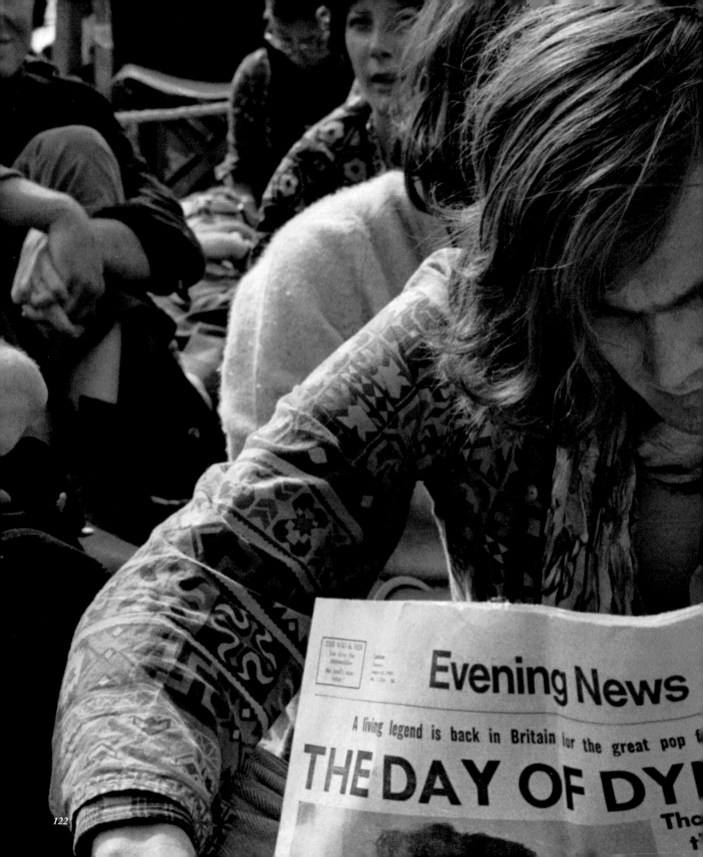

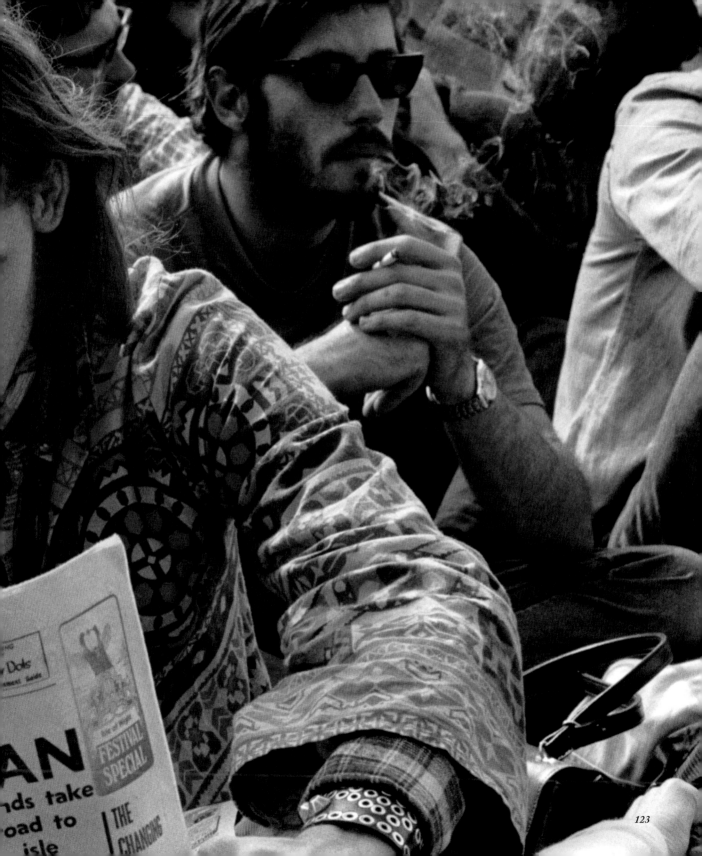

I was there!

Julie Felix

My manager at the time, Joe Lustig, told me about the Isle of Wight Festival and I wanted to do it straight away. When I realised Bob Dylan was doing it, there was no way I was going to miss it. But I nearly did miss it, because I was booked to do a BBC documentary about areas overseas that used the pound sterling, such as Gibraltar, Cyprus and Malta, I think it was.

This made the timing really dodgy as I had to be off on a plane early next day to do the filming but there was no way I was going to miss playing on the Island and seeing Dylan — it's obvious to anyone who knows me that I've always been a Dylan fan. I told Joe, 'You've got to make this happen'.

So, I remember boarding the ferry to the Island and getting to the festival site. It was magical. I recall it was my time to go on stage and I went on just before Richie Havens so it was quite late in the afternoon, perhaps heading towards dusk, but I could look out and see people as far as the eye could see.

Much nearer the front, I could see Ringo Starr and John Lennon in the audience. It was an other-worldly feeling.

It was an amazing thing seeing all those people. It was mind blowing. I remember people shouting out requests for my songs. Some kept asking for 'Going to the Zoo'. I really did not want to do it, but I did — I just did not like to refuse. Someone wanted to borrow my guitar and I absolutely refused!

Performing at dusk was overwhelming, a special kind of energy. I don't think I could feel my feet beneath me. I sang my songs, did my bit and then I was determined to see Dylan.

Richie Havens was just lovely and went down a storm. And then The Band was on and I was backstage. People were waiting for Bob to play and The Band seemed to go on forever. So, I was there and Bob Dylan had come out of his caravan and we started talking, just me and Bob. We were sat on the grass and we talked, just the two of us — I can't remember about what,

exactly... maybe his family and things like that. We talked for ages. He said he was worried that The Band were going on for a long time. He was nervous and wanted to play — it had been years since he last did a concert.

Later, it was time for him to get on stage and his manager, Bert Block, and his wife, Barbara, took me on to the side of the stage with them to watch. I loved Bob's performance; I was impressed and particularly remember 'Wild Mountain Thyme', with its roots in British and Irish folk music. He sang it beautifully and I also recall that night The Band was so tight behind him.

It wasn't the only time I met Dylan, but it was a special time. I'd met him years earlier at a couple of parties, once in Knightsbridge after he played the Royal Albert Hall. He told me he'd heard about me and spoke in a strange, rhythmic meter. He also said he'd send me some of his songs for me to record which was sweet of him — he never did, of course.

I'm an Anglophile even though I was born in Santa Barbara and grew up in California and I'm half Mexican. That August, 1969, when I played the Island, I was just moving into my home, a cottage built in 1838, in Heronsgate, Hertfordshire, and I've been there ever since.

I'd been looking for a house and I knew Donovan had moved into a new home and I asked him where he'd found it: he said Harrods, so I went to Harrods and found myself a house! I consider myself European and both my daughter and grandchildren have been born here.

'So, I remember boarding the ferry to the Island and getting to the festival site. It was magical.'

I still love performing. I'm 80, but I'll do 20 to 25 gigs a year and I love performing more than ever. I find, these days, there is something magical between an artist and the audience. It's nothing to do with fame or money or recognition but the communion between the artist and audience. I treat that with much more respect these days.

Being with Bob Dylan and playing the Isle of Wight in 1969 plus an anti-war concert at Western Springs, New Zealand, in 1971, were the highlights of my live performing career — those and my first appearance at the Royal Albert Hall.

The Island in 1969 gave me my first festival experience... and what an experience it was.

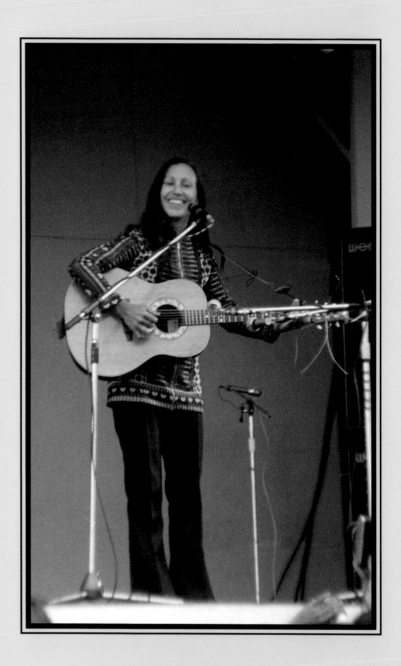

'I want to feel exalted!'
Bob takes the stage

In the midst of those fretful conversations in his caravan, before he finally ventured outside and then into the wings, Dylan had an illuminating exchange with his trusted aide Al Aronowitz. The New York journalist challenged his friend about the motivation for taking this gig. 'Why did you come to the Isle of Wight? What is it you want to do here? What do you want to get out of it? Why do you want to go out there in front of this crowd?'

Dylan flashed a surprised look. Did his friend not realise? 'I want to feel exalted!' he said.

And there it is, in a nutshell, why he was now heading for the open stage where an adoring crowd would pay homage; not the interlopers in Bethel Woods who had demanded he perform in his own backyard, that had trespassed on his private space and even copulated on his bed. Here he was, on the Island, on his own terms. He was impatient but he was ready.

He strode the last few yards up the ramp where Rikki Farr's man, Michael Baxter, was posted to guard the backstage entrance. Dylan saw him and remarked, 'Hey, look, I've got George's guitar!' indicating the acoustic Gibson J200, a classic sunburst model with flowery scratchplate, purloined from Harrison at Forelands.

All at once, he appeared before the expectant throng, a brilliant vision in that white suit, reflecting the searing stage lights and a multitude of flashbulbs. As ever, Dylan was economic with his welcome script as he reached the microphones and gazed out at the largest live audience of his career to date:

'You sure look big out there,' he smiled. As the flashlights popped, and with The Band settled behind him, he launched into 'She Belongs to Me', from the 1965 album *Bringing it All Back Home*, the album that first saw Dylan move away from an acoustic folk sound.

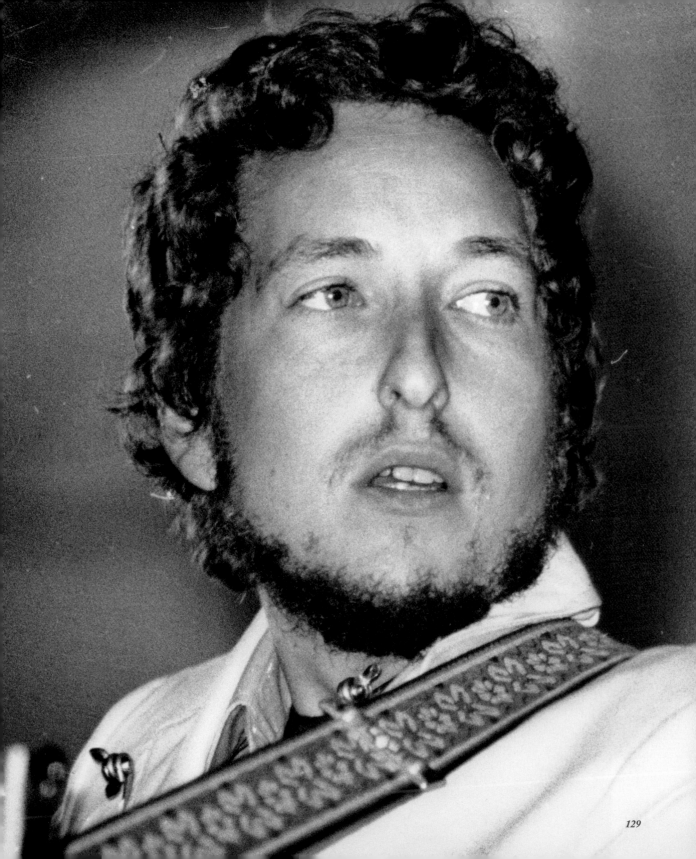

It has been suggested the song is about Joan Baez, among others, or even Sara, the woman he married just a few months after he wrote the song.

The initial audible gasps from the audience gave way to cheers, whistles and spontaneous applause. They were greeting a very different Dylan, both in looks and sound. He was refined; the 'Chiselling whine of the dentist's drill' voice, smartly observed by Ray Foulk, had gone. Determined never to copy himself, Dylan now presented a rich baritone.

The set duly unfolded, and it's been suggested the songs formed a mixture of rebukes from Dylan interspersed with love songs and ballads; bitter medicine followed by spoonfuls of sugar. The new delivery style was appreciated by many, but loathed by others weaned on his earlier rebellious style. Three of the 17 songs he would perform had not been released on record and the remaining 14 were culled from all but the first two of his nine studio albums.

'I Threw It All Away' was from his new album *Nashville Skyline* and it was preceded by a few more precious words from Dylan, 'Thank you very much. Great to be here... sure is.' The love song was lifted by The Band's guitars and Lowery organ.

It was followed by 'Maggie's Farm', a striking, robust rocking interpretation that contrasted markedly from Richie Havens' version just a few short hours earlier. The conviction of the original track on 'Bringing It All Back Home' was clearly still intact but the arrangement was markedly different, challenging his post-65-66 rock fans as he signposted his move towards country and religious influences.

Three songs in and The Band melted away as Dylan introduced his harmonica for 'Wild Mountain Thyme' – a Francis McPeake cover – just the man himself in the spotlight and the only cover in his set. Belfast musician McPeake reworked the traditional composition in the 1950s and it represented a nod by Dylan to his music's British influences. The watching Julie Felix, who had been on the same stage earlier in the day, loved every moment.

'Was It Ain't Me, Babe', his next acoustic song, a 1964 parody of The Beatles' 'She Loves You?' The former's 'No, no, no, it ain't me babe', a response to Lennon and McCartney's 'Yeah, yeah, yeah'? Whichever woman Dylan's song may be aimed at, it is also seen as a firm message to his fans... a refusal to be labelled the leader of a move-

ment or the figurehead or saviour of a generation. The acerbic, cutting approach of the original recording was replaced here with a more sombre, flat delivery – but he still rifled the message home.

Dylan remained alone for 'To Ramona', from *Another Side of Bob Dylan*. It has been suggested this may be Dylan writing to Joan Baez's mother as if from Joan herself, pondering on Bob's attitude to his female mentor. His delivery of this song on the Woodside Bay stage was as close to the original's vocal treatment as anything else in his set, a fine vibrato boosted from his chest as opposed to his nasal passages.

From *Bringing It All Back Home*, the classic 'Mr Tambourine Man' was the last of the mid-set solo acoustic offerings. Here Dylan reached for the harmonica, although many fans felt it was used too sparingly. His first drug song? Dylan is apparently annoyed at the suggestion, with the search for an inspirational muse his more likely intention.

It was truncated to just two of the four verses but the trip was taken upon the magic swirlin' ship. Missing was the 'Smoke rings of my mind' and 'To dance beneath the diamond sky'... was that because John Lennon was almost within touching distance in front of him? Lennon had taken the diamond sky image and used it on 'Lucy in the Sky with Diamonds'.

He may have subbed down 'Tambourine Man' the text but, delivered at a slower pace, he still filled three minutes and the huge assembly erupted in delight to acclaim the first truly iconic Dylan song of the set. The ovation was like a beckoning call for The Band and they duly returned to amplify the sound.

The clock was turned forward three years now to another Dylan era and the *John Wesley Harding* album of 1967. 'I Dreamed I Saw St Augustine' was now showcased for the first time live, anywhere. Here was the real evidence of the shift Dylan had made while in his post-accident Woodstock seclusion. The song demonstrated his push away from the earlier, edgy content and style. Now the sound was more country-rock, more melodious and the lyrics less strident with theological overtones – witness 'St Augustine'.

This turned out to be a very rare live performance of the song. Dylan's pulsating vocal delivery and The Band's methodical accompaniment ensured it was a rarer gem still. Was its message also Dylan rejecting any notion of himself as Messiah?

The UK singles charts during the week of the Island festival featured Dylan's 'Lay Lady Lay', taken from *Nashville Skyline*, and it would rise to a peak of No. 5 just two weeks after the event. In the States' billboard chart, it was at No. 9 that weekend, rising to No. 7. It would eventually become his greatest hit single of all.

It was widely known that Dylan's set list was often flexible and could change close to showtime. After 'St Augustine', there were repeated shouts for the hit to be played but whether it's inclusion at this juncture was a response, or coincidental, is anyone's guess. To some Dylan aficionados, 'Lay Lady Lay' – very fine love ballad though it was – may have seemed more like straight pop from the maestro.

He had written it for the score of the film *Midnight Cowboy* but missed the movie deadline and Dylan apparently simply wanted to ditch it. Thanks largely to the persuasive urgings of CBS chief Clive Davis, Dylan relented to its release as a single. Delivered here with more verve than the rather lugubrious recording, it was massively well received.

Next, a switch back to *Highway 61 Revisited*, the album recorded in the summer of 1965, which saw Dylan with a full electric band of backing musicians. He chose the title track to offer next. 'Not just a rock classic', reckoned Ray Foulk, 'but one of the songs that served to invent the genre. This was not rock'n'roll. It was not folk – nor was it pop or R&B'.

Dylan conjured up major figures – God, Abraham and Isaac – and plonked them down on a highway route he knew from his home state, Minnesota, and he did so here with much of the plugged-in verve that accompanied its first release. Here was dramatic poetry posted against a juke-box jive.

The rewinding of the clock continued next... all the way to his third album, *The Times They Are A-Changin'* with 'One Too Many Mornings.' At source, it was firmly in the early Dylan mould of solo, measured vocals backed by six-string and harmonica. Not this time, not with The Band's peppy country treatment, illuminated with Hudson's organ and fleshed with choppy guitars.

This song marked the breakdown of Dylan's relationship with girlfriend Suze Rotolo. The passage of time clearly helped him at Woodside to apply a more cheery, upbeat veneer. It remains one of Dylan's concert favourites to this day.

He swung from back to forth and the *John Wesley Harding* album for 'I Pity The Poor Immigrant' from late 1967. This was another live debut for a song with a number of lines lifted, close to verbatim, from *Leviticus and Deuteronomy*. At the time, Dylan's mother revealed he was regularly consulting a bible, left open on a stand in the study of his Woodstock home.

What followed next is arguably – and there will be arguments – Dylan's finest song. 'Like A Rolling Stone' from *Highway 61 Revisited*. Whether it's your favourite or not, *Rolling Stone* magazine placed it No. 1 in its 500 Greatest Songs of All Time. Its from-the-hip lyrics were distilled from a long draft of verse he first wrote after an earlier UK tour. He ended up with four verses and a chorus of pure gold – or 'Stream of vomit', as Dylan once described it.

But on this special night the earlier bile and venom, said to have been originally intended for Andy Warhol and his coterie, was replaced with a gentler, wafting approach. It went down brilliantly on the night and was hailed in the immediate notices in the music press, although Dylan followers have been picking over this concert version, rarely too kindly, ever since.

Dylan biographer Howard Sounes regarded the geared-down approach 'The antithesis of the screaming brilliance of his last British performance.' The song had lost its anger, according to Dylan enthusiast Chris Hockenhull.

A line was transposed here and there and the third verse left out. Canadian poet and critic Stephen Scobie said of the performance, 'Dylan is relying on his audience's familiarity with the song. Hey, he's saying, it's no big deal; it's just a song, not a way of life. We can have fun with it too.' Dylan's practice of making a virtue out of altering his own songs' content, style and delivery could be said to have begun on the Isle of Wight.

His next song was extended, not truncated, and could well have been directed at Sara, his pregnant wife. 'I'll Be Your Baby Tonight' debuted at Woodside Bay and has four verses but Dylan, creating a rich country feel with The Band, repeats the final two verses, punctuating the reprise with a fine Robertson guitar break.

A bootleg release of Dylan's *Basement Tapes* had appeared only a month earlier and included Quinn the Eskimo (The Mighty Quinn) although Dylan was not to officially release this song for another year.

It was already well-known, of course, because Manfred Mann had picked it up and had a huge hit with it both in the UK and the United States.

Dylan and The Band joyfully showcased it here, adding pace and rock to the 1967 recorded version and spicing it with fine guitar from Robertson and Manuel's piano.

The lyrics are, at first glance, simplistic but, hey, this is Dylan. He has dismissed it as 'Some kind of nursery rhyme,' but some have suggested references to the Messiah and a second coming; others see it as being inspired by actor Anthony Quinn's role as an eskimo in the movie *The Savage Innocents*. Only Dylan knows but, whatever his inspiration, he clearly liked what he served up on the night, as the Woodside Bay version was the one he included on the 1970 *Self Portrait* album.

It was very well received by the audience on the night and also by the critics. And when it appeared on vinyl, the acclaim continued. It was one of the highlights of Dylan's night.

And that was it. Come on without? Dylan and The Band left the stage as the disbelieving audience looked on, jaws hitting chests all round. Then the audible reaction as they erupted into cheers and hand clapping, demanding their hero's return. Surely Dylan was not done after 50 minutes?

He was not. The man and his band returned and 'Minstrel Boy' filled the air, the first and only brand new song of the set, apparently worked up specifically for the Island show. A restrained and self-referential ballad, it featured close harmonies with The Band. It, too, was well received and the Pye Mobile recording also appeared on *Self Portrait*. It is thought to be the only time Dylan has performed the song live.

Dylan's second and closing encore was 'Rainy Day Women #12 & 35', astonishingly the ninth concert debut of the night. The song was the opening track from 1966's *Blonde on Blonde* double album, the third of his three-album metamorphosis into rock, following *Bringing It All Back Home* and *Highway 61 Revisited*.

The track is seen by some as an inspiration for the 1967 Summer of Love and here it was, performed for the first time, at the event that arguably book-ended that movement. The word stone or stoned is used 14 times in the song and the chorus line, 'Everybody must get stoned', saw the song banned by radio stations on both sides of the Atlantic.

The audience loved it, Dylan and The Band loved it, the broad grins betraying their emotions as they happily joined together for the chorus. 'Thank you, thank you,' said Dylan – and he was gone.

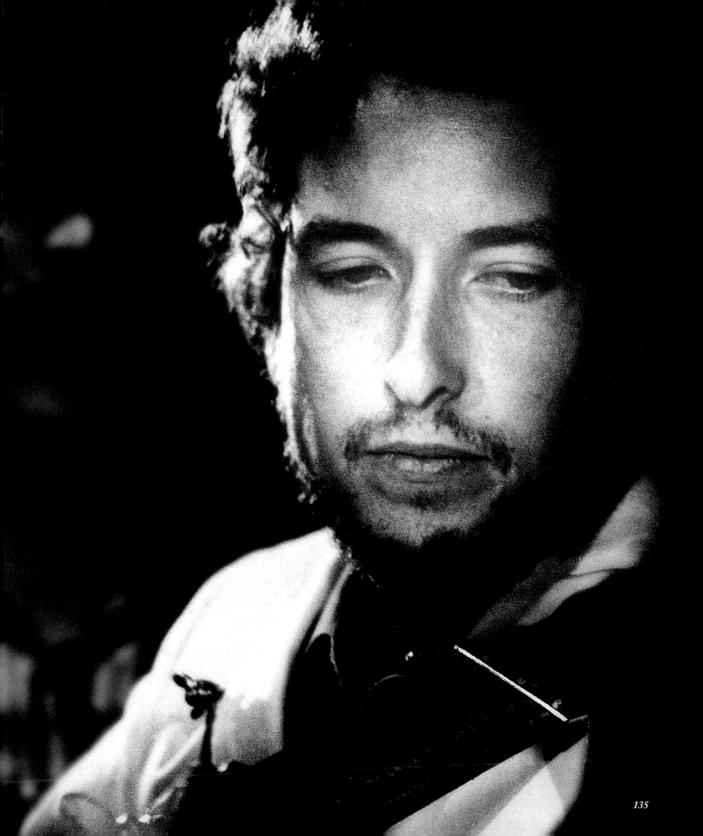

I was there!

Jacqui McShee, lead singer of Pentangle

We had finished our set on the Sunday and were waiting for Bob Dylan to go on. We really wanted to see him. But we were hungry and fancied something to eat but were told at the gate that we couldn't leave and come back so we waited... and waited... and my then husband said, 'Fuck it, sod Bob Dylan' — and we made a dash for Ryde where we had a curry.

When we got back, Bob Dylan still hadn't come on, but at least we weren't hungry. At that point, the 1969 Island festival was the biggest audience we'd ever played to. Of course, we were back to play the Island's 1970 festival and that became the biggest. We had recently been in the States playing there and we'd seen Woodstock on TV and we played a few festivals in that period — 1969, '70 and '71.

Yet I wasn't any more nervous than I would be at a normal gig — in fact I get more nervous at small folk clubs where you are much closer to the audience. I did not need anything to fortify me for our festival appearance — I didn't do drugs — but I did take Dutch courage. A couple of pints, not spirits.

I think I took a pint on stage with me. There were not many women on the scene and I had to take care of myself and have my wits about me, especially if my boys in the band were wasted!

At Woodside Bay, I remember the stage being so high, but the audience was so far away, just a sea of colour and movement. In any case, I tend to sing with my eyes closed or, when they're open, I look to the far distance so perhaps that helped.

There were a couple of distractions. There was helicopter noise that got the crowd agitated and a barn catching fire in a neighbouring field. Ha! Well, it always seemed to be that when I sang an A Capella song - there would always be some extraneous noise that wasn't part of the official proceedings

The audience was very supportive and did wave and shout at the offenders. I just ploughed on as usual!

I'd seen Bob Dylan at the Royal Festival Hall in London a

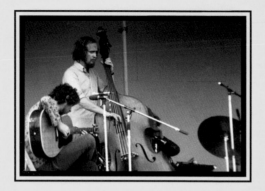

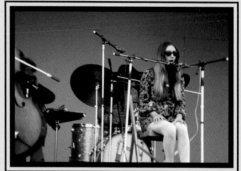

few years before that 1969 gig. I think his nerves at Woodside Bay were nothing new because, at that London gig, he was very nervous. He had a stool next to him with a jug of water and a glass. He knocked them flying on to the floor and he looked so nervous.

And of course, by '69, he'd been through that 'Judas' reaction to playing with The Band and going electric — I guess people don't like change. Even we had that with Pentangle. We were slagged off for playing folk gigs with drums and bass! And when John Renbourn played electric guitar... well! People don't like change.

That Sunday I remember seeing Tom Paxton, it must have been just before our curry dash. He was great and when we got back,

I remember our roadie climbed the scaffolding at the side of the stage to get a better view and I think we were on the same side of the stage for our vantage point... when we weren't in the beer tent! I did not get to speak to Bob there but I always really liked him, especially his early stuff and I really liked The Band. In fact, I probably liked The Band more than Bob!

When we were relaxing off-stage, I remember bassist Danny Thompson holding court over a few drinks. He was loud and a great joke teller and raconteur — he still is. We'd just be in his wake as he held court. And I recall the next year, when we took the ferry across for the 1970 festival, he was hanging off the back of the boat. Happy days.

Rock camp
Did festival camping start on the island?

Camping at contemporary rock festivals today is often a slick, organised affair, so long as the weather remains kind. Years of experience – bitter experience, some may say – has got the 21st Century festival-goer to this point.

Today's precision-planned gatherings are a far cry from the 1969 trail-blazers. Many fans set off for the Island, fully intending to stay for two or three nights but without even a sleeping bag or a tent. They kipped under trucks, beneath makeshift shelters or, if they were lucky, in the dormitory tent the promoters had erected. The idea of organised camping on site, factored in by Fiery Creations, was novel.

So unlike today. For example, in 2018 Rock Fest Barcelona had got to the point of having its camping in a neighbouring city, Montelo. There were shuttle buses taking the campers to the festival site and the camping area itself, largely on a football field, included toilets, showers, facilities for those with reduced mobility, rooms for meetings, and entertainment on tap.

Additional services were on hand: surveillance and fenced areas 24 hours a day; access control 24 hours a day; 24-hour reception and info desk; lost and found area; mobile phone charging points; cleaning service; cloakroom; space for mobile homes, and a parking area.

But the modern festival, whether it is Barcelona, Glastonbury or anywhere else, has to doff its jester's hat in the direction of the 1969 Isle of Wight Festival, for at least helping to get the ball rolling for camping provisions at festivals.

Back then, by the Monday of festival week, over 500 fans were already camping on the site - including students who had built a wooden hut and named the area 'Desolation Row', after the Dylan song. The Festival site had already doubled in size from its planned scale. There was sufficient room to ensure that no-one wishing to go to the Festival need be disappointed.

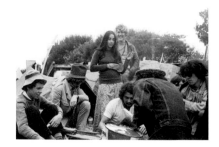

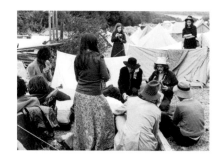

Ray Foulk recalls there were discussions in their planning meets in July and early August over whether to charge for camping. In the end, they decided to make it free – try finding that at a 21st Century festival!

'It's right to say that this was probably one of the first – if not the first - camping festival,' Ray recalled in early 2019. 'Why? Firstly, the idea of a three-day festival was almost unheard of, but also particularly because it was on an island and people would not be able to get home at night. In any event, we didn't charge.

'We had an area known as "The Camping Village" which embraced catering, shops, bars, souvenir shops, camping equipment (blankets etc) and toilets. And, in addition, an amazing giant dormitory marquee. That was supplied by Captain Lewis, of Lewis Marquees, in Hampshire.

'He was most put out at the end because people were sitting on the roof of this marquee, using it as a grandstand to see Bob Dylan, and it was quite badly damaged when the roof caved in. We had to recompense him, but I can't remember how much.'

Lewis, established in the mid-19th Century, had provided the marquees for the 1965 film *Those Magnificent Men in Their Flying Machines* and had a long standing relationship with the British military, supplying tents of all kinds. Lewis also made bell tents for the UK's Girl Guides and Boy Scouts during the last century. Their diversification into these new-fangled rock festivals must have been a culture shock.

Apart from the unhappy Captain Lewis, other marquees were supplied by Grays of Newport – like Lewis Marquees, still in business today – and Essex Distribution. Ray's recollection is there was 'No particular person' in charge of the campsite, although it fell under his range of responsibilities. The Camping Village was designed and planned by his younger brother Bill and construction elements on site were organised by Ron 'Turner' Smith.

Lessons were learned by the Fiery Creations team that would be put in place the following year. 'We did not get the food right, there was not enough food and drink on sale,' Ray admits. 'We got that right for 1970 with a much greater provision for food, and we controlled it, unlike 1969. And although we arranged for toilets on site, we also made big improvements on those for the following year.'

1969 Festival veteran Albie told *BBC Hampshire* website in 2014:

'I was there in 1969, I slept in a sleeping bag my mum made out of an eiderdown, under a hedge at Wootton Bridge. I would sell the Portsmouth Evening News on the beach at Sandown in the morning and return to Wootton in the afternoon for the festival. I started work six weeks later so wasn't able to get the time off to go the following year for Hendrix.

'Whenever I go over to the island and pass through Wootton, I always have a little smile to myself of a great two days for a 17-year-old.'

Simon Dunevein, also at Woodside Bay, said this to *BBC Hampshire*:

'I was there in 1969 – three of us travelled from Glastonbury. I remember sleeping in the (Lewis) marquee that collapsed and queuing next morning to get in.

'We were first in and I was in the front with John Lennon and Françoise Hardy to see Dylan. Saw our picture in *Paris Match* the Aug / Sept '69 copy. I have so many stories.'

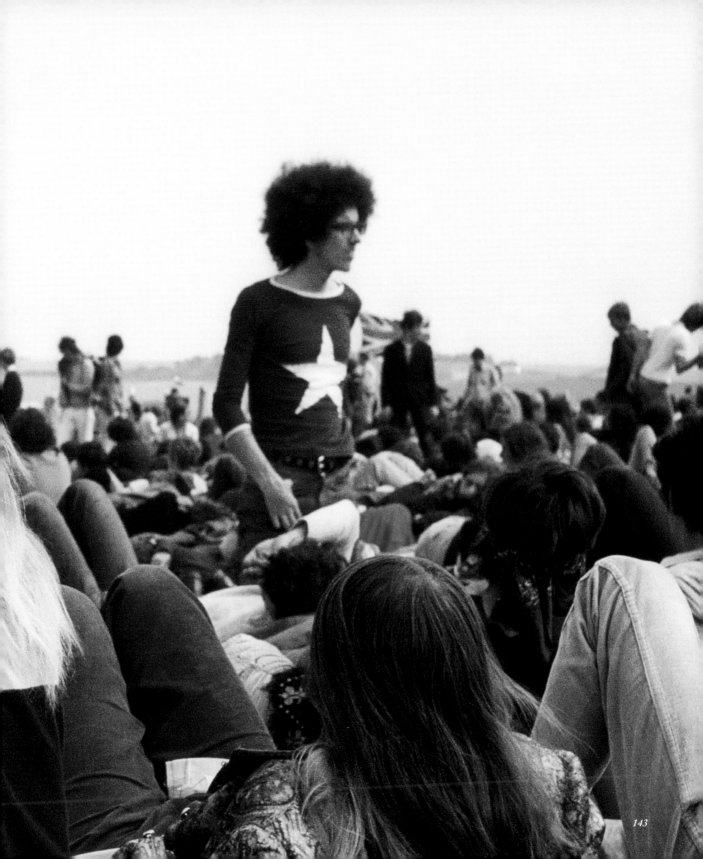

I was there!

Roger Simmonds

I was 18, had just started working in the NHS as a humble clerical officer at Hampshire Executive Council and I was on about £6-10s a week — but when I heard the news through papers like the Melody Maker *and* NME *that there was to be another Isle of Wight Festival in 1969, I had to go. As in 1968, I travelled with my pal John Corkhill from Winchester, having got our tickets from Whitwam's music store in the town.*

As I recall, the initial news of another festival did not mention Bob Dylan at first — and I would have gone anyway, Dylan or not, as I'd enjoyed my first taste of the Island festivals so much the year before.

We knew it was going to be over a couple of days, so we knew this was going to be a much bigger event. For the second year, we repeated our trick of just winging it with our rucksacks and sleeping bags — we didn't want to lug a tent around. I did drive back then but, to be honest, I couldn't afford to take a car over the Solent or even take a tent.

Bob Dylan? To be honest, I wasn't an avid fan... then. Like many people, I liked his songs but preferred other people singing them — such as The Byrds, I loved them. If there was one act I was really keen to see before setting off it was The Moody Blues. They had the On The Threshold of a Dream album out and I really liked that. I also wanted to see the Bonzo Dog Band as I was a big fan of Viv Stanshall.

We went by train from Winchester to Portsmouth Harbour on the Friday morning and got the passenger ferry to Ryde Pier. From there we walked the few miles to the site, but I remember, on the way across, we could hear the music being played on the site, presumably by the DJ, wafting over the Solent. I later heard you could hear the festival itself from the beach at Southsea.

There was a steady stream of people heading for the site. As we headed in, I remember the record that was playing — it seemed appropriate — 'Go Where You Wanna Go' by the Mamas &

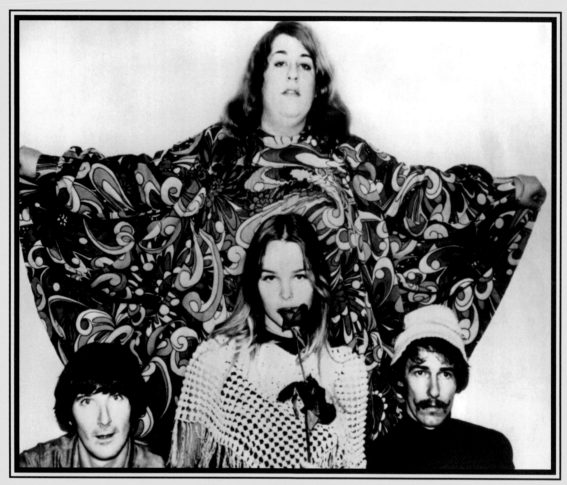

The Mamas & the Papas

the Papas. Inside the site, we got into the big dormitory tent or marquee so we wouldn't have needed a tent anyway.

At that stage, there was a fair crowd on the site, but it was not rammed. We did not have much money so there was no rush to buy food or drinks — people tended to share what they had and pass it round. A tin of baked beans was popular, and a lot of people had little primus stoves. A bit of bacon was a luxury.

That first day I remember The Nice and The Bonzos. Both were really good. I liked Keith Emerson and The Nice more than I later cared for ELP... they fused classical music and rock really well. Saturday was the first full day and it was the day of the rock bands with Sunday — Dylan's day — reserved for more reserved, folk-style acts.

I was not hugely into folk and I enjoyed Saturday. The Moodies, of course, closed it with their set and they were brilliant, just the right atmosphere for a late-night show. They were brilliant live and recreated

their studio sound so well, 'Nights in White Satin' going down particularly well. Like The Who, they played both 1969 and 1970 and I think the Moodies' 1969 set just had the edge on their show the following year.

With The Who, I think it may be the other way around. Although they were great in '69, and I loved it, I think they were even better in 1970. Joe Cocker, too, was in good form on the Saturday; Free too — and I loved Mighty Baby, very impressive — I had not realised that they had previously been the Mod band, The Action.

That great event in 1969 helped sum up the difference between the festivals of the period compared with today's festivals. First of all, even on a 'rock' day like that Saturday, the audience sat down and listened. We focused on the lyrics, what the message was. It was not about entertainment and standing and dancing... it was about the enjoyment and education coming from the stage. Festival-goers then did not need fairground rides with stalls and shops all over the place.

'... it was about the enjoyment and education coming from the stage. Festival-goers then did not need fair-ground rides with stalls and shops all over the place.'

We were not interested in buying souvenirs and gifts. In fact, I did not even buy a programme until years later when I bought one on E-bay — when it cost me a lot more than it would have done that weekend!

I don't think I even bought an alcoholic drink although, at 18, I could have done.

Sunday was more relaxed, more folky as it was Dylan's day. I enjoyed it all the same, I was not really into Tom Paxton and I can't much remember Julie Felix but I do remember the crowd got bigger, much bigger, as all those with one-day tickets for the Sunday descended.

The standout for me was The Band, even more so than Bob himself. They were just great. They had not long released Music From the Big Pink and that was great. Much of what they played that day came from that. There had been a delay before The Band

and Dylan. Much is now made of how he had not played live for three or more years before he came to the Island and then did not play for four years afterwards — but I don't think many in the crowd knew much of the significance of that at the time. We were just glad he'd decided to come to the Island.

He sounded fine and I did not feel short-changed that he had played for just an hour. That was fine by me — in fact, I'd have been delighted if The Band had played a little longer.

Next day, when it was all over, the walk back to the ferry seemed a walk too far, so Dave and I queued like so many others for a bus. All in all, it was absolutely great — a legendary event that has become a big part of my life. It cost me all of £2-10s, more than a third of my wages at the time. And well worth every single penny.

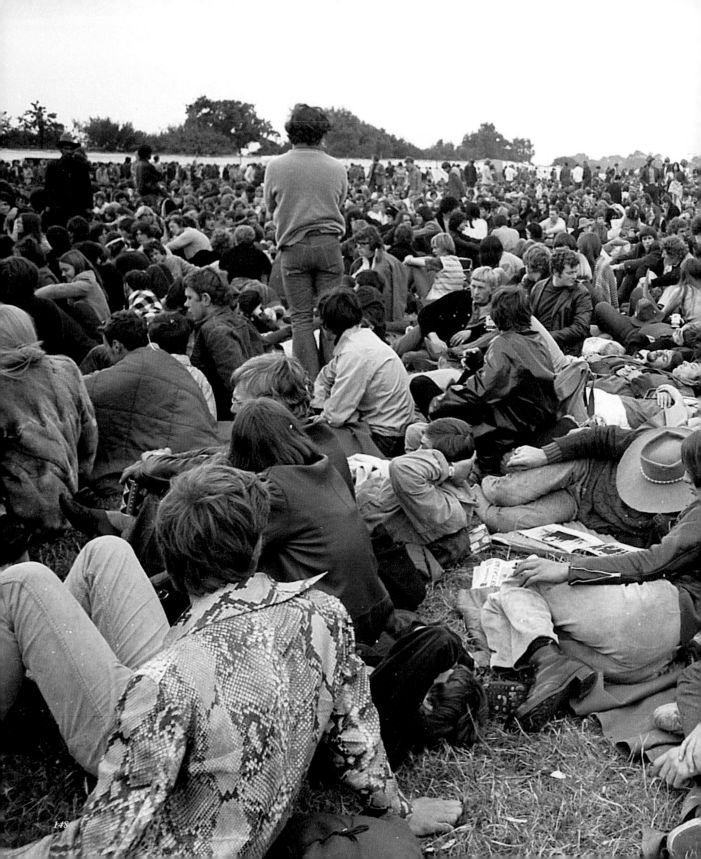

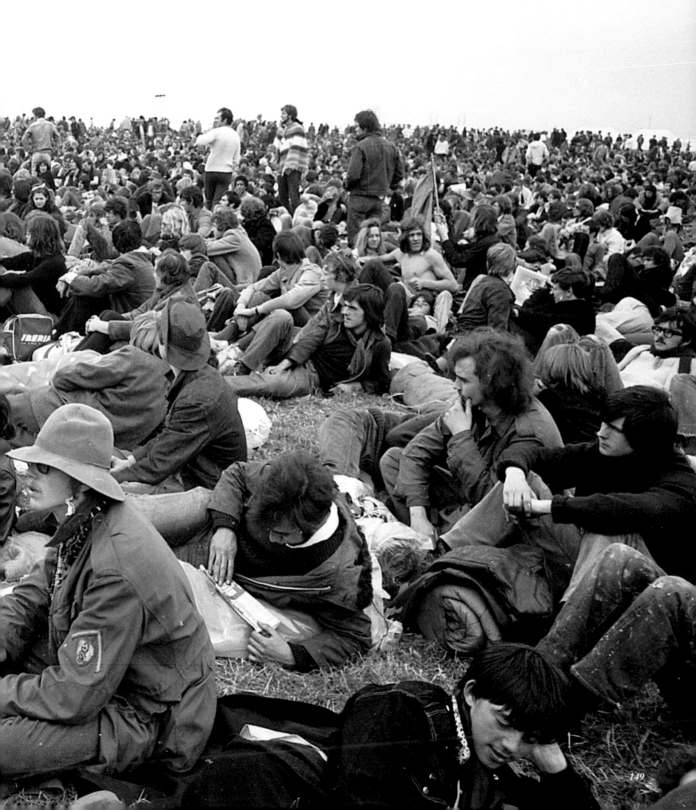

Critical reaction
The effect on Dylan & co.

Bob Dylan left the 150,000 Woodside Bay crowd wanting more, much more, having played for just a few seconds more than the hour he was contracted to perform. His 17-song set, including two encores, was rapturously received and there could be little doubt that, after a live performance hiatus of more than three years following his motorcycle accident, Dylan was back.

He even suggested as he was leaving Heathrow 48 hours later, that he was not only fully restored to live performing but he intended to return to the UK the following year. He was happy with his work. 'It was great. Wasn't it great?' he said in reply to questions about his performance. And was he coming back? 'Yes, next year.'

That confident, perhaps even bullish reaction to his Island festival performance apparently evaporated in the time it took him to cross the Atlantic. There had been a mixed press and media reaction to his performance, mostly good but the odd very bad apple.

Ray Foulk points to a 'complete fabrication' by the soon-to-be-extinct *Daily Sketch* tabloid for souring the star's initial positive reaction. The Sketch splashed with a 'Dylan Cuts It Short After Midnight Flop' banner headline on the front page, darkening Dylan's mood. Far from returning soon to the UK, he told reporters at JFK Airport he did not wish to go back: 'They make too much of singers over there,' he said. 'Singers are front-page news. When the Bee Gees split up it was all over the front page.'

Whatever the reason for Dylan's upbeat reaction immediately after the festival turning into something more seriously downbeat, there was to be no immediate return to live work; there was no return to the Island the following year and the proposed live album, facilitated by the Fiery Creations contract, would not surface in its entirety for many years.

PARIS MATCH

Nº 1062 / 13 SEPTEMBRE 1969 / 2 F

WIGHT: LE CYCLONE HIPPY

Apart from sporadic guest appearances, notably at George Harrison's Concert for Bangladesh in 1971, Dylan would not return again to a full concert performance or tour until 1974. Remarkably, this makes his Isle of Wight bill-topping performance his only full concert appearance in more than seven years… an Island oasis in a barren era of live work.

So what relevance does Dylan's Island performance have when assessing the great man's career in the round? It's a career, 1966-74 apart, that has been pretty rich both in recording output AND live touring and that carries on to the present day.

Dylan aficionado Dr Brian Hinton MBE, who has written two Dylan discography volumes as well as an illustrated history of the original Island festivals, has no doubt about the importance of Dylan's Woodside Bay performance.

'Apart from a few songs at a Woody Guthrie tribute, the only proper concert appearance he made after his 1966 motorcycle accident, for more than seven years up to his 1974 tour, was at the Isle of Wight,' he says. And Brian says this live withdrawal, other than his Island performance, followed the seismic shift he had effected with his fusion of styles and influences.

'Towards the end of 1966, after his major tour, Dylan invented rock,' he argues. 'Nothing was the same after the *Blonde on Blonde* album. He brought poetry to rock but that is why people booed him during that tour. The disquiet started at the Newport Folk Festival the previous year – that was when Peter Seeger threatened to cut his cables, such was the sense of outrage and betrayal. 1966 was the culmination of that with the infamous shouts of "Judas" when he switched to an electric performance.

'So it was a major shift and, at this point, his manager Albert Grossman booked Dylan on a world tour that would have killed him, some 200 gigs. Dylan refused and he asked for space. He actually moved to upstate New York where Grossman had a house and he found peace and quiet while still just one hour's drive from New York City.

'Bob had married Sara, who already had a child of her own, and they started their own family. But it was then he had that motorcycle accident - still shrouded in mystery, whether he is run off the road or has a collision with a truck? We don't really know how serious it was, whether life-threatening or a tumble. Whatever it was, Dylan then withdrew from the world.'

In relative seclusion, however, Dylan was hugely active after manager Grossman installed The Band – still known as The Hawks – plus drummer Levon Helm, to a house at Woodstock known as The Big Pink because of its pastel exterior. There Dylan bonds with them and they start to jam.

Dylan rediscovers *The Anthology of American Folk Music*, by Harry Smith, a comprehensive trawl through American roots music - and delves into what they call Old, Weird America. This morphed into country and blues, Brian Hinton believes, before Dylan started developing his own songs.

'Acetates were made and deliberately leaked out,' he says. 'Some found their way to England and Ashley Hutchings, of Fairport Convention, heard them. So the sound of *The Basement Tapes* came out, almost by osmosis, through cover versions including Fairport's 'Million Dollar Bash' cover, Manfred Mann's 'Mighty Quinn', Julie Driscoll's 'This Wheel's on Fire' and 'I Shall be Released' by The Tremeloes.'

Eventually a Dylan bootleg came out and the world heard just what *The Basement Tapes* were all about from this period of seclusion. Then Dylan took himself off to Nashville, without The Band, recruited some sidemen with a bunch of new songs and an official new album, *John Wesley Harding*, is released in late 1967, an apocalyptic album with stripped back sound, largely just bass and drums backing Dylan.

So now there were two different bodies of work, yet *The Bootleg Tapes* were never played outside the basement and *JWH* was never played outside the studio until Dylan and The Band came to the Island.

'That is why the Island performance is so crucial,' says Brian. 'Yet even before that happens, there is another official album release, *Nashville Skyline*, in April 1969, featuring much fuller backing and even a duet with Johnny Cash on 'Girl From North Country'. Those of us who were not actually there at Woodside Bay in 1969 probably discounted Dylan's performance. But those who were there thought it was wonderful, and the subsequent live releases have reinforced that.

'By this time, the summer of 69, Dylan looks very much the family man and comes to the Island and takes the venom out of his earlier material. He's making it family orientated and when he is playing with The Band it is like *The Basement Tapes* on an open stage.

By then The Band had brought out their own album, *Music From The Big Pink*, which was so influential.

'Quite simply, Dylan's Island festival performance is magical, and the wonder is it is not more accessible in terms of availability. You have to buy an expensive box set, 2013's *Another Self Portrait* (1969-1971) to get that full Island performance on record.

'And after the festival, although the planned live album did not initially emerge, he can't have been too unhappy because four of the magnificent performances from the Island find their way on to his 1970 *Self Portrait* album, the first time he put his own name to anything from *The Basement Tapes*.

'The original releases of the Island performances got mixed reviews when heard on *Self Portrait* but when the full performance was eventually released on 2013's box-set, everyone changed their minds. It showed his Island performance in its true light and really reflected the full force of The Band and, indeed, Dylan's playfulness.

'Why did he disappear from live work after 1966 - Isle of Wight apart - for so long? I think it was his way or relaxing and writing songs to be published. He was fully aware and in control of how they were leaked out and released by other artists. He loved the Manfred Mann cover.'

Derek Barker, owner-editor of *Bob Dylan Isis* magazine, is a Dylan fan and a respected authority. He believes the returning star 'played it safe' on his return to live performing at Woodside Bay.

'Dylan's performance at Woodside Bay is a good performance, but nondescript,' he says 'He's done the minimum and played it safe. You can tell this by the length of the set, and indeed the length of the songs. His longer songs were sidelined and you have to remember he had not performed live for some time.

'Dylan is a performer who often takes incredible risks playing live, but not here. Long songs like 'Desolation Row' are out and conspicuous by their absence.

'But this is Dylan, out of circulation for so long, playing the Isle of Wight. Ray Foulk and his brothers caught Bob at just the right time. He was looking for an opportunity to make his comeback and it was perfect timing coming, as it did, when he was thoroughly pissed off with the whole Woodstock thing.

'He wanted to get away from the snoopers and interlopers intruding on his home at Woodstock and that assumption he was going to play there just because Michael Lang and the promoters had brought that festival close to his own backyard – well, some 50 miles away – and called it Woodstock.

'So, to be offered a festival on an island in the middle of the English Channel and a holiday – initially including a crossing on the new QE2 – was just fine with Dylan.

'I think he thought the night had gone pretty well and he began to think more seriously about playing again. It was pivotal in getting him back into live performances. It was another long wait, after the Island, before he toured again but he had other commitments and he had to find a way of touring again on his own terms. What the Island festival showed him was that he could return, he could cut it.'

There were distractions for Dylan, when he returned from the Island to the States. He moved out of Woodstock and back to New York's Greenwich Village, only to find it a very different place to the one he had left a few years earlier. He considered going to Israel to live and work in the Kibbutz; had family time in Arizona and made the Pat Garrett and *Billy the Kid* movie. Eventually, he would return to touring again in 1974.

Derek reckons Dylan left the Woodside Bay stage in good spirits. 'Dylan was happy with his performance straight after the show,' he says. 'There had been no major hitches and he seemed to breathe a sigh of relief, before the press reaction got to him. It hit him hard. There were blatant lies about why he was late on stage; rubbish about him refusing to go on… there was even talk in Parliament about forbidding him to return because of the amount of money that had been paid to him. He must have thought, "why do I bother?"'

The switchback in Dylan's own view about his performance is perhaps reflected in the drip-feed of live recordings being made available rather than the planned release of a live album

'I don't know if the live album delay was down to him or the record company,' says Derek. 'With all the restoration that is possible now, the eventual release of the full live album in 2013 is impressive, beautifully recorded. Was he being told how good it was back in 1969?

'The four tracks released a year later, in 1970, on *Self Portrait*, do not sound anywhere near as good as the full release four decades later. But not too much store should be set by the fact that the 69 festival was recorded but not immediately released, because Bob records an awful lot his live shows.

'In fact, although the recording was facilitated in the contract, the decision to actually do it was more spur of the moment. In mid-August, shortly before he was due to leave for England, Dylan had a chance meeting with well-known sound engineer Elliott Mazer at the Carnegie Deli, a New York restaurant on 7th Avenue adjacent to Carnegie Hall. Dylan casually asked Mazer if he would record the Island festival. That's how it happened.'

Derek Barker is also at pains to point out that it would be wrong to pin the whole blame on Dylan's late, late show at Woodside Bay on the technical gremlins on stage.

'It is important to understand the cause of the delay because it affected Dylan badly,' he says. 'Backstage, in Dylan's caravan, were just three people – Bob, Sara and his friend, Al Aronowitz. Al told me that Bob was "freaking out" because he was so keen to get on stage. He was keyed up about his performance and waiting for two hours did freak him out.

'Al said the turnaround time for The Band to go should have been 8.30pm. Richie Havens finished his set on schedule at 8pm, so The Band should have been on 30 minutes later. The Band did not get on stage until 10.20 pm – that's 1hr and 50 minutes late.

'Now Ray Foulk has previously said that one of the reasons for Bob getting on stage so late was down to The Band playing "longer than we expected", but that is clearly not so. The Band played only nine of the 11 songs they played at Woodstock, two weeks earlier. Their set lasted just 50 minutes, well under an hour. How long did they expect The Band to play for? To say they were expected to play for a shorter time makes no sense.

'Al Aronowitz says the reason for the delay – at least, on stage – was down to faults with The Band's microphones. Two of them were not working. I spoke to Jon Taplin, The Band's roadie, and he told me they could not go on until they were sorted. There were problems with leads to two of those mics.

'Look at any of the pictures of Dylan and The Band on stage, using the same gear as The Band's own earlier set, and it looks like spaghetti junction. There are mics and wiring everywhere.

'Meanwhile, by Ray's own admission, they were having huge problems with the VIP enclosure ahead of Dylan's set because too many passes had been issued and there was serious overcrowding in there. They had to cancel all the original passes and reissue new ones to all the people who should have had them. That area had to be emptied while the new passes were issued and that took a long time.

'There was suggestion about a problem with the PA but there wasn't. The technical problem was only with The Band's mics. But it was a double problem with The Band's gear and that VIP and press area.

'So, after The Band had eventually played their 50 minutes, Bob finally got on stage to start his set at 11.08pm. Had he been able to get on earlier, he'd have been a lot more relaxed. There may even have been time for that Beatles jam. But, to be honest, I think that short set – bang on an hour – was set in stone. The way any act balances a set, you don't play just three songs with an electric band before going off into an acoustic, solo session if it is got any chance of being a long set.

'The crowd, 100 per cent, were in a forgiving mood for Dylan. There was none of the aggression, shouts of "Judas" or the booing from his previous UK tour; it was worshipping at the feet of the master. They may have wondered who was this short-haired in a white suit – but they were firmly behind Dylan. And it was a highly diverse crowd, from all over the world.

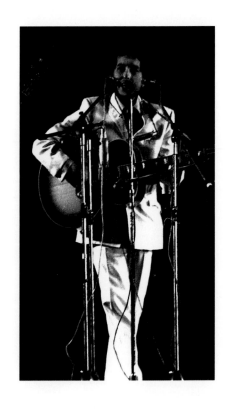

'It was only at the very end, when some could not believe it was over so quickly, that some expressed dissatisfaction. One woman set fire to a poster and threw it in the river.

'At the end of the night Dylan played for an hour and The Band for 50 minutes – one hour 50 minutes in total. And that was the same as the gap between Richie Havens walking off stage and the delay before The Band came on.'

Derek says the interaction between Dylan and the three Beatles at Woodside Bay is revealing. 'All of The Beatles, apart from Paul, came to visit Bob before he played,' he says. 'Bob didn't really know Ringo and they got to meet; George Harrison was obviously a big buddy and he had visited Dylan's home in Woodstock twice before

and he was a huge fan – Dylan liked George a lot.

'Lennon was Lennon and he loved Bob's music but I think John was naïve. For example, he was gobsmacked when he found out Bob Dylan was not the guy's real name, it was Robert Zimmerman. He had trouble relating to Bob as Lennon was very politically motivated while Dylan wasn't at all.

'When they went back to Lennon and Yoko's home in Surrey after leaving the Isle of Wight, the rumour was they did a bit of a session together but very little seems to have happened. I think Bob may have joined in one song and I think Lennon expected more. The mutual respect was absolutely phenomenal but there was this difficulty in John relating to Dylan and the gap got wider.'

Of course, the festival was not all about Dylan and there is no doubt that it was a significant milestone for quite a few other acts on the bill.

The Who followed up their dynamic performance at Woodstock with a barnstorming set at Woodside Bay, two sets that would signpost their elevation to a band regarded as the finest live act in the world.

At the 1969 Isle of Wight Festival, The Who was far more at home and calling the shots, which was in complete contrast to Woodstock where they were shunted into a dead-of-night 5am performance. They gave up their late-night bill-topping slot on the Island to the Moody Blues so they could fly in by helicopter, with great fanfare, to dominate Saturday's proceedings.

Pete Townshend, again sporting an early incarnation of his boiler-suit garb, was in blistering form on his maroon Gibson SG and was clearly delighted with their performance as he noted afterwards: 'What was incredible about the Isle of Wight thing was that The Who were totally and completely in control. Townshend also declared their Woodside Bay performance as 'a great concert'.

This all contrasted markedly with how the band summed up Woodstock. Roger Daltrey dismissed it as 'the worst gig they had ever played' and Townshend said, 'I thought the whole of America had gone mad.'

The Who in 1969 saw the band in full transition from a fine Mod power-pop band, previously geared to single releases, to a fully-fledged album-focused rock act. Their Woodside Bay set undoubtedly played a major part in this, as did their return to the Island the following year.

The Who came to be regarded as one of the most influential rock bands of all time. It was not just the music but their influence on style, too.

Another band on the Island's 1969 roster who were to return, like The Who, in 1970, was Free. Free's set was cut short by The Who's noisy airborne arrival, but they were on their way to stardom in 1969. By 1970, they were known worldwide thanks to 'All Right Now', a worldwide hit and an enduring rock classic.

In David Clayton and Todd K Smith's Heavy Load, Free recalled how their set was curtailed but they were determined to make the best of it. 'We said, "fuck it", dug our heels in and ended up playing for about 25 minutes,' said drummer Simon Kirke. 'It was enough.'

Free hit the stage with The Who's gear directly behind them, precociously talented guitarist Paul Kossoff on the Les Paul gifted to him by an impressed Eric Clapton only weeks earlier after he'd asked 'Koss' to demonstrate his vibrato technique. They erupted into tough, soulful blues rock. In those brief moments they had done what they came to do, everyone went home knowing who Free were.

Bassist Andy Fraser was overawed by the size of the crowd. 'Playing in front of that amount of people was a real drain, he said later. 'Even though there's a lot of energy coming back at you, you have to try and match that. I remember coming off after our set feeling exhausted and not really knowing how well we did.

'The audience was so far away, you couldn't even see the back of the crowd. But we were told the sound they got us through the PA was good and the reaction was great. The press we got was favourable. We just felt thankful.'

Free's best recorded work was still to come in 1970 with their iconic single hit and the album *Fire and Water*, but the Isle of Wight experience coupled with a tough preceding tour to the US helped forge them into a formidable live band.

Lead guitarist Kossoff's losing battle with drugs and differences between the main songwriters - Paul Rodgers and Fraser - led to their final 1973 demise – but Rodgers and Kirke went on to even greater commercial success with Bad Company.

The Moody Blues, like The Who and Free, were to return for the third Isle of Wight Festival of Music the following year, playing a key set as dusk set in on the Sunday – their melodies helping to

restore calm after the event was declared a free festival. This was arguably their most creative period and the band went on to even great commercial success in the UK and the United States before reaching something of a hiatus in 1974 following a period of intense touring and recording.

The Moodies were remarkably influential, both in terms of their musical legacy and their templates for conducting business in the music industry. After multiple solo projects and personnel changes, the band has continued to record and latterly perform in one guise or another to the present day.

I was there!

Loris Valvona

I was 18 in 1968 at the time of the first Island festival, Island born and bred and I was obsessed with music. I was trying to play bass in bands at the time. Just think, in three years or so we went from 'Love Me Do' to the stuff Jefferson Airplane were doing. Lucky for us on the Island, we had a few dance halls and clubs.

I'd listen to everything from The Animals and The Pretty Things to Lulu and Dusty and we had package tours of various bands. I remember I saw Family — not necessarily a household name, then, but everyone was into them. Then we heard rumours of the '68 festival at Godshill and I could not believe Jefferson Airplane, a San Francisco Band, were coming to the Island. So I went — and by 1969 I was ready for more.

By then I was an apprentice at Westlands Hovercraft, and I'd seen bands coming to play at the new Middle Earth Club in Lake. Bands such as The Pretty Things, Ten Years After and The Nice played there.

Free were on there one night but I missed them as I'd tickets to see Fairport Convention in Ryde.

Then the '69 festival — and it was Dylan! You had to look twice because we'd heard he was a recluse, almost in semi-retirement. I thought he was one of the greatest, a giant and although I could not always afford his albums, sometimes I picked them up second hand. I used to buy singles.

Not only was Bob Dylan coming but he was to be backed by The Band. So I had to be there at the '69 festival, had to be.

I've still got my ticket and the festival programme with the controversial advert for Fender amps. I think Bob insisted most of them had to have those ads ripped out as he did not want to endorse them. My own band was gigging on the Friday and Saturday nights, but we loaded up my sports car, an MGA, and set off. Because we were gigging, I went home to Ryde both nights, but we stayed over on the Sunday, fuelled with pints and whisky and Coke.

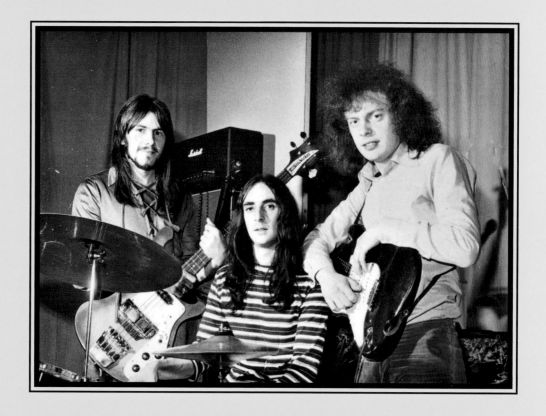

'Not only was Bob Dylan coming but he was to be backed by The Band. So I had to be there at the '69 festival, had to be.'

'...there was a consciousness among all young people, wherever you were from and whatever music you liked.'

On the Friday, I thought Eclection were good. Poli Palmer, later with Family, was with them — and everyone loved the Bonzos. Then we had to leave for our own gig, so I missed The Nice.

We were back for Saturday and I saw Blodwyn Pig — fantastic, I thought — Edgar Broughton Band were not my cup of tea. I remember seeing Family but don't remember Free... Then I made my way down to the front for The Who. I went to the left of the stage so I could be near bassist John Entwistle. I could not believe how good it was. They did the beginning of Tommy and when they played 'Pinball Wizard' the place took off.

Fat Mattress was something and nothing and then we were off for our own gig — missing out on Joe Cocker and the Moody Blues.

On Sunday, I remember the excitement of getting there and the site was absolutely heaving. We were quite near the back of the crowd, but I didn't feel cheated. I was amused by Liverpool Scene; chilled out by The Third Ear Band; sat in the sunshine to Indo Jazz Fusions — a good vibe — and that mirrored the mood... never a hint of trouble from any dickheads. I remember Gary Farr played and I bought his single, while Tom Paxton was brilliant, just brilliant.

Pentangle were brilliant, too... I remember Danny Thompson on bass — his son lives on the Island; Julie Felix was great and all the crowd wanted her to sing 'Going to the Zoo', which she did. And Richie Havens was a complete one-off, so different.

Apart from all the great acts, I remember loads of fantastic records being played between appearances on stage. And 'Amazing Grace', played before the show began at the start of each day.

These days you have to have an acoustic stage, a heavy-rock stage and a main stage or a marquee for this or that. Those days we would all sit down and appreciate Tom Paxton or The Who. It all fitted and there was a consciousness among all young people, wherever you were from and whatever music you liked. It was the same for a few glorious years.

Then came The Band. Everyone was into Songs from The Big Pink and knew their songs. They were on a different level. The delays around The Band and then Dylan coming on prompted a few chants, but no-one got angry or dissatisfied and we had plenty of liquid refreshment although I didn't indulge in drugs. I did try a smoke a few years later, but I'd seen too many people on bad trips and that wasn't for me.

And so to Dylan. Bob came out on stage and what can you say? 'Lay Lady Lay' was in the charts that week, sung in his new voice, and that's what came out on stage. Fans knew it from the single. I read a few negative things about his performance — but why? He had put it out there and we knew what to expect. I certainly enjoyed him, it was great. I particularly remember 'To Ramona' and 'Mr Tambourine Man'.

Over the years I've played a lot of Dylan songs and you can strum them acoustically or do a jazz version and they always work. He was just wonderful that night. He is up there with the very greatest of all time — Elvis, The Beatles... and Dylan.

We were a little disappointed, I guess, that it went by so quickly, but I always think: Dylan... playing the Isle of Wight... what is there not to like? I never thought then that we were witnessing the benchmark. A mark that was set for all time. But we were — and as the years have gone by, I feel more privileged to have been there.

Loris Valvona circa 1969

The legacy
The business of festivals today

Nile Rodgers is on stage at the revived Isle of Wight Festival's 2018 incarnation, playing in front of a 70,000 crowd beneath a sunlit sky and under the stage roof's turquoise and purple frontage. The structure's artwork features rainbow motifs and psychedelic emblems straight out of Dave Roe's Fiery Creations' late 1960s festival pallet.

Suddenly, Rodgers and his iconic disco band, Chic, are swamped by a choreographed invasion of hand-picked VIP festival-goers – arranged in orderly fashion backstage for this not-so-impromptu intervention. Many are young and undoubtedly on-trend, some are middle aged and somewhat self-conscious and some, well, are marching onwards from middle age towards veteran status.

Though likely to be a slightly more affluent bunch than the average punter watching out front, this is not a bad representation of the present-day festival-goer. There's the old boy in a battered Stetson and a dodgy shirt; a stocky chap sporting a John McEnroe-style headband from 40 years ago; a strutting young reporter from *The Sun* – recently transferred from the Island's *County Press* – sporting so many sparkles on her dress she resembles a walking glitter ball; an annoying shaven-headed, gum-chewing chap in a Dare2b black jacket, so intent on selfies he forgets to dance... and the boss, white-haired John Giddings, cool as you like in coal-black shades and a leather jacket to match.

'Party Time!' urged Rodgers as his band launched into 'Good Times' but was it party time – or indeed good times – for Giddings, the man who first revived the Isle of Wight Festival back in 2002? After all, his company, Solo Productions, had just sold out their controlling interest in the festival to multi-national behemoth Live Nation. The 2018 event was the first since the shift in ownership. Giddings, a multi-millionaire music industry practitioner and manager-agent has helped stage tours for acts such as The Rolling Stones, Madonna, Genesis, Celine Dion,

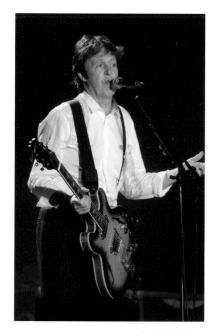

Paul McCartney

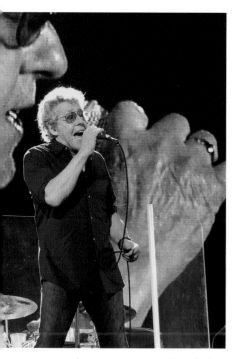

Roger Daltrey

Iggy Pop and David Bowie. He has also represented The Police, Lady Gaga, Westlife, The Corrs, Boyzone, Pharrell Williams, Simple Minds and Spandau Ballet, among others.

There is no doubt he genuinely loves the Island festival. As a teenager, he attended the monster 1970 event and, decades later, saw the opportunity to bring it back to life. So why would he relinquish control?

The answer is both easy and complex. Money. The fact that he sold out to Live Nation for just £1 only underlines this.

For the fact is that the modern rock festival, its organisation and finance, is half a century – but also, in many ways, light years – away from the pioneering Foulk Brothers' events of 1968, '69 and '70.

Five decades on, the business of staging outdoor concerts is a multibillion-dollar industry dominated by two huge companies – Live Nation and AEG Live.

Giddings told *Music Week* in 2018 that the £10 million bill for staging the event eventually persuaded him to sell to Live Nation, 15 years after the first Island revival. It was those weighty costs that meant that the iconic Island festival was sold for just £1.

'You need a safety net to help prop it up because I can't afford to lose the amount of money it costs now personally, I need financial support,' said Giddings. 'The problem is it costs £10 million to put on a festival and nothing hurts more than losing money.

'The music business has changed whereby there's Live Nation and AEG, and they are the big power players. I felt like there was a train leaving the station and if I didn't get on it, I'd be left standing there on my own, waving.'

Live Nation's parent company, LN-Gaiety Holdings, acquired the trade and assets of the Isle of Wight Festival for £1, according to documents lodged at Companies House. And the deal happened as the Association of Independent Festivals called for an investigation into Live Nation's 'dominance' of the market in outdoor events with a 5,000-plus capacity.

The Competition and Markets Authority (CMA) investigation of the Isle of Wight deal gave Giddings' sale its approval in September 2017. The acquisition by LN-Gaiety showed that the festival owed £378,426, but money due from debtors and pre-payments totalled £378,526, leaving a surplus of £100.

A further £698,820 was stacked up in legal fees. But LN-Gaiety lodged goodwill of £698,721 in relation to the transaction – leaving that notional £1 price tag. So, as *Music Week* noted, the chocolate-bar price tag doesn't tell the complete story of the value of the festival's brand.

LN-Gaiety now owns 75 per cent of Isle of Wight Festival Limited, with Giddings listed among the new company's directors and his company, Solo Promoters, named as a related party in the ownership structure.

It all seems a world away from hippies, peace and love and 'sticking it to the man', to use the late 1960s vernacular.

Giddings, for his part, does not shy away from the 21st century preoccupation with the 'Brand' he has built. Since the 2002 revival, the festival has paraded a wealth of talent, including David Bowie, The Rolling Stones, The Who, Bruce Springsteen, Muse, Foo Fighters, Paul McCartney, Rod Stewart, The Stone Roses, Amy Winehouse, Kings of Leon, Jay Z, Coldplay, The Police and Biffy Clyro.

Bruce Springsteen

'I've got an iconic brand and I need to protect the heritage of that brand,' he said. 'When you promote your own festival, you basically pay the acts you love millions of pounds, invite your mates and hope people are going to buy tickets to come and see it.

'You have to get some kind of exclusivity because you don't want a load of acts that are playing down the road the next weekend. We want people to travel and come and enjoy themselves.'

Does it all sound terribly corporate? Sure it does, especially to those who cut their teeth on the trail blazing festivals of the 1960s.

For Ray Foulk, co-promoter within Fiery Creations of the 1969 event, it is like comparing chalk and cheese. Back in 1969, he freely admits, the business behind the staging of a major festival was 'crude'.

'We invented or pioneered the setting up of ticket agencies,' he tells me. 'Usually record shops, sometimes newsagents, in towns and cities nationwide. We would supply a paying-in book and the tickets, the agency then sold the tickets and paid in the cash or cheques to us.

'We had started on a smaller scale in '68 with Harlequin Records in London but caught a cold with The Beatles' Apple Shop. We never got the money from Apple and we were told they gave away our tickets with a lot of shop stock when they were closing down.

David Bowie

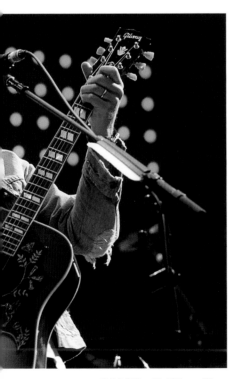

Caleb Followill of Kings of Leon

'It was tightened up in 1969 and broadened all over the country. The press ads for the festival in the music magazines almost devoted half the space to the details of ticket arrangements. And by 1970 we really went to town on this and I don't think other festivals got anywhere close to what we were doing.

'It was all backed up with really active local PR, with Peter Harrigan and David Hill hammering the various press and media outlets in every town where we had established an agency.

'By today's 21st century standards, it was crude. Cash was king. Not many people had bank accounts. People were paid in cash every week and we'd found a way for local people to get their tickets locally. By and large, before the event itself, the cash was coming in from those record shops.

'Advance sales accounted for about half the ticket sales and I'd say about half was paid at the gate in 1969. That was pretty much the same in 1970. We used the money at the gate, certainly in '70, to pay the artists' balances backstage – there would be £2,000 here, £4,000 there. So it was very crude, I must say. There was no finesse about the finances.

'But we had reasonable security, though, as Ronnie insisted on family and very close friends at the box office. We were very aware of the risk of being ripped off by people on the make.'

While Giddings routinely books his main acts up to a year in advance of the modern festival – and the tickets go on sale some seven months before it happens, often selling in double-quick time – Foulk did not have his bill-topper, Bob Dylan, until five weeks before the first acts were due on stage in 1969. The whole house of cards was built around Dylan agreeing the deal on 22 July and the Foulks were left with 38 days to sell the tickets to finance the whole thing.

Seat of the pants, then – and then some.

But when the Island's first three festivals were rolled out, alongside Woodstock in the US and with Glastonbury soon to follow, they were countercultural gatherings full of the hippie spirit.

Dylan, The Who, Neil Young, The Rolling Stones and Paul McCartney all appeared at 1960s and 1970s festivals with modest tickets prices, indeed some were free to attend. In October 2016, all of those ageing rockers appeared at the Coachella Valley Music & Arts Festival in Indio, California, where it was anything but free.

In an era where music lovers stream their music rather than buy recordings, fans had to cough up $399 for a three-day ticket. Coachella is produced by Goldenvoice, a division of AEG Live, which is ultimately owned by billionaire Philip Anschutz. According to Billboard, it sold 198,000 tickets in 2015, raking in $84.3m – then a global record for a festival.

The four next highest attended festivals in the US are owned by Live Nation and, in recent years, Live Nation and AEG Live have acquired dozens of festivals across the world between them, including the former's purchase of Summer Sonic in Tokyo and Reading, Leeds and, of course, the Isle of Wight festivals in the UK.

'We're not a Johnny-come-lately American company that is just discovering festivals,' Joe Berchtold, Live Nation's chief operating officer, told the Financial Times. 'It's been the linchpin of our concert business for the past 10 to 15 years.'

But in August 2018, the Association of Independent Festivals warned that Live Nation owned or controlled 25 per cent of all festivals staged in the UK. 'Allowing a single company to dominate festivals – and the live music sector in general – through vertical integration reduces the amount of choice and value for money for music fans,' it said.

'It can block new entrants to market, result in strangleholds on talent through exclusivity deals, and stifle competition throughout the entire live music business'.

Ah yes, business. And big business is exactly what modern festivals certainly are.

But there is no doubt all modern festivals owe a huge debt to the pioneering risk takers on the Isle of Wight half a century ago. John Giddings' post-2002 Island event is the obvious legacy and Isle of Wight events such as Bestival (until it decamped to the mainland in 2016), Rhythmtree, Jack Up The Summer and Hullabaloo all carry on the torch first lit by the Foulk brothers.

For Giddings, he has endeavoured to bring the biggest and best names in the world to the Island, very much in the spirit of the Foulk's ambitious blueprint. Here is a flavour of the headline acts they have attracted since the Isle of Wight Festival rose again in 2002.

Revival Isle of Wight Festivals

2002: *The Charlatans, Robert Plant.*

2003: *Paul Weller, Starsailor, Bryan Adams, Counting Crows.*

2004: *Stereophonics, Groove Armada, The Who, Manic Street Preachers, David Bowie, The Charlatans.*

2005: *Faithless, Razorlight, Travis, Roxy Music, R.E.M., Snow Patrol.*

2006: *The Prodigy, Placebo, Foo Fighters, Primal Scream, Coldplay, Richard Ashcroft.*

2007: *Snow Patrol, Groove Armada, Muse, Kasabian, The Rolling Stones, Keane.*

2008: *Kaiser Chiefs, N.E.R.D, The Sex Pistols, Ian Brown, The Police, The Kooks.*

2009: *The Prodigy, Basement Jaxx, Stereophonics, Razorlight, Neil Young, Pixies.*

2010: *Jay-Z, Florence and the Machine, The Strokes, Blondie, Paul McCartney, P!nk.*

2011: *Kings of Leon, Kaiser Chiefs, Foo Fighters, Pulp, Tom Jones, Kasabian, Beady Eye.*

2012: *Tom Petty & The Heartbreakers, Elbow, Pearl Jam, Biffy Clyro,*
Bruce Springsteen & The E Street Band, Noel Gallagher's High Flying Birds.

2013: *The Stone Roses, Paul Weller, The Killers, Bloc Party, Bon Jovi, The Script.*

2014: *Boy George, Calvin Harris, Biffy Clyro, Red Hot Chili Peppers, The Specials, Kings of Leon, Suede.*

2015: *Billy Idol, The Prodigy, The Black Keys, Blur, Pharrell Williams, Fleetwood Mac, Paolo Nutini.*

2016: *Status Quo, Faithless, Stereophonics, The Who, Richard Ashcroft, Queen + Adam Lambert, Ocean Colour Scene.*

2017: *Razorlight, David Guetta, Run-D.M.C., Arcade Fire, Catfish and the Bottlemen, Rod Stewart, Bastille.*

2018: *The Wombats, Kasabian, The Script, Depeche Mode, Liam Gallagher, The Killers, Manic Street Preachers.*

2019: *Noel Gallagher's High Flying Birds, George Ezra, Biffy Clyro, Fatboy Slim, Richard Ashcroft, Courteeners, Bastille*

It's an impressive list, certainly contemporary and always aimed at attracting the latest Generation Z fans while also appealing to festival fans from every era. That's why, in 2018, John Giddings ensured there was a nod to the original 1968 festival's golden anniversary and he is doing the same again in 2019.

'Dig out your blouses and bell-bottoms because this year, the Isle of Wight Festival is going back in time,' urges the official festival blurb. 'Think Bob Dylan and The Who, because the festival is throwing it back 50 years to the iconic 1969 event by revealing its Summer of '69 – Peace and Love theme.'

It's a fine gesture but, as we shall see in Chapter 16, Giddings is not the only man determined to honour the memories and the music of the original festivals.

I was there!

Dave Cramp

In 1968, at the time of the first Island festival, I'd just left school with a keen interest in music. My mate in Yarmouth asked me if we should go and I said, 'What is it?'. He said there was a beer tent and that was good enough for me — we had no idea what a pop festival was. We thought it would be like any other gathering in a field with a beer tent — like the County agricultural show. We didn't think it was a good idea to go on our Lambrettas, so my mate's dad took us in his Bedford van, threw us out as we got close and told us to follow the crowd.

I recall watching The Move, Arthur Brown and Jefferson Airplane but didn't appreciate how big that American band was. It was an all-nighter and as the sun rose the field looked like an African refugee camp with everyone huddled in blankets — it was a cold August night. Even Fairport Convention looked freezing huddled in blankets under blue spotlights. I remember John Peel saying he had sneaked a lift to the Island in Tyrannosaurus Rex's Ford Anglia van.

So, we were definitely on for the second one in 1969, I was 17 by then. We missed the Friday but went on Saturday morning and left our scooters at one of the lads' sisters' in Lushington Hill, not far from Woodside Bay, and I was shocked when we walked to the site. I expected it to be like 1968 but this was different — huge by comparison.

We saw the site manager, Ron Smith, who we knew from his engineering firm in Totland. He ushered us in without having to show our tickets. We found ourselves somewhere behind a big marquee, looking at this odd machine which had a sort of lawnmower engine attached plus a kind of hopper with a long round tube attached. Around it were canisters of liquid and we did not have a clue what it was.

It turned out to be the famous 1969 foam machine and when it got going it pushed out masses of foam and the smell of Fairy Liquid was incredible. The foam was soon 10ft high and we suddenly saw a kid on a pushbike emerge from it, he looked like a snowman!

'The foam was soon 10ft high and we suddenly saw a kid on a pushbike emerge from it, he looked like a snowman!'

We walked into it and it was just a wall of white and I wondered if we'd ever come out the other side. We never saw the infamous sex act that took place in it later — or the slim naked girl — but it was quite a memory.

We had no tent but found somewhere to sleep. We spotted a gap on a lorry trailer between its headboard and the tarpaulin stacked on it. I recall we must have been falling asleep because I stirred to the sound of Joe Cocker's voice introducing a new song — Delta Lady. He said, 'You people at the Isle of Wight are the first to hear this'. That woke me up. He was great. We didn't watch him, just listened from the trailer.

We'd seen The Who's helicopter come down earlier and it apparently had a bumpy landing. Pete Townshend said, 'I think we might be walking home as we've lost our faith in aviation'. They were great that day, doing most of Tommy.

The entire crowd was sat or laid down. We ended up in different places watching different acts. I remember at one point we had a group of Americans in front with one of them turning to an English guy, asking, 'What is this "dreaded lurgy?"' That made me laugh. People left stuff all over, scattered belongings... no-one considered anyone would touch or steal things.

There was a long delay before Dylan came on. I wondered, is he coming on? Is he here at all? I thought he would come on with The Band and, when he didn't, I wondered a little more. I wasn't a huge Dylan fan, but I liked that blues harmonica. I just didn't know what to expect. But he was perfectly good, if not the highlight for me. He was by far the biggest name, but not the highlight.

The Who were more to my liking but overall, I am most glad I got to hear Joe Cocker and I nearly slept through it. It sounded as though he was singing to every single person in that crowd individually. I nearly missed him — and I did not actually see him — but Joe was my highlight.

Jimi Hendrix and Isle of Wight 1970 beckons

'Car to Portsmouth.
Time: three hours.
Ferrie [sic] *to Isle.'*

This was the one-line reminder Jimi Hendrix jotted down on some notepaper to a friend. It was his travel plan for the 1970 Isle of Wight Festival of Music, 12 months after the 1969 event at Woodside Bay. Fate decreed it would be Hendrix's last UK concert performance and he would be dead just 17 days after his bill-topping appearance on the Island.

Four decades later that note was displayed at Hendrix in London, an exhibition devoted to the American guitar virtuoso at the Brook Street, Mayfair flat he had called home in the late 1960s. Just nine words that signposted his trek to a career-ending festival finale.

When Fiery Creations picked over the carcass of their 1969 event, the good news was they were 'In funds' – without making life-changing fortunes – and encouraged to go for something bigger and even better the following year, to herald the new decade. The immediate question was simple enough, but difficult to answer: how to follow Dylan?

Fiery Creations' documents printed in January 1970, rediscovered by Ray Foulk as he prepared the text for his *Stealing Dylan From Woodstock* volume, revealed the Foulks were already contemplating a huge five-day festival. It also proposed a gargantuan stage with tiered seating for up to 1,000 journalists and a further 1,000 VIPs. Clearly the logistical nightmare that contributed to the delays ahead of Dylan's performance was weighing heavily on the promoters.

There was also a plan for a heliport to be incorporated into the massive stage area – the hairy landing by The Who at Woodside Bay was fresh in everyone's minds. Large 40ft x 30ft video screens, pretty

much unheard of then but now a 21st Century festival staple, were also among the plans.

Such a grandiose structure never made it beyond the initial planning stage but the dye for a monster festival had been cast. And such a big event needed a big, big act to follow in the huge footprints of Dylan. Initial debates between the Foulk brothers rehearsed the arguments they already knew: there were really only three established genuine superstar acts in the world: Elvis Presley, The Beatles and Bob Dylan – and they had already had Dylan.

Elvis was still huge but not relevant to the festival generation; a letter from Ray Foulk to George Harrison, capitalising on the good relationship the promoters enjoyed with him at Forelands Farm, suggested The Beatles could front the greatest musical festival of all time on the Island, but even before it could be seriously acted upon, Paul McCartney announced the collapse of the band by quitting.

So instead, Isle of Wight 1970 would be a larger, five-day affair with a whole raft of top acts. Even so, a truly big name was a must. A key avenue opened up just three months after the Woodside Bay event closed when Ray Foulk flew to New York to tie up the loose ends of the Dylan contracts. Bert Block was so delighted with the relationship that he agreed to represent the Foulks in North America moving forward.

With the dawning of the 1970s, it seemed a new era was also opening up after the momentous events of 1969. The capture of Dylan for the Island event was massive but the persona he presented – white suit, cropped hair, smart cufflinks – was a deliberate step away from the protest troubadour and fired-up poet of the early and mid-60s. He never sought the title role as leader of the hippie generation or spokesman for the Counterculture and clearly, by 1970, a vacuum needed to be filled.

Hendrix fitted the bill. He had been spotted three years earlier in New York by Chas Chandler, The Animals' bass player, who was scouting for talent to manage. Chandler took Hendrix with him back to London and, having achieved nothing in the States, Jimi's first single, 'Hey Joe', was released in December 1966. Just a year later, *Melody Maker* readers voted him the world's No. 1 rock musician.

'I saw Jimi as the governor rebel of all time,' Chandler said later. 'I mean, he may be nice as ninepence as a bloke, mind, but here was

a guy who was going to turn on all the chicks, crucify every blues guitarist in the world.'

And there was, clearly, already some genuine respect between the master and the virtuoso. Hendrix's star had first risen dramatically after the 1967 Monterrey Pop Festival, where his version of Dylan's 'Like a Rolling Stone' was widely acclaimed. Even more significant was the cover of 'All Along The Watchtower', a Dylan song from *John Wesley Harding*, which Hendrix recorded for his *Electric Ladyland* album. It became an instant classic and, down the years, has been performed many times by Dylan, taking several cues from Hendrix's haunting rendition. It remains Number One in *Rolling Stone's* poll of the Greatest Cover Versions of All Time.

Not only that, while Dylan had snubbed Woodstock in 1969, Hendrix had been the main man in his absence, his status only accentuated by the way his performance was depicted in the Woodstock film released during the following year. If there was a 1970 name around which the Island festival could be built, it was Jimi Hendrix.

Geoffrey Cannon wrote in *The Guardian*, 'He was Muddy Waters' "Hoochie Coochi Man": the voodoo myth of magic male potency, alive and pulsating on stage, playing his guitar with his teeth, setting it alight, and flickering his tongue at the little girls, as he sang "Wild Thing, I'm Coming To Getcha," with an enormous wicked grin.'

And so the challenge was on, not only to present the best festival ever assembled, in terms of the roster of talent, but also to fight off those who, in the weeks and months that followed the Dylan festival in 1969, attempted to launch a wrecking ball and prevent any further festivals taking place on that little diamond of chalky rock in the English channel.

The fiercest opposition came squarely from the establishment on the Isle of Wight itself. The Island's long-established newspaper, *The Isle of Wight County Press*, had studiously ignored the event itself but, on the Friday following it, carried a venomous leading article penned by the sitting Tory MP for the Island, Mark Woodnutt, that lit the blue touch-paper on a firecracker of a campaign to derail the Foulk Brothers' plans.

Headlined 'What Price Pop?', Woodnutt began his rant in faux Biblical style before moving on to 'Present an accurate record for poster-

ity'. Those drawn to the 'Green fields of Wootton', would, he claimed, 'Have despaired of human beings who could leave such an indescribable scene of litter and filth behind them… shocked by the remains of fires in the nearby graveyard… understandably concerned by the fears of residents for the safety of their property and the rightful claim that they and their families should be allowed to sleep in peace.'

Ray Foulk remembers all those at Fiery Creations were 'Outraged and amused simultaneously', as the local hysteria was offset by much more positive press from the national and music press. The Foulks did not know in the early weeks and months following the Dylan festival just what a battle they would have on their hands to make a bigger, bolder event happen in 1970. That they prevailed is a testament to their determination.

The fact that Hendrix – soon to become a founder member of that select band of artists who perished at the age of 27 – would be joined in playing before an unwieldy crowd of some 500,000 fans by acts such as The Doors, The Who, Leonard Cohen, Joan Baez, The Moody Blues, Free, Chicago, Miles Davis, Emerson Lake and Palmer, Donovan, Melanie, Rory Gallagher and many, many more, illustrates what a fine event it promised to be.

Yet its initial legacy, Hendrix's tragic death in Notting Hill's Samarkand Hotel on 18 September notwithstanding, were legal moves to block such events happening on the Island ever again. That block was effective for another three decades until the successful 21st Century revival of the event in 2002.

How that came about is another story, for another day. The legacy beyond that early negative backlash was to be felt for decades, before breaking through in the present day with large-scale festivals flourishing in the closing decades of the old century and beyond the Millennium up to the present.

Glastonbury, the Hyde Park Festivals, the split-site V-Festivals, Reading, Leeds and a clutch of others hosting events for different musical genres plus, of course, John Giddings' revived Isle of Wight Festival from 2002, must all doff their collective caps at the enormous influence of the Isle of Wight Festivals of Music. And in terms of scale, the 1969 and 1970 Island events were ground breaking.

Better to close, perhaps, on the words of Hendrix, discovered where he died in 1970. Ex-Animal Eric Burdon had played a club gig, jamming with the guitarist at Ronnie Scott's Club two days before Hendrix passed away. When Burdon arrived at the Samarkand Hotel, before the ambulance crew came, he found Hendrix had written a five-page poem, 'The Story of Life'. Its last verse read:

'The story of life is quicker than the wink of an eye. The story of love is hello and goodbye. Until we meet again.'

The wink of an eye, indeed. Hendrix closed an Isle of Wight story that began humbly in 1968 but which truly exploded into life with the Dylan festival of 1969. Three fantastic events spanning just 730 days – little more than two years of can-do enterprise, hope and fearlessness. We will not see their like again.

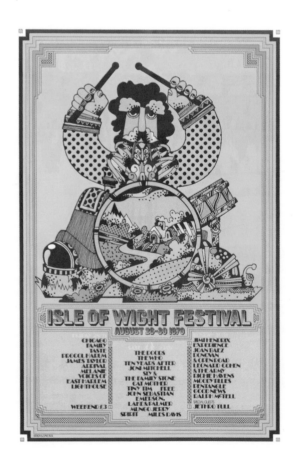

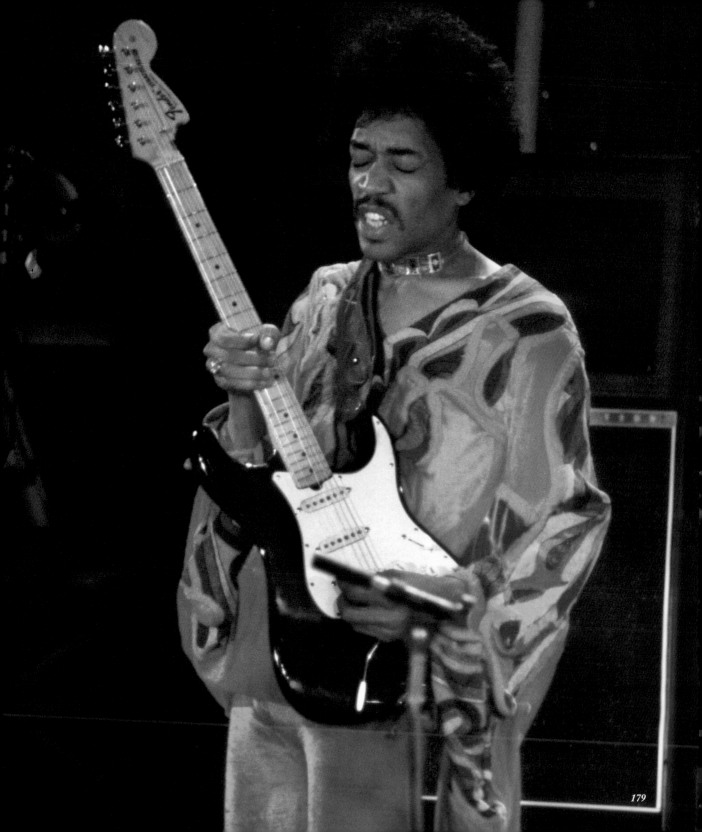

I was there!

John Giddings

John Giddings (Solo Productions), was a teenage fan at the 1970 Isle of Wight Festival of Music. He revived the Isle of Wight Festival in 2002. His words are taken from the BBC's Hits Hype Hustle - An Insiders' Guide to the Music Business.

Bob Dylan had not played live for three years and had stepped out of the public eye after a motor-bike crash. This was the longest of long shots but, somehow, these blokes with no background in music persuaded the biggest artist in the world to sign on the dotted line. You've got to take your hat off to them.

The whole thing was such a success in 1969 they decided to do it all over again in 1970. Maybe they should have quit while they were ahead.

Everyone has their first festival and the Isle of Wight Festival, 1970, was mine.

I remember everybody at school (in St Albans, Hertfordshire) wanted to go and nobody had a mobile phone or emails — how the hell we managed to meet up among 600,000 people is beyond me. They quadrupled the number of people on the Island for those four days.

We all went skinny-dipping, I remember that. We camped up and it was the first time I had seen dope. They put their dope in silver paper dipped into tomato sauce so the police dogs could not smell it. And it was four days of the best bands you could ever think of.

Strange as it seems today, some of the crowd did not think you should pay to see this incredible show, even though tickets cost just £3 — a pretty good deal, even then.

'We all went skinny-dipping, I remember that. We camped up and it was the first time I had seen dope.'

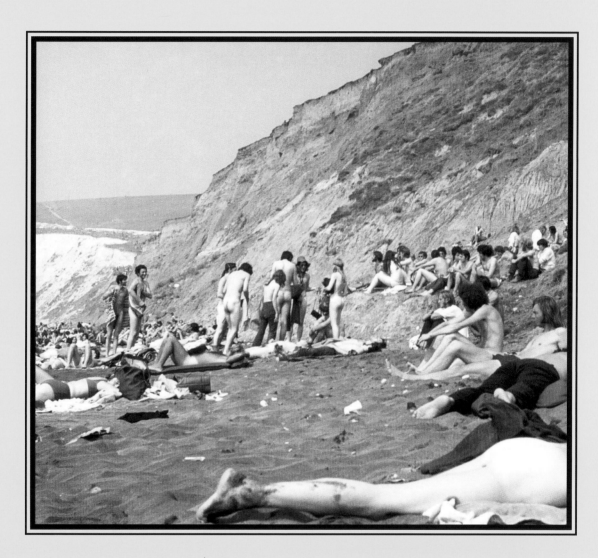

Thanks for the memories
- making them live on

Anyone who performed at any of the original Isle of Wight festivals, or was lucky enough to have been there to watch them, will now be well into their 60s. At least!

So lifelong music nut Andy Knight was feeling unashamedly wistful when he got into conversation with friends in 2017 about the looming 50th anniversary of the iconic 1970 Isle of Wight Festival, when a huge crowd, estimated at anything up to 600,000, swamped the festival site at East Afton Farm, near Freshwater.

Andy proposed 'Afton50' - a celebration of the 1970 event to be held in 2020 – but this quickly evolved into a bid to commemorate all three original festivals, 1968, 69 and 70. All Wight Now was born with Andy as its founding chairman. The race was on to put together an anniversary event in 2018 to mark 1968's inaugural 'The Great South Coast Bank Holiday Pop Festivity', held near Godshill.

The first of that trio of events, organised by the Foulk Brothers – Ronnie, Ray and Bill – was a relatively modest affair, a single all-nighter, with a raft of acts including The Move, The Pretty Things, Tyrannosaurus Rex, The Crazy World of Arthur Brown, Fairport Convention and American headliners Jefferson Airplane.

The All Wight Now committee sought to include acts with their roots in the original event and at a suitable Island venue. This was pulled off with former Fairport Convention founder member Ashley Hutchings - awarded an MBE in 2015 for his key role in the development of the folk tradition - swiftly booked to play with his trio. He was followed by The Pretty Things' Dick Taylor and Phil May agreeing to play followed by Arthur Brown, still crazy after all these years, pencilled in as a fitting finale act.

Tapnell Farm joined the fun, providing a venue at The Cow, overlooking the legendary 1970 festival site. In addition, a free-to-enter exhibition was included with displays creating an audio-visual treat. CH Vintage Audio showcased original sound equipment from the 1969 and 70 festivals. It included the WEM mixers and sound gear used by Bob Dylan in 1969 and Jimi Hendrix, The Who and others in 1970.

The strains of Hendrix's live Island performance were played again through parts of the very system that carried his 1970 riffs across the masses at that event. 'It's a great thing to be part of this celebration,' said Chris Hewitt. 'It would be quite something to perhaps have some of those acts play through the original equipment again.'

Neil Everest staged an exhibition of festival photography featuring the work of his respected photographer father, Charles Everest. Much of Charles's IW work features at the gallery at nearby Dimbola Museum and Galleries, in Freshwater, and was expanded for the Tapnell event.

Sculptor Guy Portelli, who first shot into the public consciousness with his success on TV's *Dragons' Den*, was on site, carrying on work to create a mosaic featuring hand prints donated by festival artists, forming a map of the Island.

'As a piece of art it is a contemporary response to social history and it brings the Isle of Wight Festivals, from half a century ago, up to date,' he said. 'The art is still responding to that. I think it is important because we'll not have the chance to do this again.'

From a single piece the project has now expanded to three mosaic panels: the original 'early years' map with handprints from artists linked the 1968-69-70 events; a 1969 Woodstock panel featuring artists from that festival and a modern Island panel featuring artists linked to the revived festival post-2002.

The event, on Saturday, September 1, was a resounding sell-out success, with all three main on-stage acts also joining Andy Knight for a mid-evening talk-in about the 1968 event.

The real talking point afterwards was the quality of the music with Ashley Hutchings' Trio trawling the Fairports' back catalogue and paying tribute to Dylan with a beautifully crafted set – splendidly punctuated by Hutchings' reminiscences of his early days in the business.

Taylor and May were on blistering form, combining with Island musicians J.C. and Angelina to bring fresh verve to The Pretty Things' under-rated Sixties offerings. They all then returned to lend quality support to the colourful outpourings from Brown, still a very fine vocalist in his mid-70s.

Hutchings was delighted to be part of it all and the memories it stirred. He said: 'In the summer of 1968, Fairport Convention made its way to the Isle of Wight to play at the first rock festival on the island. I was a band member and can affirm that we all felt we were part of something special. This was partly because our favourite group, Jefferson Airplane, were on the bill - but certainly also because the event itself had a special atmosphere.

'Wind 50 years forward to the summer of 2018, and I found myself, together with two lovely singer/musicians and friends, driving up to Tapnell Farm on the island not knowing what to expect. What we three experienced was very special indeed. The organisers of this 50th anniversary celebration of that first festival had arranged not only a nice venue, which was just the right size for our show, but also add-ons like a photographic exhibition; a display of the original sound equipment that was used in 1969 and 70 and other wonders. There was even an artist who was taking handprints of performers, old and new, from '68 and '18 and turning them into a wonderful mosaic.

'The script I had written for the trio's performance went down well with organisers and audience. A special event deserved this rather than just a string of our usual songs. The words and music piece covered in short form the history of the festival, the history of my band, Fairport Convention and a string of suitable songs.'

In 2019, Ashley is acting as the creative director for the 1969 50th anniversary event, scheduled for Saturday, August 31 – half a century to the weekend since Bob Dylan played the Isle of Wight.

'It's another year on and as Bob headlined the '69 festival, this time round we are all putting Dylan in the forefront of our thinking,' he said. 'This is a happy thing for me because I have loved his music since I was a teenager. Now in my 74th year, the great man has made me a friend and sent me a wonderful quote for my website.

'If he was here on the island again I'm sure he would appreciate what is being done to celebrate a great part of musical and social history. Roll on August, I can't wait.'

Arthur Brown

The Pretty Things, of course, also played at the 1969 IoW Festival and there is a very good chance they will be back to play in August, 2019, at the planned 50th anniversary event for the 1969 festival.

Dick Taylor, who was a founding member of the Rolling Stones before establishing The Pretty Things in 1963, was delighted with the 2018 event at Tapnell.

'It was fantastic to be involved in marking the 50th anniversary of the 1968 festival,' he said. 'I thought it was brilliant, spot on.

'I've very fond memories of the original 1968 festival and I'm glad we honoured it as it is often eclipsed by the scale of the 69 and 70 event because they were so huge. At the Tapnell anniversary gig, I just loved it. These days I appreciate just being able to play and it was great for Phil and me to play with Island artists J.C. and Angelina.

'We got together a couple of days beforehand to run through things and make sure we could back Arthur, too. Arthur is great, still doing it. We had so much fun.'

Local Island bands were represented: The Alberts contributed a set and guitarist Paul Athey, who played at the 1968 festival as part of Halcyon Order, played a superb acoustic set in the exhibition marquee.

The 1969 celebration in 2019 is designed to be a rather bigger affair with Dylancentric, a band put together specifically for the event, interpreting the great man's work. Duelling guitar rockers Wishbone Ash, celebrating their own 50th anniversary, will be there plus folk-rock icon Richard Thompson. Kossoff: The Band Plays On represent Free's blues-rock input while several stars from the '69 festival roster will be back, including the remarkable Julie Felix; Jacqui McShee's Pentangle and The Pretty Things.

In addition, with the younger generation in mind, the organisers snapped up one of the most talented singers ever seen on *ITV's The Voice*, Deana Walmsley, the 2019 runner-up, to play the event and to also appear and perform at the media and press launch in May. She had wowed TV viewers with a string of fine performances, including Dylan's 'Make You Feel My Love', during the series.

The legacy of the original festivals goes beyond the All Wight Now celebration itself. The event teamed up with Cowes' rock-themed restaurant That 60s Place for the May media launch and owner Steve Tewkesbury admits the original Island festivals were part of his inspiration.

'Woodstock has become a high profile event in retrospect,' said Steve, who opened his business in July, 2017. 'To some degree it's overshadowed those brilliant Island festivals. That fits with the Americanisation of the world. But England – and the Island – punches above its weight, especially in music. That 60s Place attempts to represent that and virtually everything in there is English... apart from Bob Dylan. He's there, with his Island festival performance in 1969 represented.

'I'm just reliving my youth. I don't think I appreciated growing up in the 1960s and I think that's true of a lot of our customers. Let's enjoy it now! We are delighted to help All Wight Now's 1969 celebration.'

The powerful legacy of the original festivals is plainly manifested in the Island's critically-acclaimed Platform One College of Music, offering a range of courses from a Saturday rock school for teenagers to foundation courses and BA honours degrees in commercial music plus Masters courses accredited by the University of Chichester.

It attracts students from across the Island and from the mainland and its work has been embraced and showcased by Jon Giddings and the post-2002 revived festivals. Bands from Platform One play each year on the main stage and in their own marquee.

Director David Pontin says: 'Platform One was set up by my brother Peter and me in 1999. There is that heritage on the Isle of Wight from the iconic original festivals and a musical momentum with a creative force. When we first set up and looked at the musical landscape, there was not a massive amount going on. It became clear that we had to be industry-facing in what we do; everything had to be geared to the music industry because we had kids on the Island who might not be able to afford to get off the Island, let alone go to gigs or universities on the mainland.

'Those 1968-69-70 festivals put the Isle of Wight on the map. Platform One from day one has been an independent not-for-profit venture and the Isle of Wight is part of the musical vocabulary thanks to those festivals. We had a group of our students go on a tour of dates in Holland in mid-April 2019 and people there will talk about the Isle of Wight... they talk about the Island everywhere we go.

'Back in 2002 we worked with the Isle of Wight Council trying to show why we needed to bring the festival back to the Island,' says David.

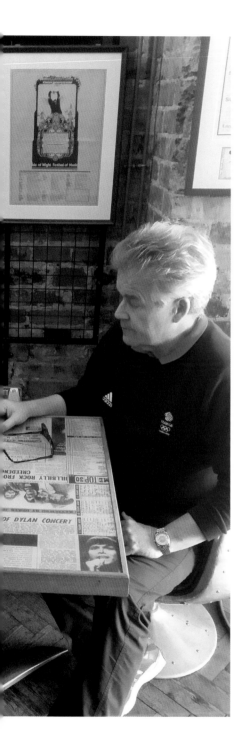

'Part of the resurrection of the festival was the peripheral Island-wide gigs and events that went with Rock Island, as it was first called, when John Giddings revived the festival. The council rather let that fringe element of the festival slip away, but it was back – and Platform One has been heavily involved ever since with John embracing what we do. Since 2002 we have had a band on the main stage every year and that's quite something as those slots have a real commercial value.

'Both John and Rob De Bank, the man behind Bestival, are patrons of Platform One. The really great thing is that every Platform One student who performs at the festival is awarded membership of the Performing Rights Society (PRS) which means they can start earning a living from their efforts as the PRS collects royalties for the reproduction of its members' work.'

Internationally acclaimed DJ and promoter Rob Da Bank is impressed: 'Platform One is one of the brightest, futuristic looking schools I've ever seen and is a truly inspiring educational establishment that is firing out new musical talent at a rate of knots. I'm a huge fan.'

Fellow patron John Giddings agrees: 'Platform One does an amazing job in nurturing talent and helping their students learn about the music business. We are proud to be able to help them in any way possible.'

And so on to the 2019 All Wight Now celebratory event. What is that quote from Dylan, referenced by Ashley Hutchings, as the 2019 roster of musicians get ready to salute the 1969 event? Well, Dylan said that Hutchings was: 'The single most important figure in English folk-rock'. Quite a compliment.

All Wight Now is ready to party all over again on the Island in 2019 to salute those musical heroes of 1969. And then they plan to do it all over again in 2020 to mark 1970's Last Great Event.

That, as they say, is another story...

Author Bill Bradshaw (right) with Peter Harrigan, press and PR director
of the 1969 and 1970 festivals at That 60s Place in Cowes, Isle of Wight.

Lymington

Lymington Town

Lymington Pier

The Solent

Yarmouth

Totland
Firey Creations
HQ

Freshwater
Afton Down
Festival Site
1970

1969
The Isle of Wight Festival

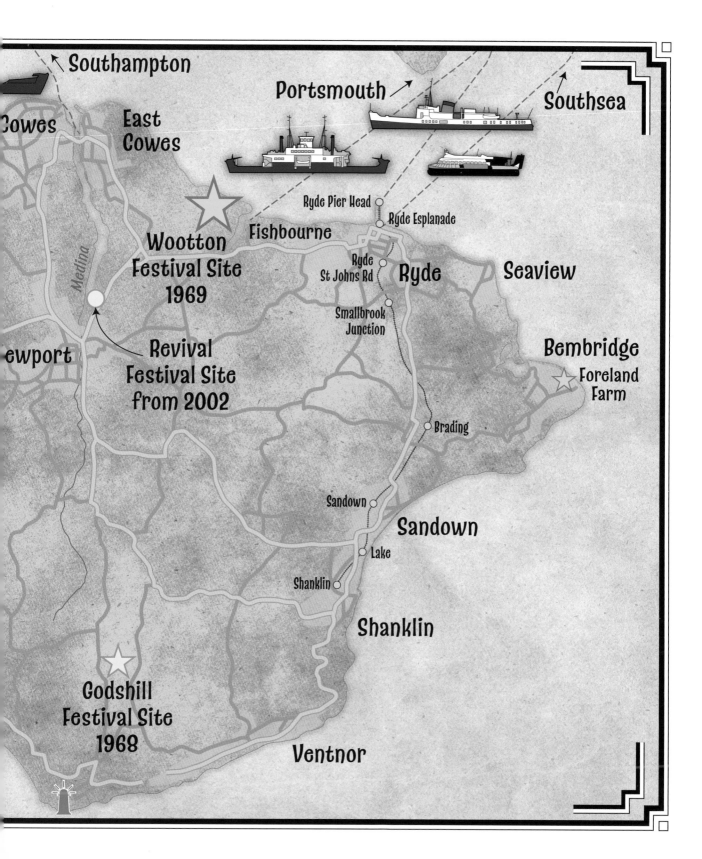

Southampton

Cowes

East
Cowes

Portsmouth

Southsea

Medina

Wootton
Festival Site
1969

Fishbourne

Ryde Pier Head

Ryde Esplanade

Ryde
St Johns Rd

Ryde

Seaview

Newport

Revival
Festival Site
from 2002

Smallbrook
Junction

Bembridge
Foreland
Farm

Brading

Sandown

Sandown

Lake

Godshill
Festival Site
1968

Shanklin

Shanklin

Ventnor

Photo credits

This project would not have been possible without the generosity of a number of photographers who were present at the Isle of Wight Festival 1969 and Woodstock. Thanks to all those involved - this book would not have been possible without you. A special thank you to ukrockfestivals.com for putting us in touch with a number of photographers too.

Photographs and artwork courtesy of:

Cummings Archive (Getty Images) - 77
Jean-Louis Atlan (Getty Images) - 90-91, 122-23
Peter Bull - 64-65, 87, 115 (top), 127, 137, 156
CameronLife Photo Library (www.cameronlife.uk) - 179
Mac Colton - 8-9, 16, 17, 25, 37, 62-63 (bottom), 98-99, 100, 101, 148-149, 157
Fiery Creations Archive - 21 (right), 22
Stephen Goldblatt - 27, 33-34, 35, 61, 62-63, 63, 67, 68-69, 69, 79, 83, 84-85, 85, 88, 89, 96-97, 111, 112-13, 114-15, 116-17, 121, 135
Ron Howard (Getty Images) - 18-19
Anwar Hussein (Getty Images) - 41
Isle of Wight County Press - 164-65, 165, 166, 167, 167-67
Keystone-France (Getty Images) - 1
David Kohn - 105, 118-119
Elliott Landy - 42-43, 48-49, 50-51, 52-53, 54-55, 57, 58-59
Martin Lubikowski (ML Design) - 188-89
Cherry Lee-Wade - 97 (top)
Habans Patrice (Getty Images) - 94-95, 44-45, 106-07
Rolls Press/Popperfoto (Getty Images) - 73, 138-39
Dave Roe - 12, 15, 71, 75, 178, 192 (top)
Greg Shepherd - 102-03 (top & bottom) 140-41, 140, 141 (top & middle), 142 (left & right), 143, 172-73, 181
Ian Tyas (Getty Images) - 5, 129
Loris Valvona - 161, 163
Vernon Warder - 109

Bob Dylan at the Isle of Wight Festival 1969
50th Anniversary Special
by Bill Bradshaw

Published by

Medina Publishing Ltd.

Suite 15 Link House

140 Tolworth Broadway

KT6 7HT

Coordinated by Sherif Dhaimish

Designed by Luke Pajak

Cover photo - Bob Dylan performing at the Isle of Wight 1969 - Ian Tyas
(Getty Images)

ISBN: 978-1-909339-385

Printed by Opolgraf in Poland

CIP Data: A catalogue record of this book is available from the British Library

www.medinapublishing.com

Other reading

By Ray Foulk with Caroline Foulk

When the World Came to the Isle of Wight is festival organiser Ray Foulk's internationally acclaimed illustrated account of the 1968, 1969 and 1970 events.

Available at www.medinapublishing.com

When the World Came to the Isle of Wight

VOLUME ONE

STEALING DYLAN FROM WOODSTOCK

Festival organiser
RAY FOULK
with Caroline Foulk

When the World Came to the Isle of Wight
1970

THE LAST GREAT EVENT

WITH **JIMI HENDRIX** AND **JIM MORRISON**

also featuring
Joni Mitchell ★ Leonard Cohen ★ Miles Davis ★ Joan Baez
Richie Havens ★ the Who ★ ELP ★ the Moody Blues and more

RAY FOULK
with Caroline Foulk

In volume one, *Stealing Dylan from Woodstock*, Foulk tells of the 1969 Isle of Wight Festival, Bob Dylan's one and only full concert appearance in seven-and-a-half years and one that played its part in a highly transformative period of the artist's life. Foulk explores how the festival famously stole Dylan from Woodstock in '69, and was the starting point for all music festivals in the UK.

Hardback - ISBN: 9781909339507 - £22.95

The following year, documented in volume two, *The Last Great Event*, was to be Jimi Hendrix's last major performance - seventeen days later he was dead. Many remember this festival as a magical experience, encapsulating the sixties trip of sex, drugs, rock'n'roll and a political yearning for a better world. But for others, a question looms large over the history: did this festival help precipitate the end of the dream of an alternative society, or did it reflect the changes already taking place?

Hardback - ISBN: 9781909339576 - £22.95

Bellyband edition (Volume One & Two) - Hardback - ISBN: 9781911487005 - £35.00